HOMEWOOD HOUSE

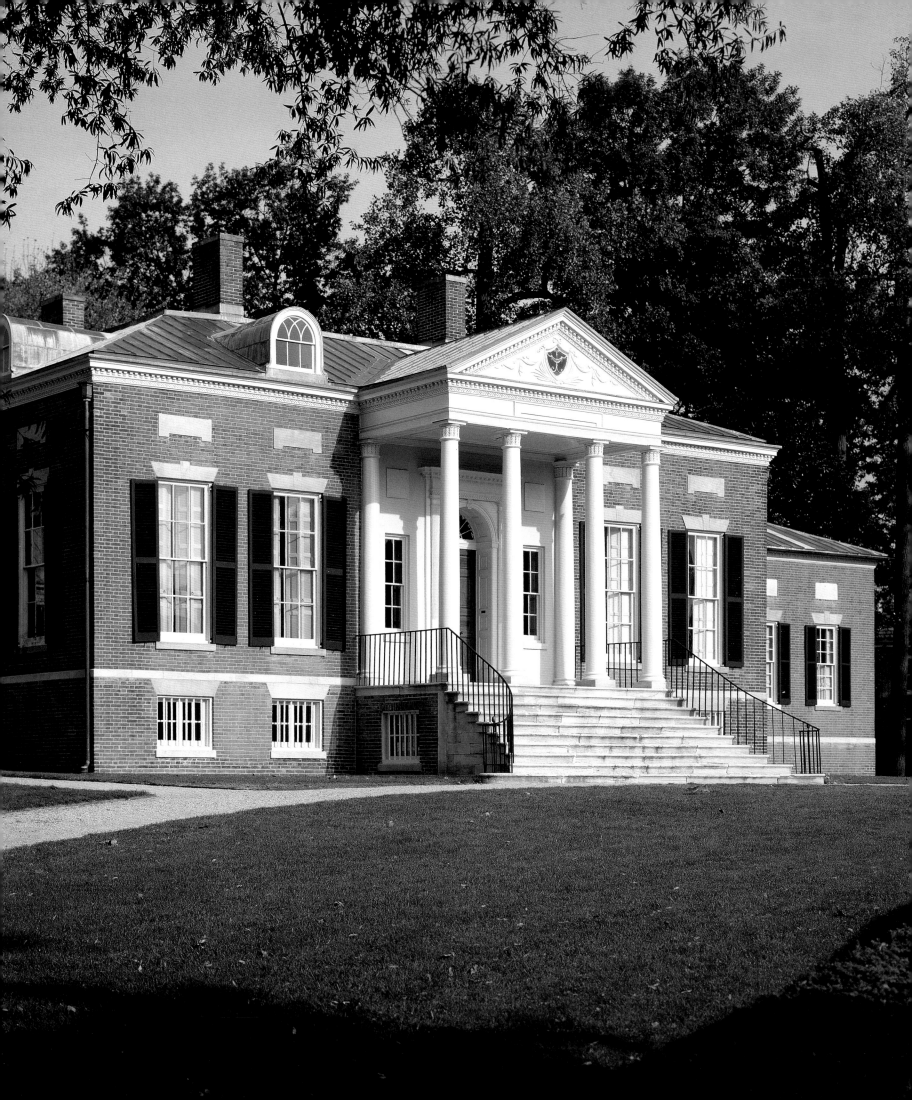

HOMEWOOD HOUSE

Catherine Rogers Arthur and Cindy Kelly

THE JOHNS HOPKINS UNIVERSITY PRESS · BALTIMORE AND LONDON

© 2004 The Johns Hopkins University Press
All rights reserved. Published 2004
Printed in Singapore on acid-free paper

2 4 6 8 9 7 5 3 1

The Johns Hopkins University Press
2715 North Charles Street
Baltimore, Maryland 21218-4363
www.press.jhu.edu

Library of Congress Cataloging-in-Publication Data
Arthur, Catherine Rogers, 1968–
Homewood House / Catherine Rogers Arthur and Cindy Kelly.
p. cm.
Includes bibliographical references and index.
ISBN 0-8018-7987-6 (hardcover : alk. paper)
1. Homewood House Museum (Johns Hopkins University).
2. Carroll, Charles, 1775–1825—Homes and haunts—Maryland—Baltimore.
3. Carroll Family—Homes and haunts—Maryland—Baltimore.
4. Historic buildings—Maryland—Baltimore.
5. Dwellings—Maryland—Baltimore.
6. Baltimore (Md.)—Buildings, structures, etc.
7. Baltimore (Md.)—Biography.
I. Kelly, Cindy, 1945– II. Title.
F189.B19H66 2004

975.2'6—dc22 2004002762

A catalog record for this book is available from the British Library.

Book design by Robert L. Wiser, Silver Spring, Maryland
Principal photography by James T. VanRensselaer, Baltimore, Maryland

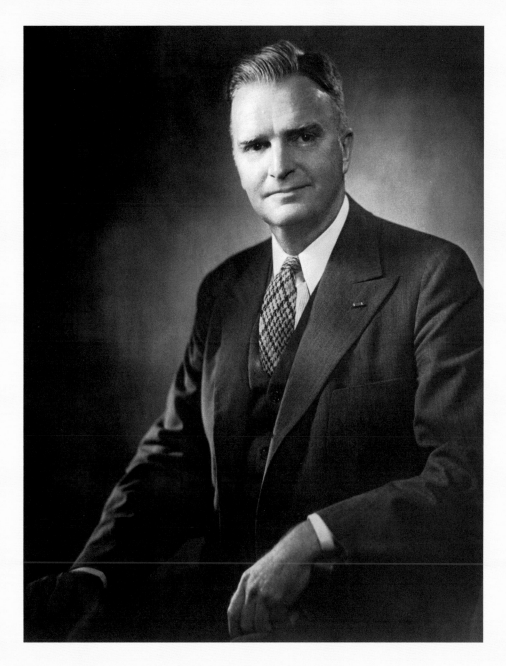

ROBERT GRAFF MERRICK
1895–1986

Robert G. Merrick, an alumnus and trustee of the Johns Hopkins University, ensured that Homewood would be restored and open to the public as a museum through a most generous gift to the university in 1973. He funded the restoration and established an endowment for Homewood. Mr. Merrick, himself a historian and collector of early Maryland prints, lived in the east wing of Homewood while he was a graduate student. His daughter, Anne Merrick Pinkard, continues her father's tradition of dedication and generosity by serving as a university trustee and a founding member of the Homewood Advisory Council. Her advocacy on behalf of this house has taken many forms, most notably in her vision for this book, her gift to Homewood in memory of her father.

Photograph © 1953 by Fabian Bachrach.
The Ferdinand Hamburger Jr. Archives of The John Hopkins University.

2

The daisy pied and all the sweets the dawn of Nature yields
The Primrose pale the Violet blue lay scatter'd o'er the field
Such fragrance in the bosom lies of her who I adore. Ah! Gramachree &c.

3

I laid me down upon a bank bewailing my sad fate
That doom'd me thus the slave of love and cruel Molly's hate
How can she break the honest heart that wears her in its core. Ah! Gramachree &c.

4

You said you lov'd me Molly dear ah why did I believe
Yet who could think such tender words were meant but to deceive
That love was all I ask on earth may heav'n could give no more. Ah! Gramachree &c.

5

Oh had I all the flocks that graze on yonder yellow hill
Or low'd for me the numerous herds that yon green Pasture fill
With her I love I'd gladly share my Kine and fleecy store, Ah! Gramachree &c.

6

Two Turtle doves above my head sat courting on a bough
I envied them their happiness to see them bill and coo
Such fondness once for me she shew'd but now alas! tis o'er. Ah! Gramachree &c.

7

Then fare thee well my Molly dear thy loss I e'er shall mourn
Whilst life remains in Strephon's heart 'twill beat for thee alone
Tho' thou art false may heav'n on thee its choicest blessings pour. Ah! Gramachree &c.

From Dale's 2d Collection of Sixty Scots Songs. Price 7/6

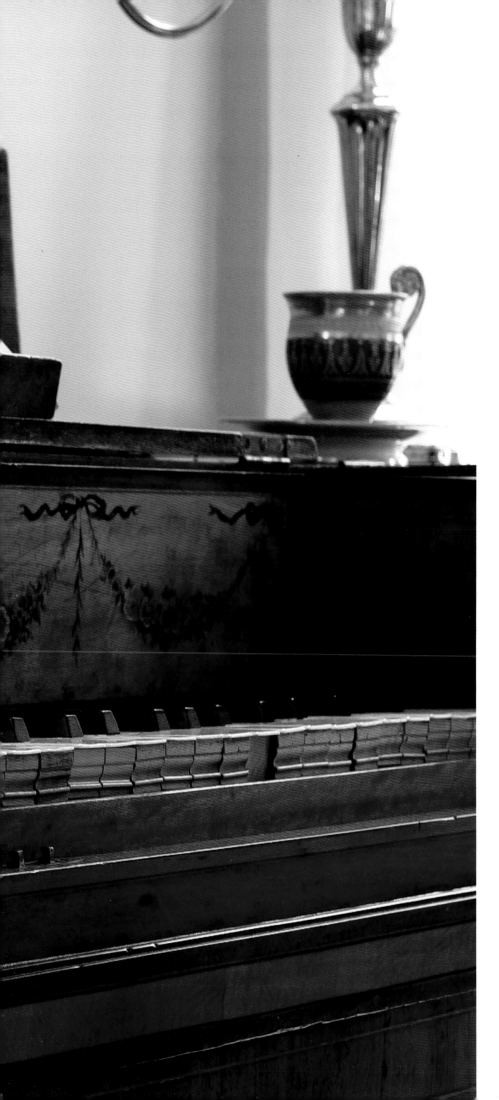

Contents

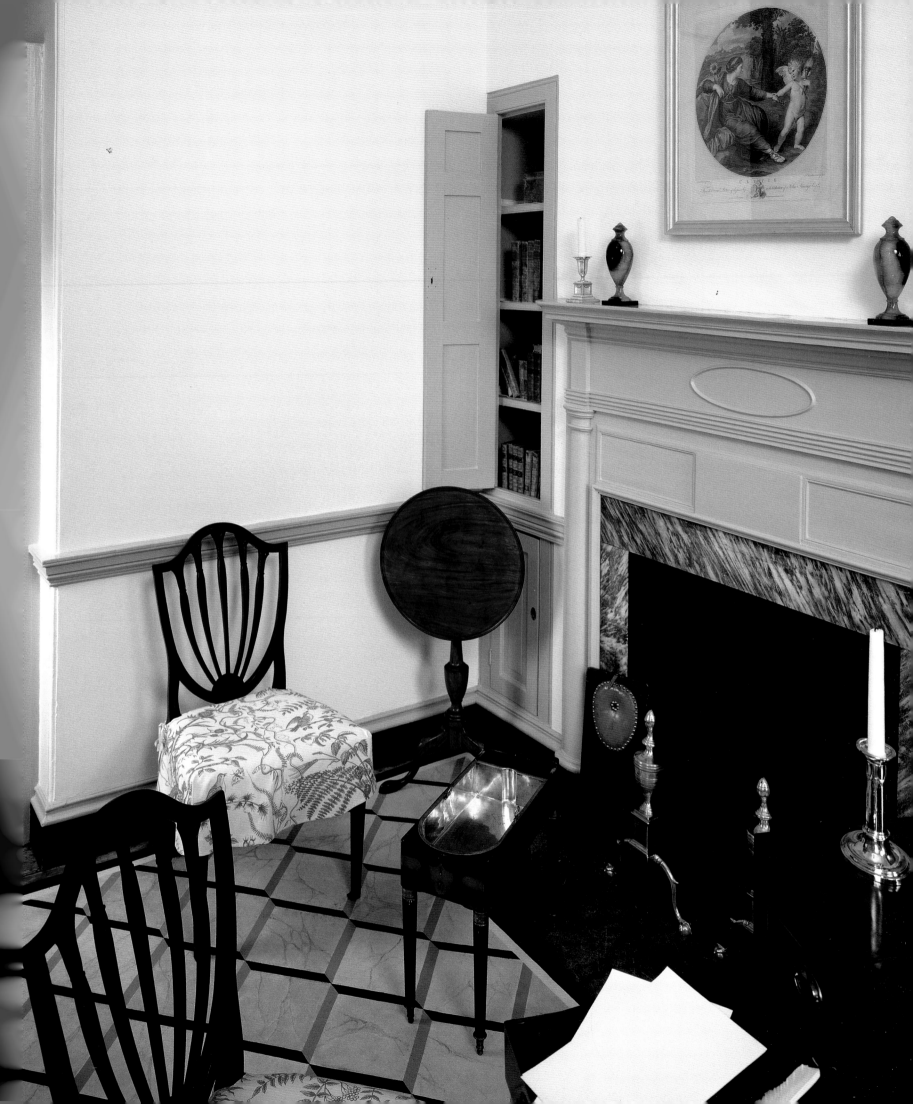

ACKNOWLEDGMENTS

WE THANK ANNE MERRICK PINKARD for her devotion to Homewood House throughout its seventeen-year history as a museum. She has served on the Homewood Advisory Council since its creation and has given generously toward its furnishings. It was her commitment to the publication of this book that above all else brought it to fruition. No one took a greater interest nor followed the progress of this book more closely than she did. And in supporting this publication, Anne Pinkard paid tribute to her father, Robert G. Merrick, for his vision of Homewood House as a museum.

In addition, a number of people have won our everlasting affection and gratitude for their involvement. For critical readings of the manuscript, we are grateful to Aurelia Bolton, Sotheby's representative in Baltimore and a member of the Homewood Advisory Council; William Elder, former curator of decorative arts at the Baltimore Museum of Art and a member of the Homewood Advisory Council; and Susan Tripp, former curator of university collections and the first director of the Homewood House Museum. They drew on their knowledge of the earliest history of Homewood and their involvement in its restoration to advise us. Judith Proffitt, program coordinator at Homewood and curator of Building Homewood, the 2002 exhibition and associated events that celebrated the two-hundredth anniversary of the building of Homewood, was always gracious and helpful when we approached with myriad inquiries. She generously shared findings from her research on the Edwards brothers, who built Homewood. Other scholars whose research and ideas for that exhibition influenced our thinking about the house include Bernard L. Herman, W. Peter Pearre, M. Edward Shull, and Damie Stillman. Kipling Bohnert, Janet Clemens, Chelsey Moore, Pauline Pelletier, Elizabeth Shaw, and David Strathy, all Hopkins student employees at Homewood, helped with transcriptions and research. We thank them all.

Others whose support was important to us are the members of the Homewood Advisory Council, Carroll family descendants whose ancestors lived here, and the current director of Historic Houses, Robert Saarnio.

We also thank Robert J. Brugger, our editor, and Linda Forlifer, our manuscript and production editor, at the Johns Hopkins University Press, for helping to guide this book into finished form. Their sound advice and encouragement will always be remembered.

Finally, we express our heartfelt gratitude for the ongoing patience of our friends, families, and colleagues while we worked on this book.

Opposite page. The dressing room adjacent to the master bedchamber may have been used by Harriet Carroll as a sitting room. It includes a small, built-in cupboard with shelves that could have been used as a bookcase, medicine cabinet, or dispensary.

Pages vi–vii. Music was an important part of the education of young women in the early nineteenth century, and musical instruments and virtuosity were an expression of refinement and gentility. A forte piano represented a significant expense and was probably for the education of the Carroll daughters.

Homewood House Museum, gift of Mr. and Mrs. Mahlon Apgar IV, HH87.8.1.

Overleaf. The Green Chamber, or master bedchamber, provided an additional space in which to entertain family and close friends— a place to visit and take breakfast, tea, or hot chocolate, a popular beverage in the early nineteenth century.

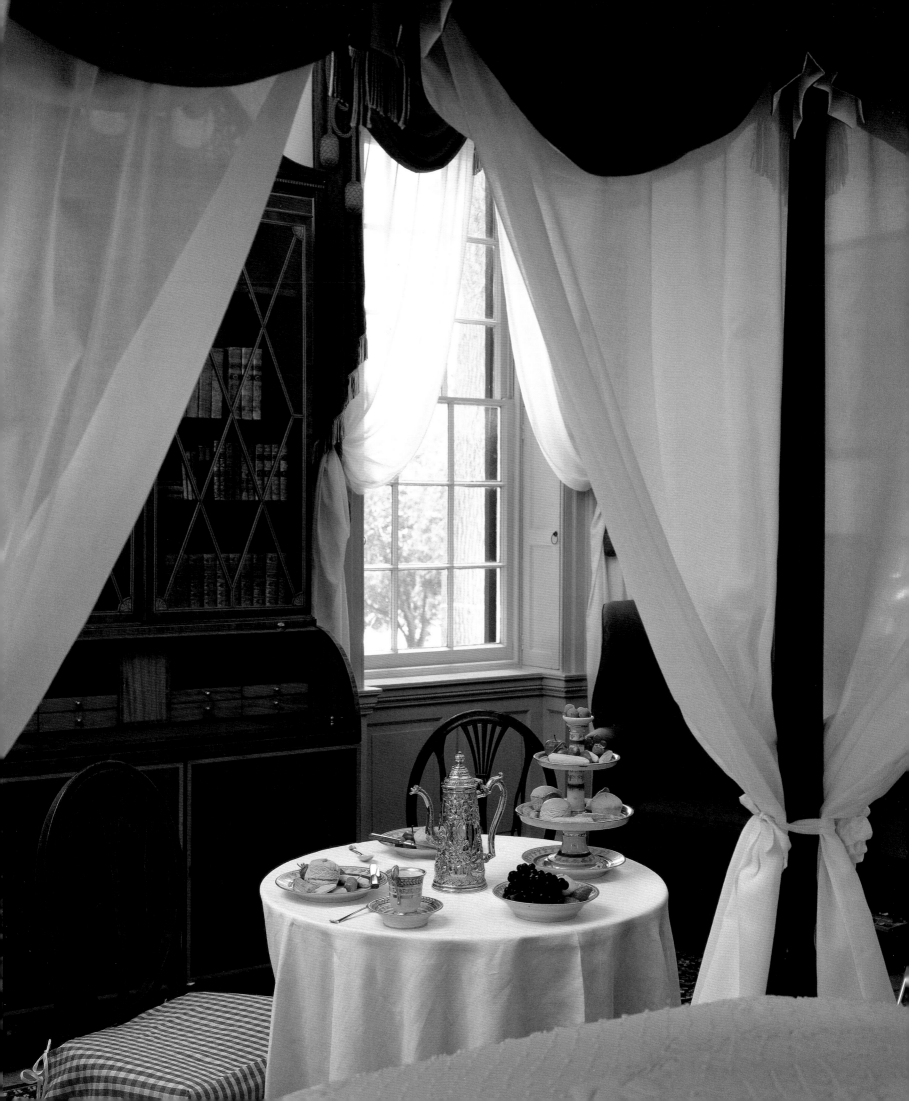

HOMEWOOD HOUSE

INTRODUCTION

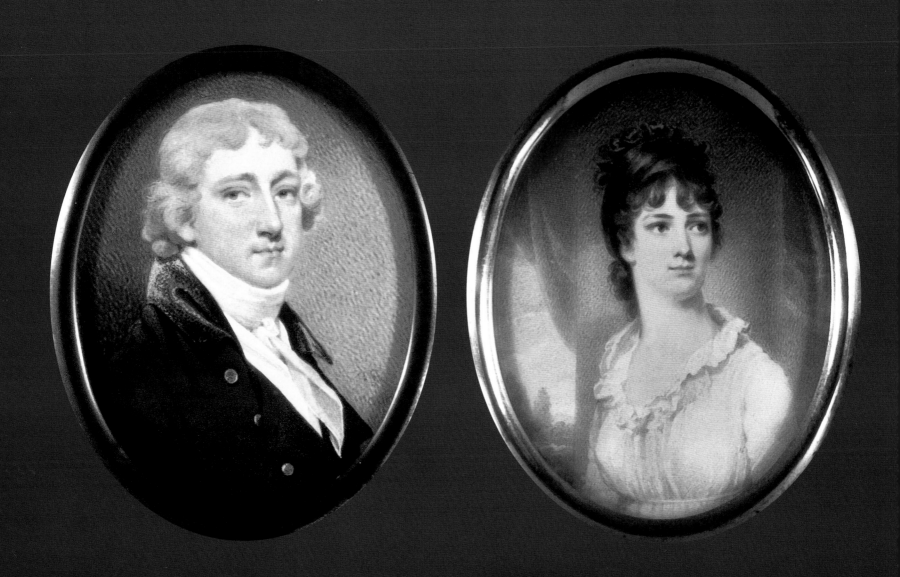

*I need not inform you that my Father and all my Friends are highly
pleased with our intended alliance—He means to fix us about
a mile from the Town of Baltimore—In the first instance he will bear
all the expenses of a full and genteel establishment for us.*

Charles Carroll Jr. to his prospective father-in-law, 1800

I N THE SPRING OF 1800, Charles Carroll of Carrollton (1737–1832) gave a wedding gift of 130 rolling acres of farmland to his son Charles Carroll Jr. (1775–1825) and his new daughter-in-law Harriet Chew Carroll (1775–1861). The land, bordered by forest, afforded a view to Baltimore's harbor. On it the newly married couple would build a "full and genteel establishment," Homewood, which is today considered by architectural historians to be one of the finest examples of Federal period domestic architecture in the United States. The property eventually became the campus of the Johns Hopkins University in Baltimore, now called the Homewood campus.

The gift marked an auspicious beginning for the marriage of Charles Carroll Jr. and Harriet Chew (FIG. 1), both children of prominent, powerful families. Harriet's father, Benjamin Chew, served as chief justice of colonial Pennsylvania; her husband's father, Charles Carroll of Carrollton, a signer of the Declaration of Independence, was one of the wealthiest men in America. Charles Carroll of Carrollton wanted his son to renovate an existing building on the land, manage the farm, and maintain a town house in downtown Baltimore as his primary dwelling.[1] Eventually, he believed, his son would inherit and move to Doughoregan Manor (FIG. 2), the family's vast estate then encompassing fifteen thousand acres in what became Howard County.

To the consternation of his father, Charles Carroll Jr. had more ambitious plans. He would build Homewood, a grand yet intimate house that was far more costly than his father had hoped. Charles Carroll Jr. envisioned Homewood as a fashionable country seat that exemplified the work of the most skilled Baltimore craftsmen using the finest materials available (FIG. 3). When construction began in 1801, two decades after the American victory in the Revolutionary War, Baltimore was enjoying unprecedented prosperity and growth. The city's population had doubled from about thirteen thousand in 1790 to nearly twenty-six thousand in 1800.[2] Given its fine natural harbor, Baltimore had become the "general depot of imports and exports for the middle part of the American States." John Mullin, author of the *Baltimore Directory for 1799*, describes the development of the city and its location, geography, and industry. Commenting on the growth of the city, he wrote, "The

FIG. 1. *These portraits of Charles Carroll Jr. (1775–1825) and Harriet Chew (1775–1861) are thought to have been made immediately before their marriage in Philadelphia in July 1800.*

Miniatures by Robert Field, 1800, watercolor on ivory, signed and dated RF 1800. Photographic reproductions, originals no longer extant, former collection of a descendant.

houses, as numbered in 1787 were 1,955; about 1,200 of these were in the town, and the rest at Fell's Point. The number of houses at present is about 3,500; the greatest part of these are brick and many of them are handsome and elegant."[3]

The magnificent houses being built and furnished testified to new wealth and the emergence of Baltimore's mercantile economy (FIG. 4). On the highest hill west of Homewood was Druid Hill (built 1797–1801), the country house of Nicholas Rogers, a fourth-generation Baltimorean. Charles Carroll Jr.'s older sister, Mary Carroll Caton (1770–1846), and her husband, Richard (1763–1845), spent summers at Brooklandwood (1787) in Baltimore County (FIG. 6). The Ridgely family lived at Hampton (1790), the largest house in the United States at the time. Belvidere (1794), a country estate within the boundaries of Baltimore, belonged to Revolutionary War hero John Eager Howard (1752–1827), who was the husband of Harriet's older sister Margaret, or Peggy (1760–1824), and who later became governor of Maryland. John Donnell (1754–1827), another wealthy merchant, owned Willow Brook (1799), a twenty-six-acre estate with elaborate gardens. Harriet Chew Carroll's family owned Cliveden in Germantown, Pennsylvania, an escape from hot and humid Philadelphia summers (FIG. 5). Within this context Homewood was unique. The brick one-and-a-half story, five-part-plan house shows remarkable attention to interior and exterior detail and reflects American taste for the Palladian style.

Over the years, neighboring country seats and villas have been lost to development or adaptive reuse, but Homewood survives in virtually unaltered condition. Druid Hill's original classical lines have been victorianized and camouflaged in its adaptation first for use as a park pavilion and eventually as the Baltimore Zoo's administration building. Subsequent owners have significantly modified Brooklandwood, which has served as the main building for Saint Paul's School on Falls Road since 1952. The encroaching city claimed many others. Belvidere and Montebello are known to twenty-first-century Baltimoreans only by their namesakes, the Hotel Belvedere and Lake Montebello. Homewood, however, "has escaped the various menaces that beset old houses in the path of a growing city and stands

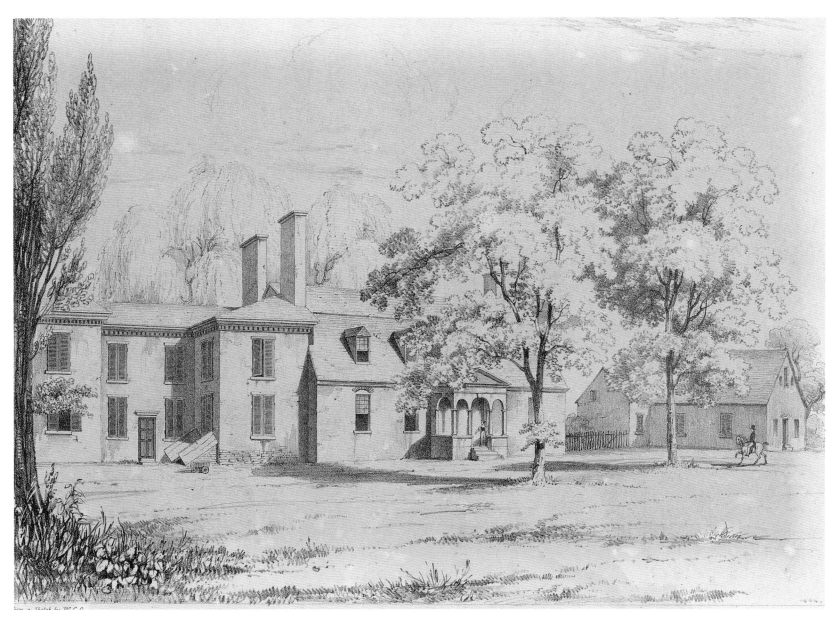

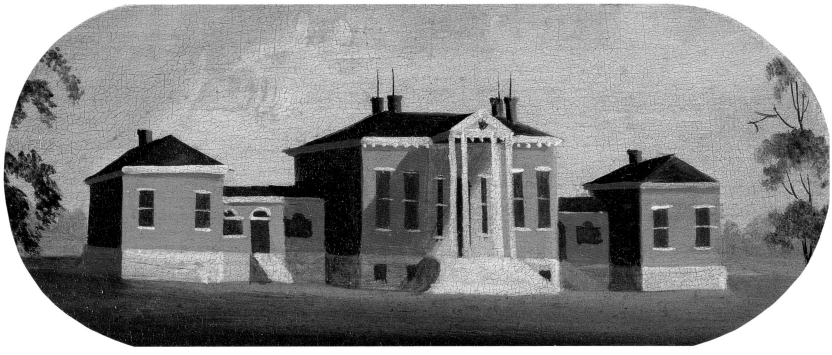

Fig. 4. *This map gives a clear view of the city at the time Homewood was built and shows many of the country houses, or villas, of Charles Carroll Jr.'s contemporaries.*

Warner and Hanna's *Plan of the City and Environs of Baltimore,* engraved by Francis Shallus, Philadelphia, 1801. Homewood House Museum, gift of Mr. and Mrs. Arthur J. Gidman, HH97.3.1.

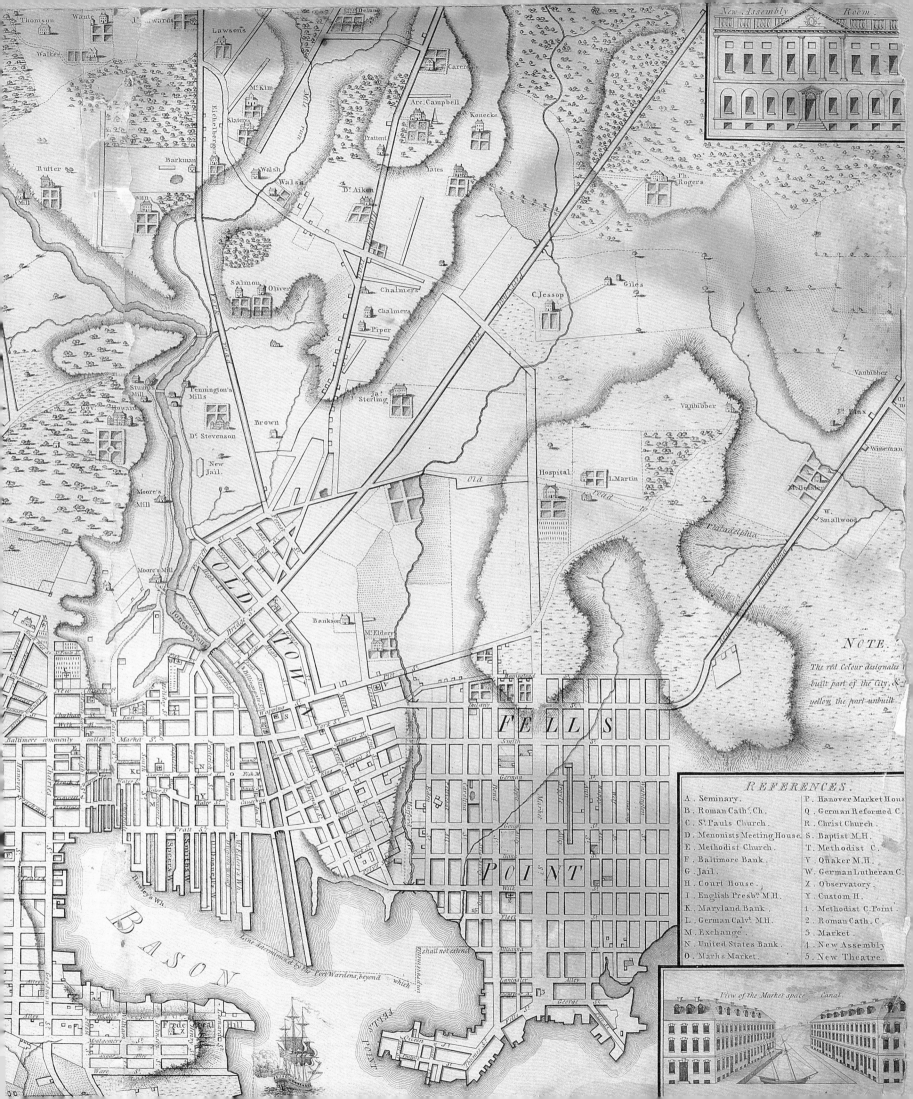

New Assembly Room.

REFERENCES.

A. Seminary.	P. Hanover Market House.
B. Roman Cath? Ch.	Q. German Reformed C.
C. St Pauls Church.	R. Christ Church.
D. Menonists Meeting House.	S. Baptist M.H.
E. Methodist Church.	T. Methodist C.
F. Baltimore Bank.	V. Quaker M.H.
G. Jail.	W. German Lutheran C.
H. Court House.	X. Observatory.
I. English Presb? M.H.	Y. Custom H.
K. Maryland Bank.	1. Methodist C. Point.
L. German Calv? M.H.	2. Roman Cath. C.
M. Exchange.	3. Market.
N. United States Bank.	4. New Assembly.
O. Marks Market.	5. New Theatre.

NOTE.

The red Colour designates the built part of the City, & yellow the part unbuilt.

View of the Market space Canal.

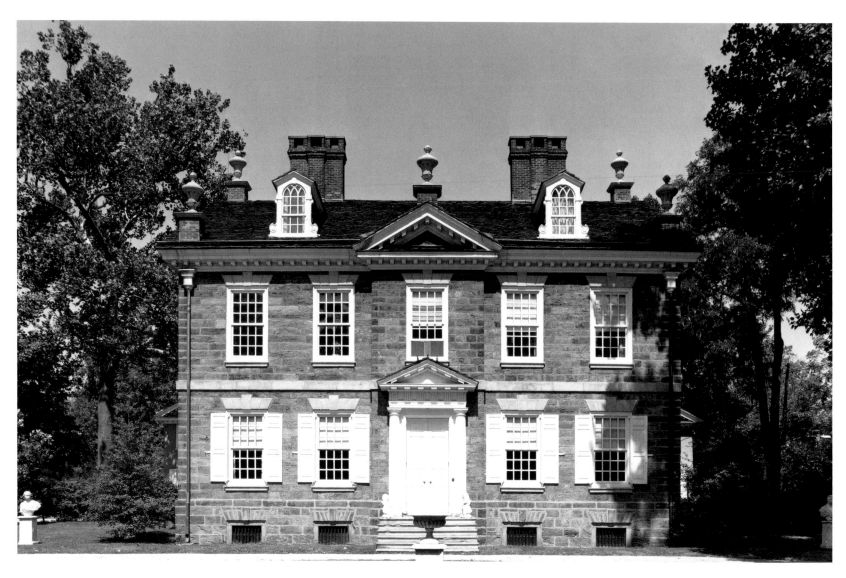

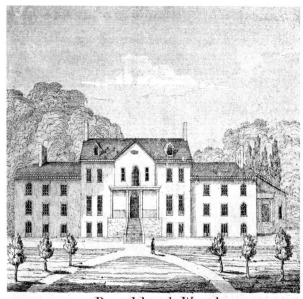

Brookland Wood
The Residence of Alex. D. Brown, Esqr

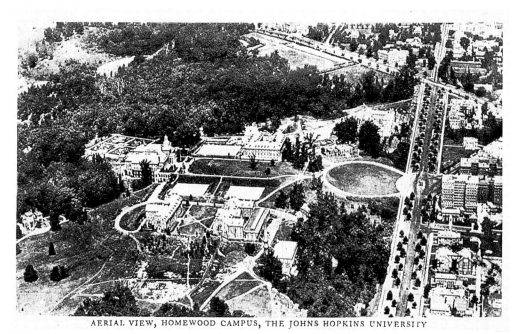

AERIAL VIEW, HOMEWOOD CAMPUS, THE JOHNS HOPKINS UNIVERSITY

unharmed in the grounds of The Johns Hopkins University, looking serenely down on the rushing traffic of one of Baltimore's busiest thoroughfares," noted university trustee J. Gilman D'Arcy Paul in a 1939 booklet about Homewood (FIG. 7).[4]

Through two centuries, Homewood has endured—at least partly by virtue of its architectural integrity and beauty and the use of quality materials and craftsmanship in its original construction. Homewood has benefited from the stewardship of the Johns Hopkins University over the past one hundred years. Although its elegantly finished rooms have served several purposes, from housing for graduate students to offices for the university's president and deans, no major addition or alteration has compromised the integrity of the house.

In 1973 one of Homewood's most devoted friends, university trustee Robert G. Merrick, generously provided the financial resources needed to restore Homewood. Robert Merrick lived at Homewood during his days as a graduate student in political economy and was aware of Homewood's significance. His residence at Homewood influenced his lifelong love of Maryland and especially Baltimore history. Merrick, who became president of the Equitable Trust Company, assembled a large collection of Maryland prints, which he gave to the Maryland Historical Society. He established an endowment for the restoration and ongoing preservation of the house and to help ensure Homewood's continued survival. It was his hope that Homewood, through extensive archival research, archaeology, and physical investigation of the building, would be restored and furnished to reflect its original appearance for use as a museum. The restoration reflected the university's broader commitment to excellence in research and raised the standards for historic preservation projects.

By 1982, a comprehensive evaluation was under way, led by Susan Gerwe Tripp, then director of university collections. The result of the study was a historic structure report that would guide the restoration. Homewood opened as a historic house museum in 1987. The work begun during the restoration is ongoing. Through programs, exhibitions, and publications, scholars continue to learn from Homewood and new discoveries are presented to the public.

FIG. 5 (opposite, top). Cliveden was built between 1763 and 1767 in the Germantown section of Philadelphia by Harriet's father, Benjamin Chew, chief justice of colonial Pennsylvania's Supreme Court. Like Homewood, Cliveden reflects the ideals of the Palladian style, although in an earlier Georgian manifestation. The house is currently owned and operated as a museum by the National Trust for Historic Preservation.

Library of Congress, Prints and Drawings, HABS Ill. PA-51-GERM, 64-5.

FIG. 6 (opposite, left). Brooklandwood was purchased by Charles Carroll of Carrollton for his daughter, Mary Carroll, and her husband, Richard Caton. In 1791, Falls Road was extended to the property and renovations were made to the existing house to make it fit for use in the summer.

Brooklandwood, marginal view from Robert Taylor, *Map of the City and County of Baltimore, 1857,* lithograph. The Maryland Historical Society, Baltimore.

FIG. 7 (opposite, right). Aerial view of Johns Hopkins University, Homewood Campus, Baltimore, Maryland, c. 1925.

BUILDING HOMEWOOD

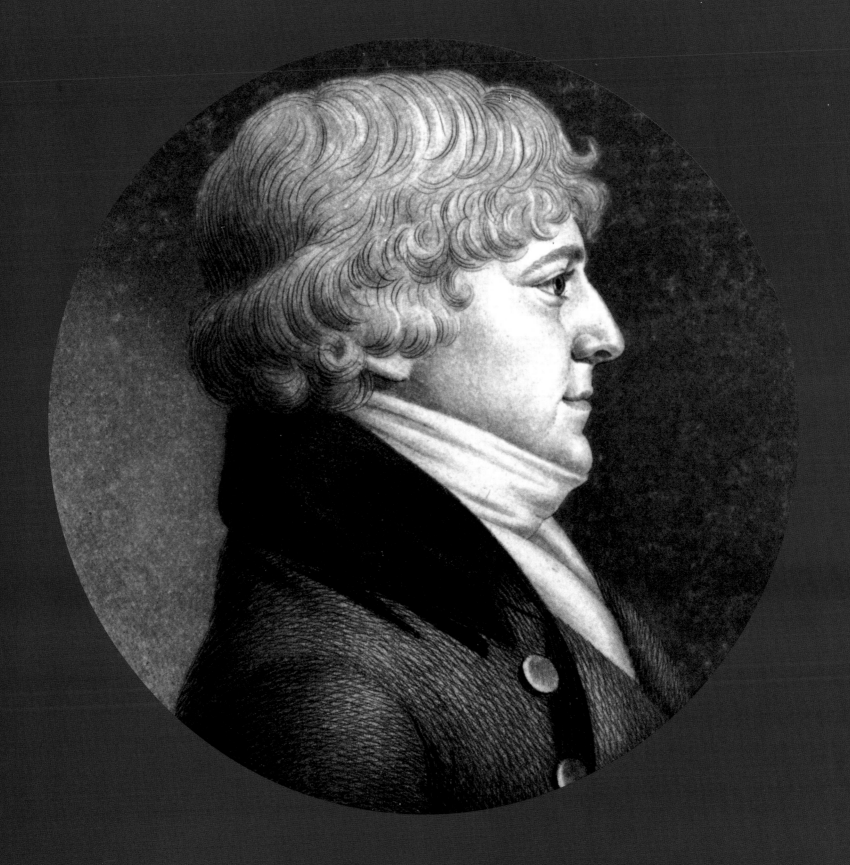

Charles Carroll Jr. and His Family

THE SOPHISTICATION of Homewood's design would suggest an architect familiar with the latest stylistic developments; to date, no drawings or plans for Homewood have been discovered. In the early nineteenth century, architecture as a profession was in its infancy, and before 1850 the construction of most country houses could be traced to gentlemen architects. Charles Carroll Jr. may have played the role of gentleman architect, producing Homewood's overall design, selecting decorative details, providing oversight of the work, and insisting upon the highest quality (FIG. 8). He had been classically educated and exposed to the latest architectural styles through travels in Europe; his prominent family possessed sufficient wealth to support the design and building of his house.

A gentleman in the early nineteenth century might demonstrate his taste and status by designing his house. Thomas Jefferson was perhaps the most prolific and well-known example. Charles Carroll Jr. would have been interested in Jefferson and his work as an example worthy of emulation. Additionally, many of Baltimore's gentlemen architects were included in his social circle. This group of contemporaries who participated, to varying degrees, in the design and construction of their houses included his brother-in-law, John Eager Howard, who built Belvidere (FIG. 10), and Nicholas Rogers, who designed his summer house, Druid Hill, as well as Greenwood for his brother Philip. Charles Carroll Jr. was acquainted with Benjamin Henry Latrobe, America's first professional architect. In 1805 Latrobe submitted two designs for the Basilica of the Assumption in Baltimore, which was under the direction of Charles's cousin, John Carroll, the archbishop of Baltimore.[1]

Charles Carroll Jr. had an impressive family legacy. Charles Carroll the Settler (1660–1720) arrived in Maryland from Ireland in 1688. The succession included Charles Carroll of Annapolis (1702–82) (*see* APP. C, CAT. 16), Charles Carroll of Carrollton (1737–1832), and Charles Carroll of Homewood (1775–1825).[2]

The American Carrolls sought freedom from the discrimination they had suffered as Catholics under English, Protestant rule. The property they amassed

FIG. 8. Saint-Mémin, who made this engraving of Charles Carroll Jr., charged gentlemen twenty-five dollars for a profile portrait, a copperplate, and twelve engravings.

Charles Carroll Jr., by Charles Balthazar Julien Févret de Saint-Mémin, c. 1800, engraved after the original charcoal and chalk on paper, 2½ inches in diameter. Corcoran Gallery of Art.

helped guarantee their freedom; with property ownership came voting rights as well as income potential. In the colonies, Catholics had been subject to discrimination, depending on the religious beliefs of those in power. Even though Charles Carroll the Settler had come to the Maryland colony as attorney general to Lord Baltimore, the English government jailed him twice for expressing his Catholic views. Maryland law at times forbade Catholics from holding office, building Catholic churches, and voting.

Charles Carroll of Carrollton had distinguished himself as one of four Maryland signers of the Declaration of Independence (the only Catholic signer) and later as a leader in the state of Maryland, serving as a state senator, U.S. senator, and framer of the Maryland Constitution (FIG. 9). He profited greatly from property transactions and money lending and had considerable investments in the Baltimore Iron Works, the Second Bank of the United States, and other promising enterprises.

Having risen to prominence, he saw to the proper education of his children to prepare them to continue the family legacy. He gave each child money for a house and its furnishings and supported each with an annuity of five thousand dollars. By the end of his life, Charles Carroll of Carrollton had spent more than one million dollars in support of his son Charles and daughters Mary and Catherine. Each of the children built or renovated a grand house and enjoyed the lifestyle their annuity made possible. Unfortunately, none of them inherited the business acumen of their father, and all remained dependent upon his generosity.[3]

Continuing the family tradition of a classical education, Charles Carroll of Carrollton had his son educated in Europe, as he had been. Organized Catholic schools were outlawed in America before the Revolution so Catholic education was avail-

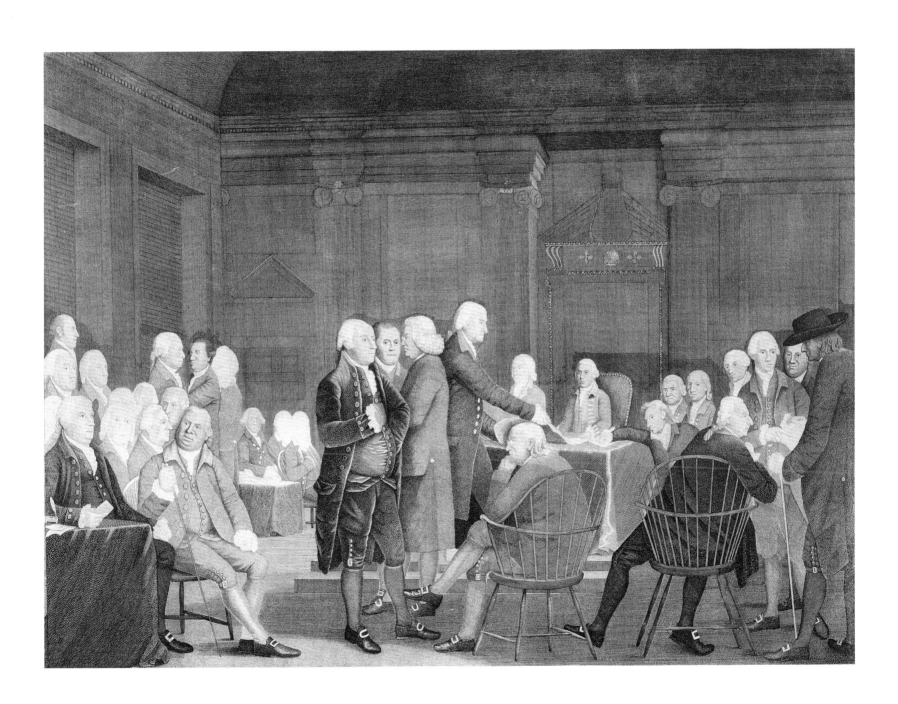

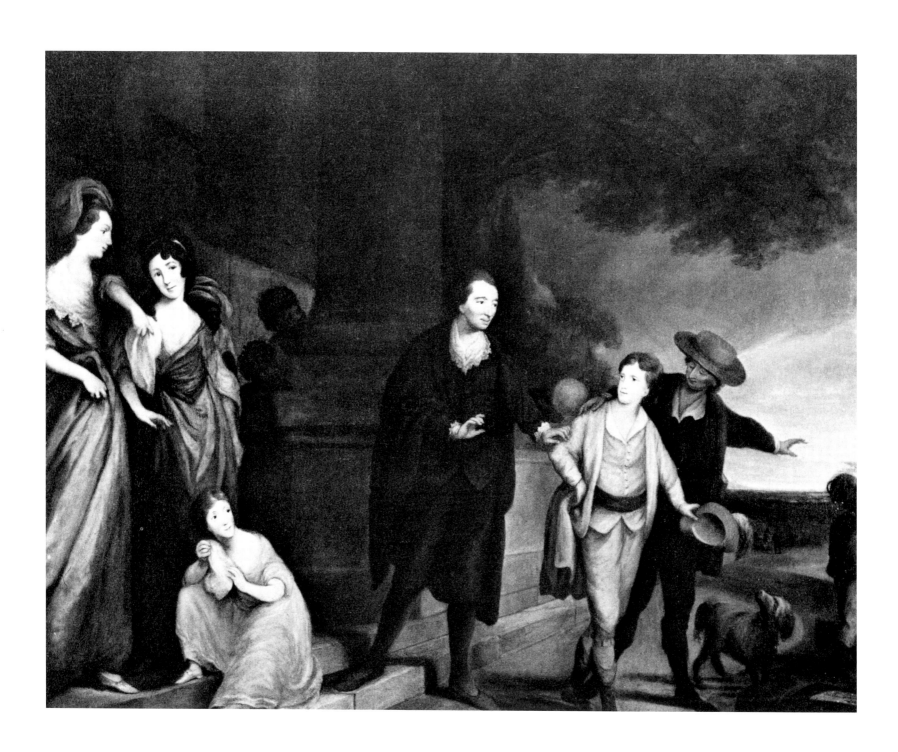

able only abroad. By the early nineteenth century, Baltimore had its own Catholic schools, but the family continued to send their sons to Europe. Referring to the usefulness of an education in the classics, Charles Carroll of Carrollton wrote, "I find no conversations more agreeable than that of a Horace, a Virgil, or a Racine." Charles Carroll Jr. left home at age ten to attend a Jesuit school in Liège, located in what is now Belgium.[4] *The Departure,* a painting by Robert Edge Pine, depicts the boy's family bidding him a tearful goodbye (FIG. 11). For nearly ten years, until 1794, Charles studied Greek, grammar, rhetoric, philosophy, and literature with Jesuit instructors, and he may have traveled in England, France, and other European countries. When he returned to the United States at nearly twenty years of age, he traveled and visited within the region and made plans to settle in Baltimore.

Charles Carroll Jr. was handsome, charming, and social, attending parties and dances, and associating with prominent families, including the Custises, the Stiers, the Penns, the Gracies, and the Chews. Despite the difficulties of traveling, friendships between Philadelphians and Baltimoreans were common. Benjamin and Elizabeth Chew regularly entertained visitors at dances and parties in their fashionable town house on Third Street in Philadelphia (FIG. 13). Their daughter Harriet, a dark-haired beauty, may have met Charles at such an occasion (FIG. 12). Correspondence suggests that he spent months at a time in Philadelphia, presumably in part, to court Miss Chew before plans were made for their marriage.

Harriet's charms are the subject of legend. Late-nineteenth-century and twentieth-century sources report that, when George Washington sat for his famous portrait by Gilbert Stuart, he asked Harriet, then a young girl and a friend of his granddaughter (by marriage) Nellie Custis, to accompany him during the sittings because her conversation "could give his face its most agreeable expression."[5] Benjamin Chew and Charles Carroll of Carrollton were both acquaintances of President Washington, so the story is plausible although unproven.

The "intended alliance" between the Chew and Carroll families was favored by friends and family alike. "He [Charles Carroll of Carrollton] has bought 130 acres

FIG. 11. Charles Carroll Jr., like his father before him, was sent abroad to receive a classical and Catholic education.

The Departure of Charles Carroll Jr., by Robert Edge Pine (1730–88), unsigned, c. 1785, inscribed on the lid of the trunk in the lower right: "Mast. Charles Carroll / Liege [sic] by way of / London," oil on canvas, 60 inches × 80 inches. Private collection of a descendant.

of land about two miles from me," wrote Col. John Eager Howard to his brother-in-law on 12 June 1800, "and intends building, and completely furnishing, a good house, giving him a carriage, servants, etc. In completing these objects, I believe the young Gentleman will not be limited with regard to money, but afterwards he is to be allowed five thousand dollars a year."[6] Howard, who had married Harriet Chew's sister Peggy, apparently wanted to assure his in-laws that Charles Carroll Jr. would provide for Harriet in the stylish manner to which she was accustomed.

The families faced the decision of who would preside over the marriage ceremony, since the Chews were Anglican and the Carrolls were Catholic. They also made financial arrangements including a dowry, somewhat unusual at this time, as a means of preserving family assets among the wealthy. According to the law, a widow could inherit one-third of her husband's estate. To prevent such an occurrence, Charles Carroll of Carrollton offered Harriet Chew three thousand dollars per year in the event that she should survive his son.[7] She then agreed to forfeit any rights to the property, ensuring that Homewood and other Carroll assets would remain in the family, protected from any husband Harriet might marry after Charles Carroll Jr.'s death.

FIG. 12 (opposite). The style of Harriet's dress indicates that this portrait may have been painted just before her marriage to Charles Carroll Jr.

Harriet Chew (Mrs. Charles Carroll, 1775–1861), by John Trumbull. Yale University Art Gallery, Trumbull Collection.

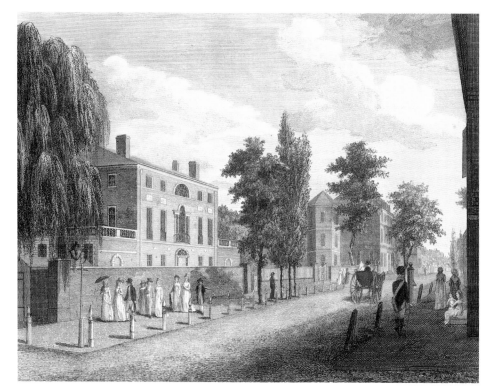

FIG. 13. Benjamin Chew's town house was located on Third Street, along with those of Samuel Powel, Thomas Willing, and William Bingham, all wealthy and influential members of Philadelphia society. The house clearly visible here is that of Bingham.

View in Third Street, from Spruce Street, Philadelphia, drawn, engraved, and published by W. Birch & Son. Rare Book Department, The Free Library of Philadelphia.

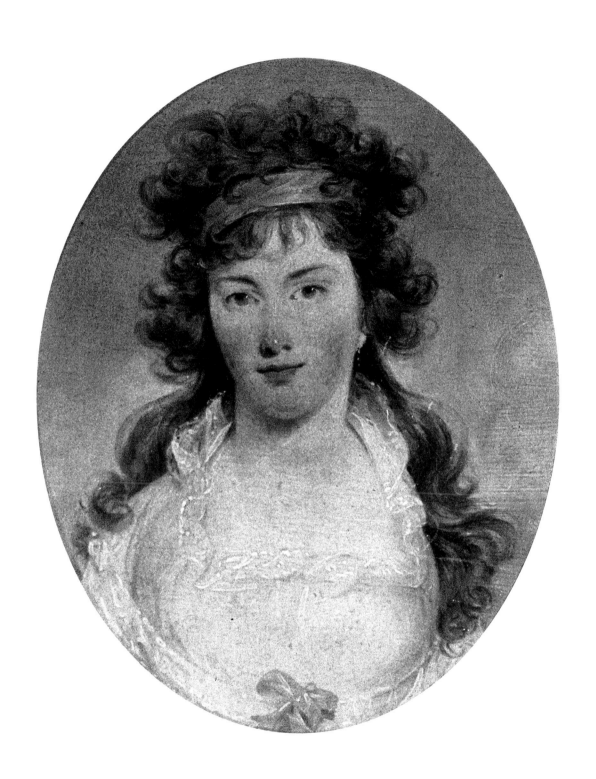

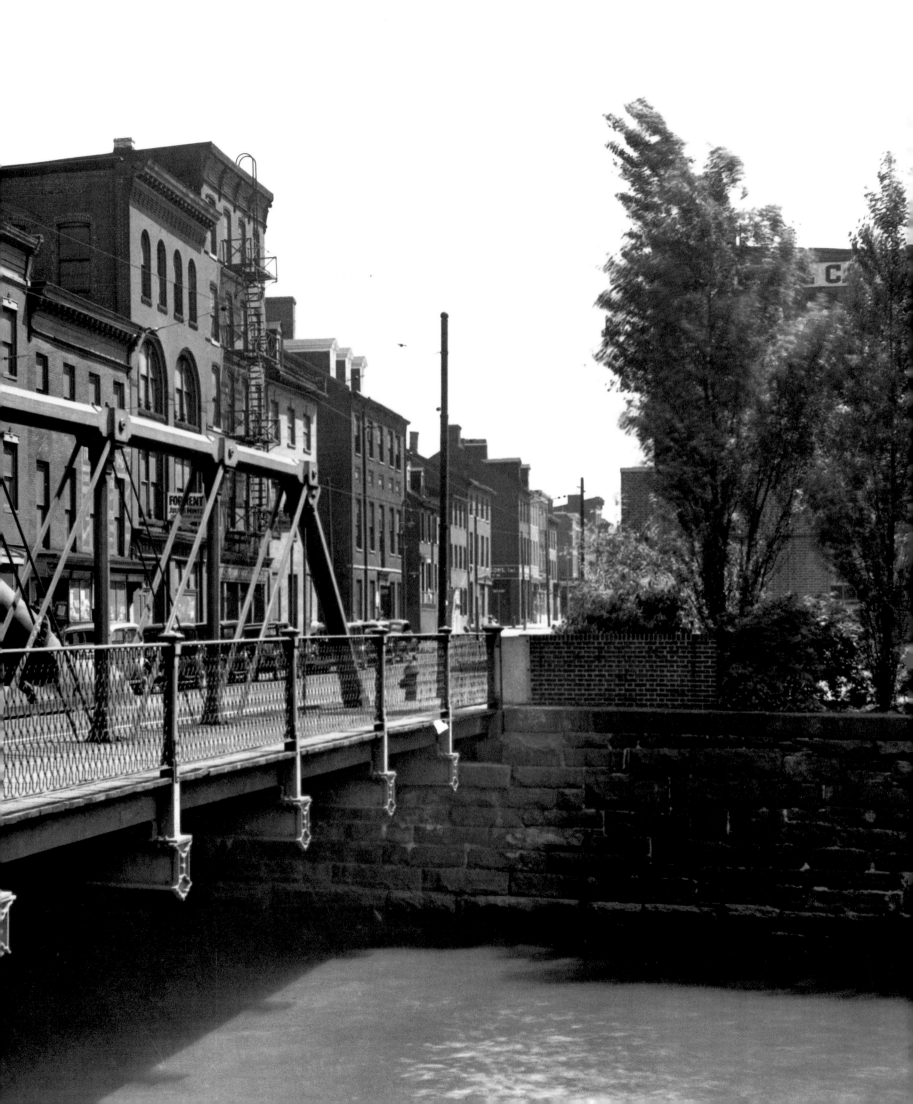

Construction: Creating a Country House

WHEN CHARLES AND HARRIET married on 17 July 1800 at Old Saint Joseph's Church in Philadelphia, they seemed to be suitably matched and to have a secure future. He was well educated, charming, and elegant; she was from a comparable family and was known for her beauty, poise, and intelligence. Letters from Charles attest to his "unalterable affection" for Harriet.[8] They initially stayed in Philadelphia after they were married and came to Baltimore about six months later, taking up residence in a town house on King George's Street (now Lombard Street) (FIG. 14). The following spring they broke ground for their country house.

Building Homewood was an ambitious construction project that would require a great deal of patience and financial support from Charles's father. Although the family was "comfortably settled at Homewood" by 1802, changes and additions continued to be made through 1806.[9]

Gentlemen architects learned by studying building manuals and other design books, of which there were nearly two hundred titles in Baltimore by 1810.[10] Charles Carroll Jr. had access to architectural books in his father's library. Many of these volumes, including Palladio's *Four Books of Architecture* and Robert and James Adam's *Works in Architecture*, were included in the collection of the Library Company of Baltimore, of which Charles Carroll Jr. was a member. Founded by wealthy merchants in 1796 and supported by subscriptions, the private Library Company housed an extensive collection of books on architectural design, which must reflect the intense interest in architecture among Baltimore's elite. In addition to documenting characteristics of the classical orders of architecture, many of these design books offered clear diagrams and designs for decorative elements, discussed overall proportion, and gave guidelines for construction. *The Country Builder's Assistant* (published by Asher Benjamin in 1797) was the first original American work on architecture and gave detailed instructions, "with measures exactly figured," for newels, cornices, chimneypieces, columns, banisters, doors, and other carpentry work.[11]

FIG. 14. *This 1930s view of the 1800 block of East Lombard Street (formerly King George's Street) shows what remained of the elegant town houses constructed in the late eighteenth and early nineteenth centuries. Particularly note the three-and-a-half-story buildings with dormer windows. Little is known of Charles Carroll Jr.'s town house, the family's residence during the winter months.*

Library of Congress, Prints and Drawings, HABS Ill. MD, 4-BALT, 75-1.

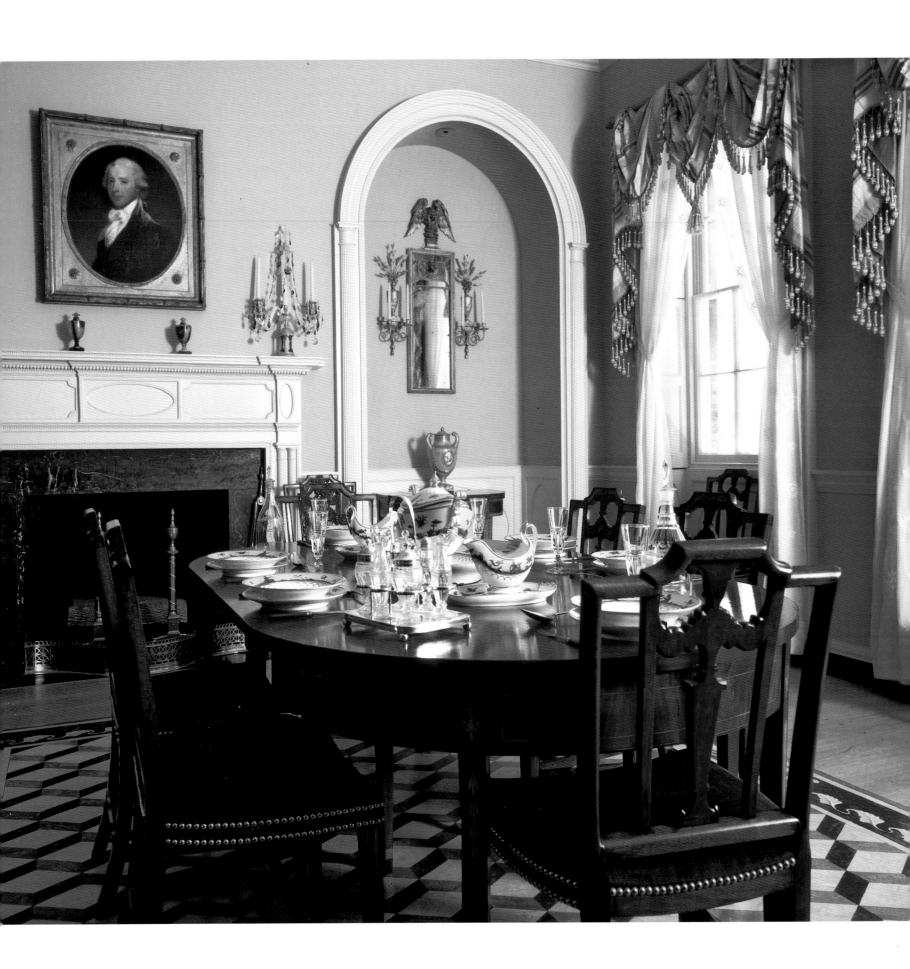

The gentleman architect relied upon the builder, and the builder's craftsmen of many specialized trades, to reproduce such designs. Stucco and ornamental plaster craftsmen flourished in the Baltimore area in the 1800s. James and George Smith, for example, advertised in 1795, "Chimney Caps, Composition Ornaments … executed in the cheapest manner." Precast ornaments could be ordered from large manufacturers such as George Andrews, who had outlets in New York, Washington, and Baltimore.[12] Most of the craftsmen responsible for the construction of Homewood are unrecorded, with the exception of the builders.

Brothers Robert and William Edwards, highly skilled carpenters who were at the forefront of their trade, were the builders of Homewood. Robert served as secretary of the Carpenters' Society, the first trade society in Baltimore. It was organized in 1791 to standardize building practices and fees, much as the guild system had in England. In the role of builders, the brothers were responsible for coordinating the work of various trades involved in the construction of the house. The Edwards brothers billed Charles Carroll of Carrollton for work on Homewood between 1801 and 1804.[13] From the payment records entered in Carroll's account book, William Edwards appears to be the primary builder during the later stages of construction. This documented relationship led R. T. H. Halsey (1865–1942), the scholar instrumental in the development of the Metropolitan Museum's American Wing in 1924, to credit William Edwards with building Homewood. He also attributed to Edwards a room from a three-story brick town house at 915 East Pratt Street in downtown Baltimore, which closely resembles Homewood. The room survives as the Baltimore Room at the Metropolitan Museum of Art (FIG. 16). The basis of his attribution is similarity in the handling of detail, extensive use of a running bead molding, and an unusual feature—reeded, convex pilasters in door surrounds, which are identical to those in Homewood's reception hall (FIG. 15). In the early 1920s, Halsey moved the room to the Metropolitan's American Wing and displayed it as an outstanding example of Federal architecture.[14] Halsey, who later played an important role in the 1930s restoration of Homewood, postulated that William Edwards may

FIG. 15. *The most notable of the many similarities in architectural detail between Homewood and the Baltimore Room at the Metropolitan Museum are the reeded, convex pilasters used in many door surrounds. They are most similar to those in Homewood's reception hall, shown here, and drawing room, shown in FIG. 44.*

FIG. 16 *(opposite). Now in the Metropolitan Museum, this room was removed from a town house on Pratt Street, thought to have been previously owned by Charles Carroll of Carrollton and perhaps constructed by the Edwards brothers, the same men responsible for building Homewood.*

The Baltimore Room, The Metropolitan Museum of Art, New York, New York.

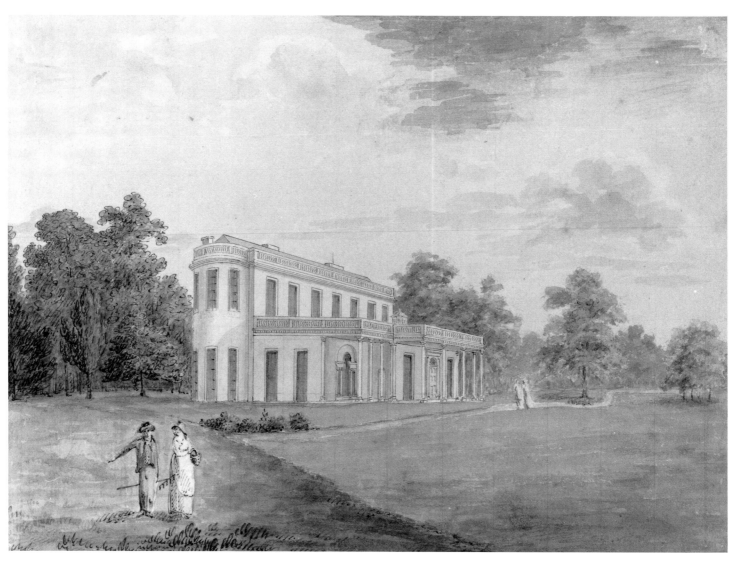

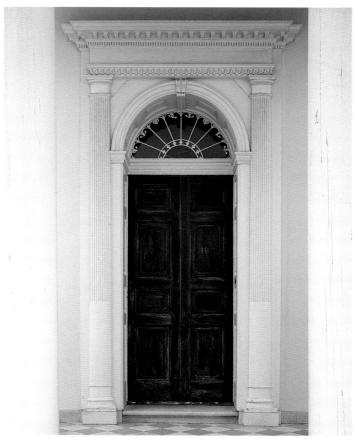

have been responsible for the design and construction of Brooklandwood and Montebello, both completed in 1799 (FIGS. 17 to 19). Charles Carroll Jr.'s brother-in-law John Eager Howard contracted with the Edwards brothers in 1805 to build a house on Paca Street; other land and building transactions between the parties are also recorded. Similarly, the Edwards brothers built a stable for one of Harriet's sisters, Sarah Galloway.[15] Between 1800 and 1820, the Edwards brothers acted as the family's builders.

Homewood is the result of the taste and ideas of Charles Carroll Jr. and the skilled work of Robert and William Edwards. Insight into this sort of relationship between patron and builder is provided by the extensive correspondence between Charles's contemporary George Read, also the son of a signer of the Declaration, and his builder Matthew Pearce in New Castle, Delaware. These letters reveal how the relationship may have worked and how design choices evolved. George Read, also subsidized by his father, made critical decisions regarding the design and construction of his house, called Read House, which was built between 1797 and 1804.[16]

Matthew Pearce mentioned the importance of the collaborative relationship with the owner when he discussed in particular the design and production of ironwork. "I wish you here to determine the Pattern of your Railing over the front door, in this, Taste differs so much, that I wish you to exercise your own." Throughout the correspondence, Read shows his command of—and concern for—decorative details ranging from carved woodwork to brick bond, "Dimittee" fabric to "pink fringe" for window and bed hangings. His insistence on the "best & most fashionable quality … altogether a la mode" runs throughout the correspondence.[17] Through a relationship similar to that of Read and Pearce, Carroll and the Edwards brothers would have decided upon specific details of Homewood.

The design for Homewood incorporated a classical five-part plan based on the theories of Andrea Palladio, the sixteenth-century Italian builder. Inspired by the temples he saw during his travels throughout Rome and southern Italy, Palladio borrowed architectural elements from these temples for use in the town houses and

FIG. 17 (opposite, top). Montebello, the country house of General Samuel Smith, is thought to have been built (and possibly designed) by William Edwards, to whom payments were made for the construction of Homewood.

Montebello—The Seat of General Smith, by William Russell Birch, c. 1810, watercolor and pen and ink over graphite, The Baltimore Museum of Art: Presented in honor of Calman J. Zamoiski Jr., president of the Board of Trustees (1977–81), by his fellow trustees, BMA1980.165.2.

FIG. 18 (opposite, left). Montebello's primary entrance shared many details with Homewood's. Nearly identical reeded, elliptical pilasters flanked double doors. A round-arched fanlight was surrounded by paneled and carved detail; the scale, proportion, and composition suggest a common design source, builder, or both.

Montebello detail, The Maryland Historical Society, Baltimore.

FIG. 19 (opposite, right). The entablature of Homewood's south portico doorway shares the use of a classically inspired wave motif with the cornice of Montebello's portico.

Homewood detail.

country villas of nobles and merchants in and around Venice and northern Italy. The Palladian style, first adapted by the English for their country houses, soon began to inspire gentlemen architects and builders in America. Scottish architects Robert Adam (1728–92) and his brother James (d. 1794) published the influential *Works in Architecture* in 1778–89. Their designs interpreted the work of Palladio and incorporated decorative details from the initial archaeological investigations of the ruins at Pompeii and Herculaneum. Robert Adam was himself an archaeologist who was active in the later excavation of the great palace of Diocletian at Spalato; the development of his style was influenced by his direct contact and experience with ancient architecture.[18] What could now be described as the Adamesque style, or Palladianism in America, placed an emphasis on symmetry and interpreted classical motifs by adapting them to domestic architecture, with its less-imposing scale. At Homewood the Adamesque affinity for symmetrical building units determined the choice of a five-part plan, with two hyphens flanking the main block and connecting it to two wings, or dependencies. The Palladian style extended even to window design, with three-part, arched windows punctuating the hyphens, fanlights over doorways on the principal façade and garden front, and composite order columns and pilasters around windows throughout the interior and exterior of the house. These elements exemplify classical details originating in antiquity, interpreted by Palladio and Adam, and adapted for America.

Correspondence from Charles Carroll of Carrollton to his son attests to the fact that no expense was spared in pursuit of the son's desire to create a house in the newest fashion. Letters written during the construction of Homewood reveal the father's increasing frustration with his son's mounting expenses as the house became substantially more than a serviceable farmhouse. He wrote to his son in 1803, "Had you followed my advice, and built a plain and convenient house, you would have saved at least ⅓ of the money which has been paid for your buildings and out of that saving, occasional aids could have been granted for improving your Farm; but without reflection you suffered yourself to be led on from one

FIG. 20. *Andrea Palladio's* Quattro Libri dell' Architettura [Four Books of Architecture] *(1570) inspired English architects and, in turn, gentlemen architects and builders in America to create "appropriate" classical architecture for both public and domestic use. This design for a five-part-plan villa represents the sort of stylish country residence that wealthy Americans sought to emulate.*

Special Collections, Milton S. Eisenhower Library, Johns Hopkins University.

LA SOTTOPOSTA fabrica è à Maſera Villa vicina ad Aſolo Caſtello del Triuigiano, di Monſignor Reuerendiſſimo Eletto di Aquileia, e del Magnifico Signor Marc'Antonio fratelli de' Barbari. Quella parte della fabrica, che eſce alquanto in fuori; ha due ordini di ſtanze, il piano di quelle di ſopra è à pari del piano del cortile di dietro, oue è tagliata nel monte rincontro alla caſa vna fontana con infiniti ornamenti di ſtucco, e di pittura. Fa queſta fonte vn laghetto, che ſerue per pe-ſchiera: da queſto luogo partitaſi l'acqua ſcorre nella cucina, & dapoi irrigati i giardini, che ſono dal-la deſtra, e ſiniſtra parte della ſtrada, la quale pian piano aſcendendo conduce alla fabrica; fa due pe-ſchiere co i loro beueratori ſopra la ſtrada commune: d'onde partitaſi; adacqua il Bruolo, ilquale è grandiſſimo, e pieno di frutti eccellentiſſimi, e di diuerſe ſeluaticine. La facciata della caſa del pa-drone hà quattro colonne di ordine Ionico: il capitello di quelle de gli angoli fa fronte da due parti: i quai capitelli come ſi facciano; porrò nel libro de i Tempij. Dall'vna, e l'altra parte ui ſono loggie, le quali nell'eſtremità hanno due colombare, e ſotto quelle ui ſono luoghi da fare i uini, e le ſtalle, e gli altri luoghi per l'vſo di Villa.

expense to another." Despite his complaints, Charles Carroll of Carrollton ulti-
mately acknowledged his son's enthusiasm about Homewood's construction. On
5 December 1805 he conceded, "It gives me satisfaction to hear that your house
progresses rapidly that ye improvements of yr farm will be less costly than you
contemplated, and that you are diligently occupied in the superintendence of your
workmen, and that the occupation amuses you."[19] Homewood appears modest
and intimate, despite its substantial 8,000 square feet, a one-and-a-half-story villa
on a raised basement.

The outbuildings are an important part of the concept for how the whole landscape
should appear. Also built of brick, the carriage house and the privy are the only out-
buildings that survive (FIGS. 21 and 22).[20] The grounds originally included a bath-
house, dairy, smokehouse, springhouse, fenced-in well, and icehouse. Given their
sophisticated understanding of Palladianism, which encompassed a carefully devel-

FIG. 21 (opposite).
Homewood's carriage house
or barn, 1930s photograph.
Library of Congress, Prints and
Drawings, HABS MD-4, BALT. 1-22.

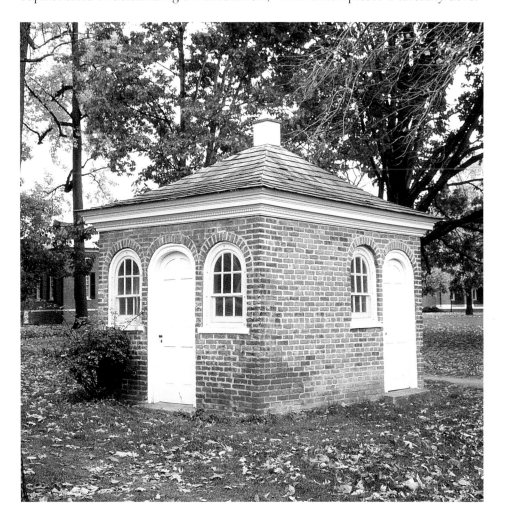

FIG. 22. The Homewood privy,
located on the north lawn
of the house, has two sides—
presumably one for men and
the other for women and
children. The interior features
a domed plaster ceiling and
chestnut-paneled walls.

oped and intellectual relationship among the house, outbuildings, and grounds, Charles Carroll Jr. and his builders would have thoughtfully sited each of the structures. Other features of the property included a stone quarry (along Stony Run Creek in the vicinity of what became San Martin Drive on the west side of the Hopkins campus) that was used before Charles Carroll of Homewood became the owner.[21]

Homewood was designed with traditional elements of a summer retreat: careful siting to catch summer breezes, a floor plan promoting good cross-ventilation and natural light (FIG. 23), and a dramatic view of the town and harbor to the south. The unobstructed prospect from Homewood would have included glimpses of Belvidere, buildings around Courthouse Square, church spires, and the harbor bustling with maritime activity (FIG. 24).

Although Homewood follows a classical model, it has many unique details not found in any design books of the period. These idiosyncratic details suggest that Charles Carroll Jr. was involved in Homewood's design. Design book details are reinterpreted and applied in unexpected ways, such as capitals (without columns) as a decorative element. The concept for Homewood's roof was sophisticated, a way to introduce running water into the house. An inherent flaw in the design made this clever and logical idea impractical—the roof apparently leaked from the beginning. Its system of gutters to collect rainwater survives beneath a metal, standing-seam roof reconstructed in the 1980s based on evidence that a metal roof had replaced the original wood shingle (*see* FIG. 98). The house is full of stylish answers to practical concerns: bookshelves on either side of the fireplace in the office protect expensive books from rot and vermin (FIG. 25); doors operate on concealed pins rather than hinges, lending a more finished and elegant appearance; and the spectacular coved ceiling of the master bedchamber contributes to the light and airy quality of the room (FIG. 26). Such details, as well as the overall plan, made the house uniquely his.

Charles Carroll of Carrollton continued to complain about his son's excessive spending: "What an improvident waste of money—you are so imposed on by your undertaker [the builder], who leads you into extravagant expenditures on your

FIG. 23. Floor plan of Homewood.

Based on a drawing from *Great Georgian Houses of America,* published for the benefit of the Architects' Emergency Committee (New York: Kalkhoff Press, 1933).

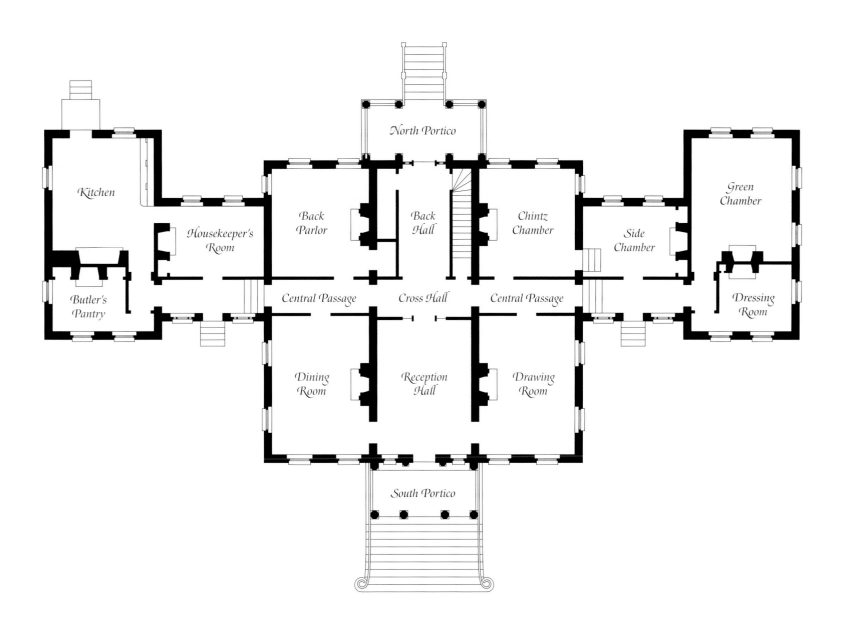

Kitchen

Housekeeper's
Room

Back
Parlor

North Portico

Back
Hall

Chintz
Chamber

Green
Chamber

Side
Chamber

Butler's
Pantry

Central Passage

Cross Hall

Central Passage

Dressing
Room

Dining
Room

Reception
Hall

Drawing
Room

South Portico

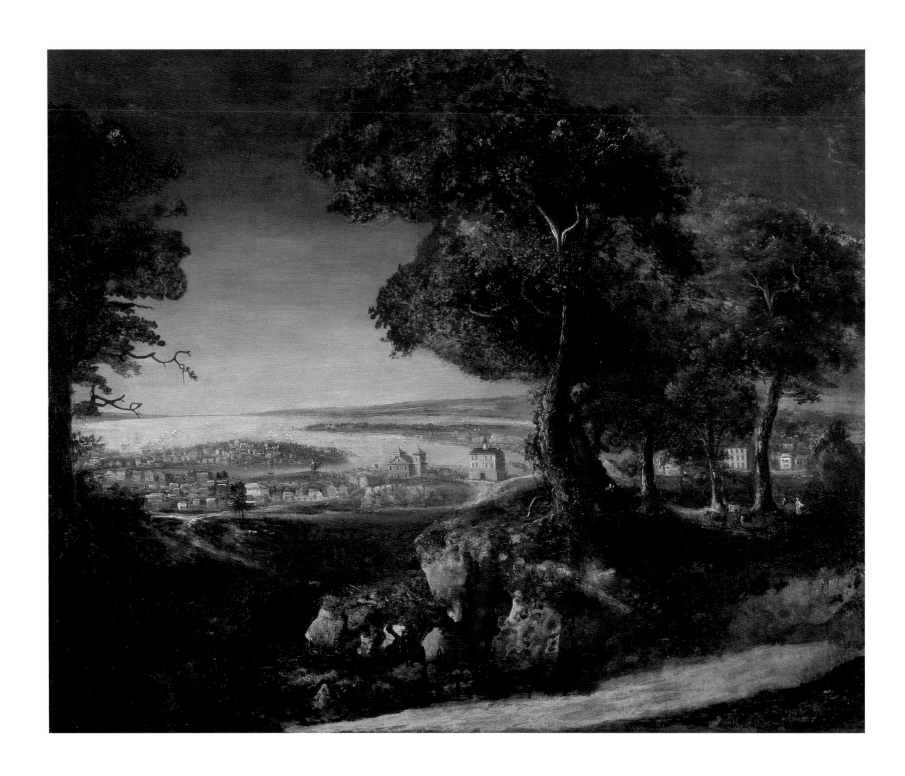

buildings to swell his commissions and his account. The time will come when you will severely feel and deeply regret so much money thrown away on such baubles, which a want of thought or a silly pride has occasioned you to spend without consulting me." Under young Charles's direction, the cost of his house and furnishings grew to more than forty thousand dollars; his father commented, "It seems to me there is no end of these expenses." Eventually, Charles Carroll of Carrollton begrudgingly agreed that Homewood should be built according to his son's plan. "I do not think the plan of the house herewith returned can be reduced so as to make it comfortable and therefor, I agree to it."[22]

A letter dated 16 August 1802 implies that, only eighteen months after the beginning of construction, the house was fit for summer residence. Shortly thereafter, the couple's first child was born, a son named Charles, who would be one of the five surviving Carroll children. Harriet's family and Charles's father visited frequently, as did neighbors from surrounding country estates. "Yr. Father and myself lodged two nights with Harriet," Elizabeth Oswald Chew, Harriet's mother, wrote to her son Benjamin Chew, "who tho the House is not finished has Her Chambers dry and Comfortable and very Convenient indeed it is much Handsomer and Better House than I could have expected & more done than I coud have believd ... Mr C is indefatigable & Harriet quite Happy in Her prospects of improvements."[23]

Although the origins of the name *Homewood* are unclear, an estate in early America often derived its name from that of an earlier property owner. Deeds for the property make no mention of the name but describe a farm comprising three tracts. Charles Carroll Jr. built Homewood on the tract known as Merryman's Lot.[24] His reference to the land as "Homewood Farm" probably had its origins in the fact that, in the early 1700s, Thomas Homewood is known to have owned a tract of three hundred acres that included the Merryman tract; this property was known as Homewood Range. By the time Charles Carroll Jr. wrote his will in 1806, the name was in general use. He refers to "my country house and tract of land near Baltimore called Merryman's Lot but now by me generally called Homewood."[25]

FIG. 24. This view from Belvidere illustrates the contrast between the pastoral surroundings of a country seat and Baltimore-Town to the south. From Homewood, the view was probably similar but would have included Belvidere itself.

View of Baltimore from Howard's Park, by George Beck (1748/50–1812), c. 1796, oil on canvas. The Maryland Historical Society, Baltimore, gift of Robert Gilmor, MHS 1846.3.1.

Furnishing the House

To furnish the house, Charles and Harriet Carroll could choose from furniture makers and other craftsmen who flourished in Baltimore, Philadelphia, and New York. Charles's father had ordered almost everything, from horsehair for bedding to the most elegant silver, from England. His meticulous records, recorded in a letterbook now in the collection of the New York Public Library, show that he directed his agents to purchase objects of the highest quality. The English taste of Charles Carroll of Carrollton was clear; he ordered items qualified by terms such as "neat," "fine," and "plain," meaning fashionable but not elaborately ornamented. In the previous generation his own father had advised him to "Enjoy yr Fortune, keep an Hospitable table But lay out as little money as Possible in dress furniture and show of any sort Decency is yr only Point to be aimed at." Even though frugality was a priority, Charles Carroll of Carrollton specified that he wanted items that were fashionable but not showy; for example, a "genteel" silver tureen and punch ladles should be "all best finished and no work that will harbor dust."[26]

These letterbook entries include copies of Charles Carroll of Carrollton's orders for a wide variety of goods placed through his London agent, William Murdoch. Although these orders were primarily for his own use, they are illustrative of not only the family's taste and insistence on quality but also the challenges and long delays involved in ordering from abroad in the late eighteenth and early nineteenth centuries. This record of goods ordered for his and presumably his children's use helps give a clearer picture of the hierarchy of imported goods. He was importing fine linen for his own shirts as well as coarser fabrics for his servants. The variety is surprising and included a range of goods from "4 dozn Hatts for plantation Negroes of an inferior quality" to "7 pairs of black kid shoes with handsome roses." What is most surprising is that he preferred to import four dozen hats, especially of inferior quality, rather than to obtain them locally.

Annapolis 16 October

Invoice of Goods to be shipped on acct of C.C. of C. and to be consigned to R^{d.} Caton of Baltimore

Linens

2 pieces of fine Irish linen yard wide for shirts for C.C.

3 do. of strong serviceable linen for house servants

Woolens

70 yds of German serge of a dark green & very good quality for servants liveries

160 yards of green Frize napped sometimes called Penistone for Housemaids

100 yds of strong good Fustian for summer liveries

24 sticks of twist

Haberdashery

100 [yd] of osnaburg thread of a good quality

50 [yd] of shoe thread sound & strong attend to the quality—the shopkeepers commonly ship to this country the refuse of this article

50 knots of leading or ploughing lines

6 [yd] of coloured thread

3 pair of scissors for cutting out

6 curry combs—3 groce [gross] of small white metal buttons for servants liveries

Stationery

3 reams of best letter paper

4 do of common writing of a good quality, and which not occasion the ink to spread

12 bunches of best dutch quills

1 box of wafers of different sizes sorted

…

Groceries

12 [lb] of fig blue pale colour stamped & with a crown

6 [lb] of powdered blue

½ pound of mace

half pound of cloves

7 [lb] of cinnamon

half pound of nutmegs

20 [lb] vermichelli

30 [lb] of Hartshorn shavings

Hatts

1 dozen Hatts of a good quality fit for house servants

4 dozⁿ Hatts for plantation Negroes of an inferior quality, but better than those last sent for they were detestable rubbish.

Pickles

2 potts of small yellow East India mangoes

Glass

2 dozn Tumblers

2 do wine glasses

Moulds for Jellies

1 dozn moulds of different sizes tinned when [*illegible*] for jellies.

Corks

4 groce [gross] of best velvet corks

Ironmongery

4 [lb] 4 d clasp hob nails

4 [lb] 3 d hob nails

2 dozen grass or grain scythes

nb the last sent were bramble scythes

Carpeting

20 yds of carpeting for staircases[27]

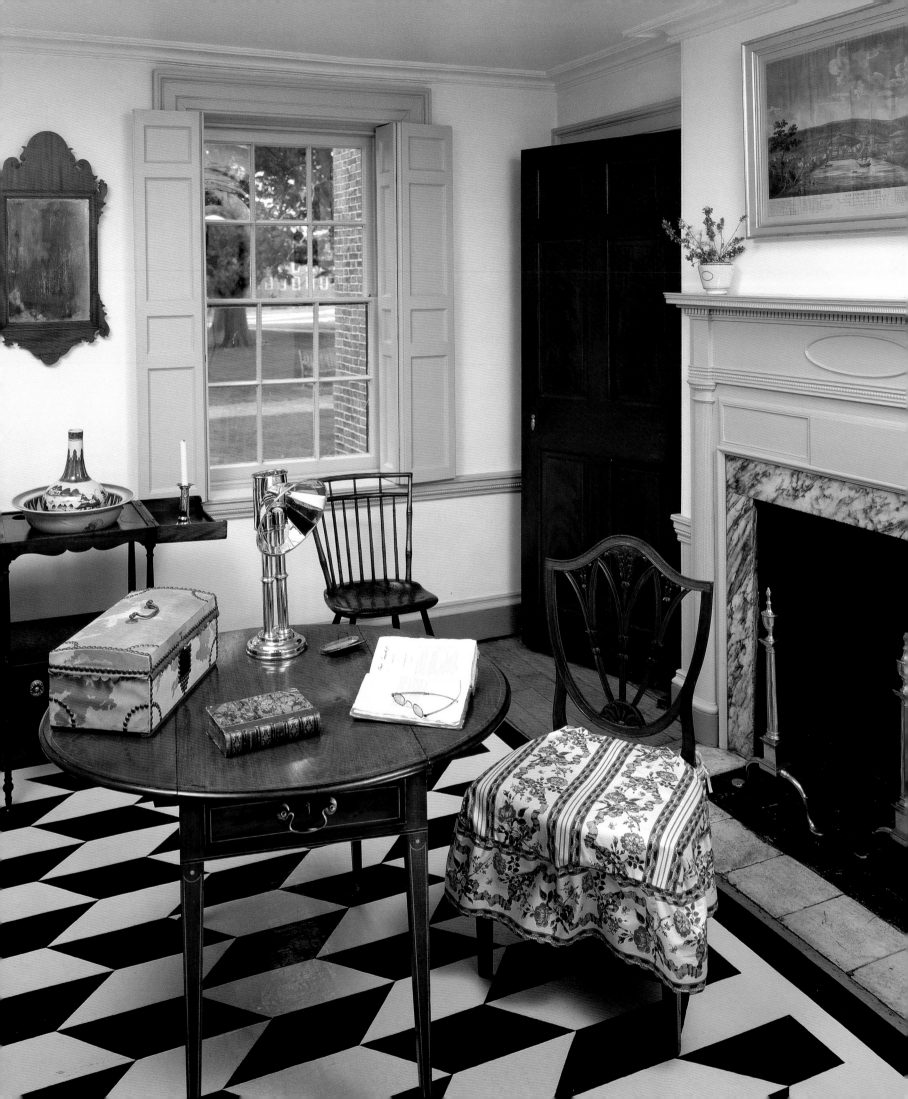

By the early nineteenth century, American furniture of quality comparable to that the Carrolls had previously ordered from England was available. Baltimore cabinetmakers, in particular, created furniture in the London fashion; many craftsmen advertised that they had recently arrived from London. The Englishness of Baltimore furniture evolved into a recognizable Baltimore style, largely the result of the influx of both English goods and English-trained craftsmen.[28] Surviving furniture with a Carroll family provenance attests not only to their taste for English goods but also to the pronounced Englishness of the Baltimore furniture they selected.

The advantage of ordering locally, or at least domestically, was the ability of the patron to select specific design elements for the piece of furniture. On 14 September 1797 Charles Carroll Jr. was in New York, staying with Archibald Gracie and planning to meet friends and family, including Hugh Thompson, Richard and Mary Carroll Caton, Catherine (Kitty) Carroll, Nicholas Rogers, and Charles Ridgely of Hampton.[29] The association of this group for the purpose of this trip (perhaps to include "shopping") establishes the comparable taste of the participants. Prominent and wealthy Baltimoreans purchased furnishings from many sources and perhaps competitively observed the consumption patterns of their peers. Probate inventories of and documented purchases by members of this group contribute to Homewood's furnishings plan in the absence of detailed information specific to Charles Carroll Jr. and his house.

Charles Carroll Jr. sought the advice of Peggy Chew Howard, his sister-in-law and the mistress of Belvidere, to help Harriet select furnishings for their town house. Peggy's husband, John Eager Howard, refused the request on behalf of his spouse because "she cannot do it with propriety." He suggested that Harriet could do her own shopping "much more to her satisfaction" and that Peggy "would have no hesitation in giving her every assistance."[30] To make such a request, Charles Carroll Jr. must have admired life at Belvidere, which makes information about Belvidere's furnishings especially relevant to Homewood.

FIG. 25. The office, located in the east hyphen, has two cupboards flanking the fireplace. Rather than open bookshelves, these have doors that can be closed and locked, protecting the valuable books from dust, light, vermin, and theft. Surprisingly, both doors open toward the fireplace, perhaps further to protect the books (from popping embers) when the doors are open.

With the exception of documentation of the choices of furnishings made by the couple's contemporaries, there is limited evidence specific to Homewood. Several family letters, especially those from Charles Carroll of Carrollton to his son, make reference to a few purchases, including floorcloths and carpets, and the father's gift of a painting (a portrait of himself) to his son. The inventory taken upon Charles Carroll Jr.'s death in April 1825 gives some indication of the furnishings that remained at Homewood (*see* APP. A). This inventory, however, lacks detail in its descriptions and shows only what remained after the 1816 separation of Harriet Chew Carroll and her husband. On 11 June 1816 Charles Carroll of Carrollton wrote to John Eager Howard, Richard Caton, and Robert Oliver that

FIG. 26. The ceiling of the master bedchamber is the highest in the house, at fifteen feet, three inches. The ornamental plaster details are elegant and stylish, and the height of the ceiling would have helped keep the room cool and airy.

she [Harriet] informs me that there are seven beds and six mattresses and blankets and sheets thereto belonging, and a proportion of the Plate at Homewood be packed up and sent to Philadelphia with the above mentioned furniture for Mrs. Carroll's use ... Whatever furniture over and above what is numerated in these directions ... I authorize hereby to select such as in their opinion may be proper for Mrs. Carroll's use, and cause to be shipped to Philadelphia. The two ponies also it is my wish Elizabeth and Mary Carroll should possess ... As it is expedient that my son and his wife should separate, he will surely see the propriety of allotting to her the furniture and servants, the coach and the pair of horses particularized in these directions; he ought not, and I am confident will not object to parting with property to render the future situation of a wife once dear to him and his children as comfortable, as his compliance with my wishes and his duty will make it by alleviating the distress of an event though necessary, yet most painful under the circumstances which have occasioned it.[31]

No inventory of what was actually taken is known. The 1825 inventory of the contents of Homewood at Charles Carroll Jr.'s death reflects only what remained at that time and does not provide a clear picture of the entire contents of the house when the whole family lived there.

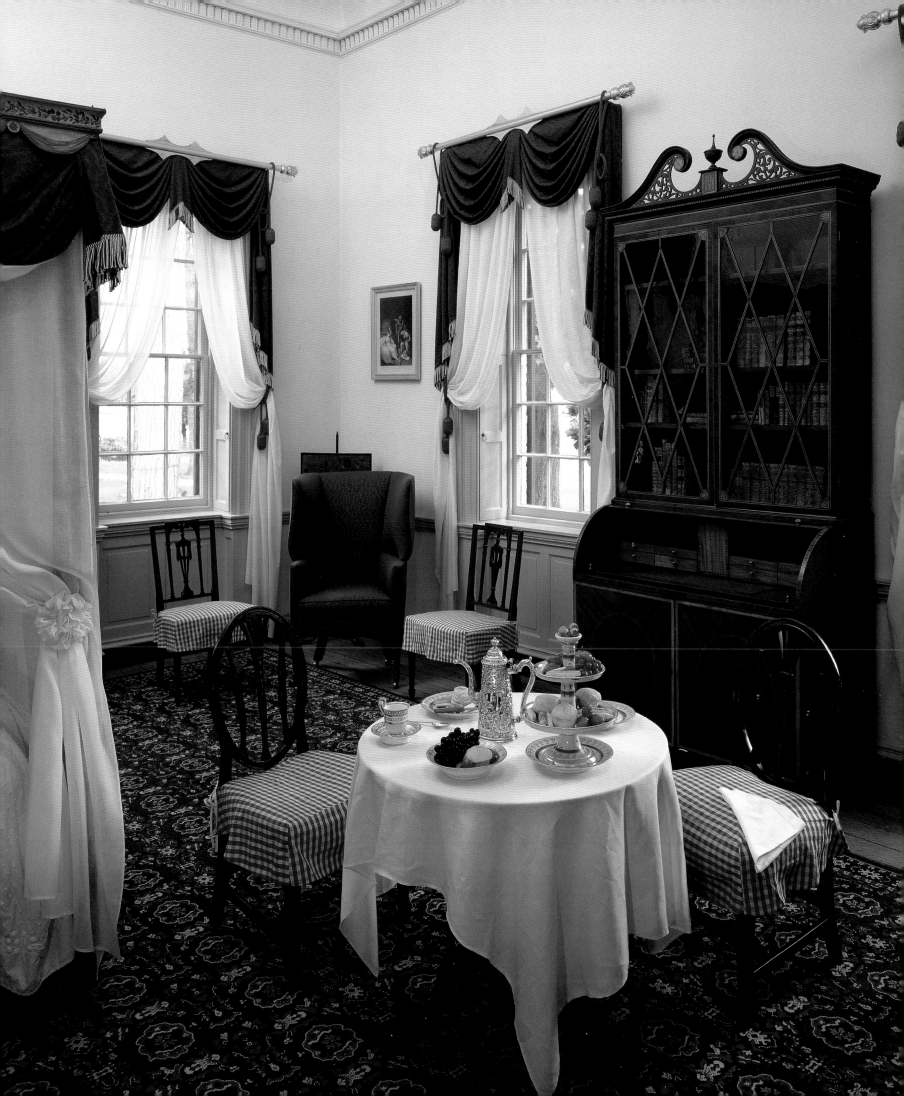

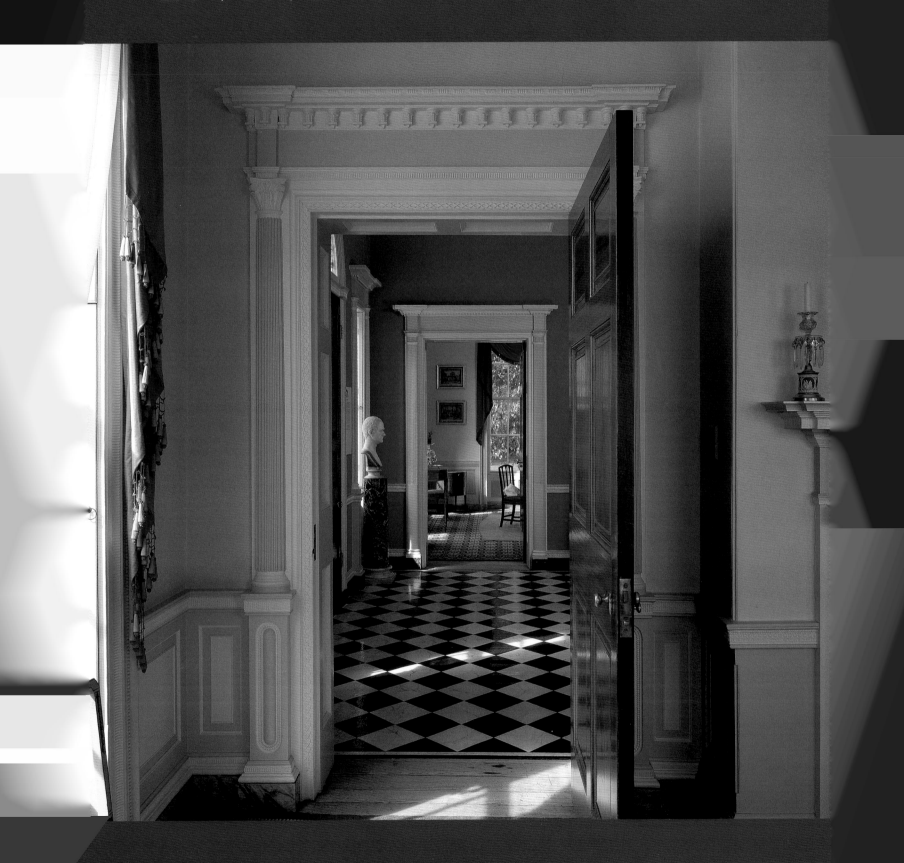

IN THE EARLY NINETEENTH CENTURY, Charles Street extended north only as far as Saratoga Street, so to reach Homewood, visitors traveled north from Baltimore on the York Turnpike, a rutted, dirt road between Baltimore and York, Pennsylvania. Travelers endured substantial hardship and even danger on Maryland's "abominable roads where one runs the risk of being upset at any moment on sharp stones or of being thrown into mudholes." Carriages on the way to Homewood would turn off the major thoroughfare onto a private drive, Red Lane (today probably somewhere between what became 29th and 33rd Streets).[1] Turning onto the drive would have offered a different experience; the newer road and carefully planned views would have been a pleasant change. The drive was sited so that glimpses of the house and "the grounds, which are well watered, are handsomely bordered by wood, and the lawns [which] have been carefully planted with groves and clumps of forest trees," would have come into view.[2]

Farther along the Homewood drive, visitors would cross a small stone bridge over Sumwalt's Run. Charles Carroll Jr. commissioned the bridge in 1801 at a cost of one hundred dollars, and it was a point of contention between father and son. Charles Carroll of Carrollton complained that the bridge was "an improvident waste of money."[3] His son could have built a less-costly timber bridge (FIG. 28) or routed the drive differently to avoid needing a bridge. A small stone bridge survives west of the Baltimore Museum of Art near the Merrick gates of the Johns Hopkins University's campus; elegantly finished with stones scored to look more rustic, this bridge is most likely the "improvident waste of money" referred to by the elder Carroll and would have provided a highly fashionable and controlled approach to the house (FIG. 29). The brick carriage house, also built by Charles Carroll Jr., was a decorative whimsy with gothic windows and doors (FIG. 31).[4] These elements purposely stood in contrast to the classicism of Homewood. At the end of the mile-long drive, the visitor arrived at the foot of the grand portico (FIG. 30).

FIG. 27. The three primary entertaining rooms are located across the front of the house. Guests could move easily from the reception hall into either the dining room or the drawing room. This view from the drawing room, across the reception hall, and into the dining room captures the carefully planned view and the play of light within the house.

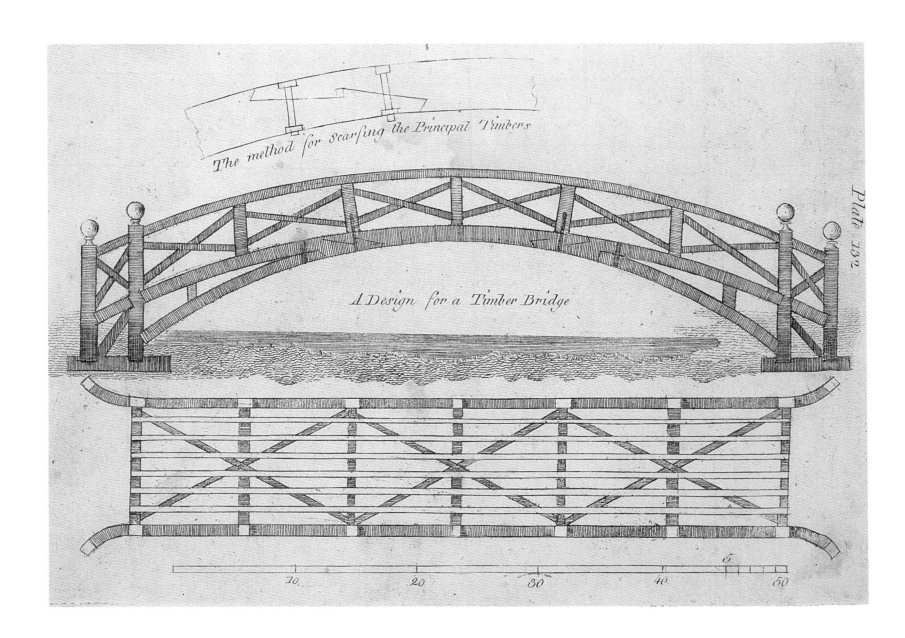

The method for scarsing the Principal Timbers

A Design for a Timber Bridge

Plate 132

10 20 30 40 50

FIG. 28. *William Pain's*
The Practical House
Carpenter, *published in*
Boston in 1796, includes plate
132, "A Design for a Timber
Bridge," a functional and
decorative element to add to
the landscape.

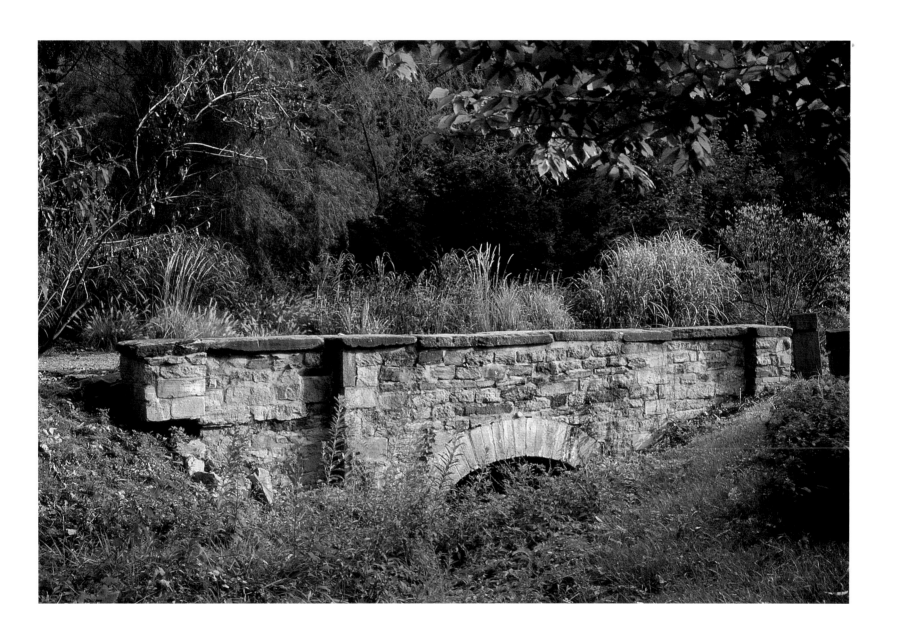

FIG. 29. Much to Charles Carroll of Carrollton's disappointment, Homewood's bridge was built of stone rather than less-expensive timber. Large stones were scored to resemble smaller ones, creating a rustic look.

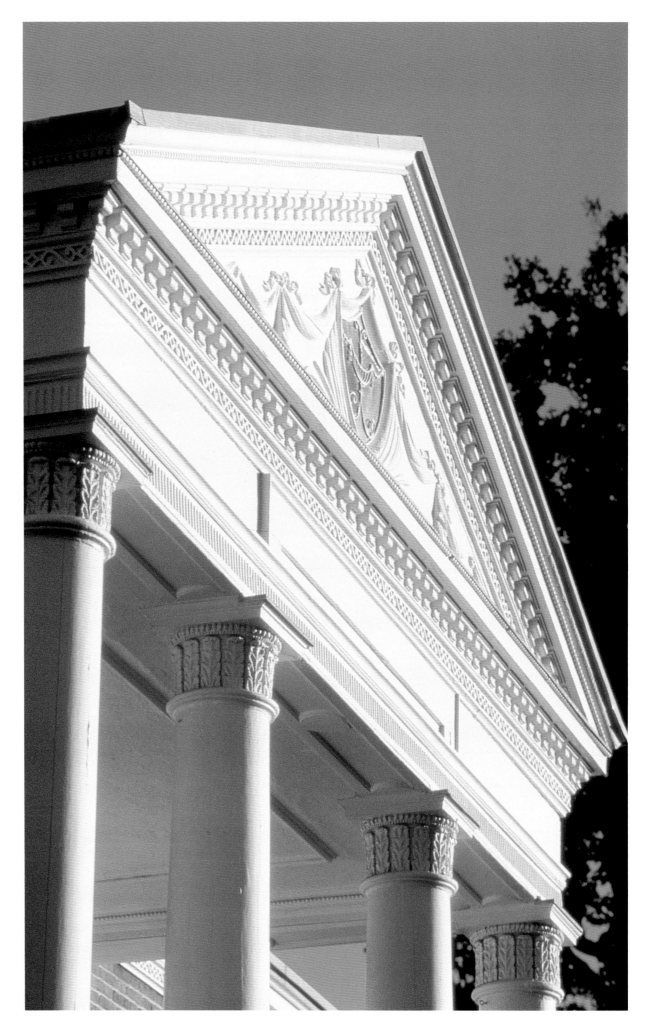

FIG. 30. The south portico
provided a dramatic entrance
for visitors to Homewood
and includes a full vocabulary
of Federal motifs—a shield-
shaped window with an
urn-shaped central pane,
Adamesque swags and
bowknots, and stylized
acanthus leaves as capitals
for the attenuated columns.

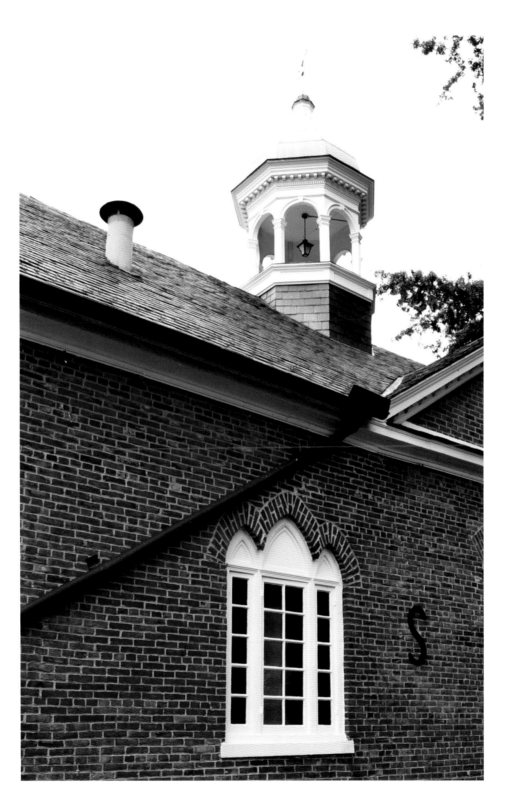

FIG. 31. *Gothic details of Homewood's carriage house or barn provide a playful contrast to the rigid classical design of the house. The decorative cupola may have also provided an attractive vantage point from which to view the property.*

Photograph by Carl Schnepple.

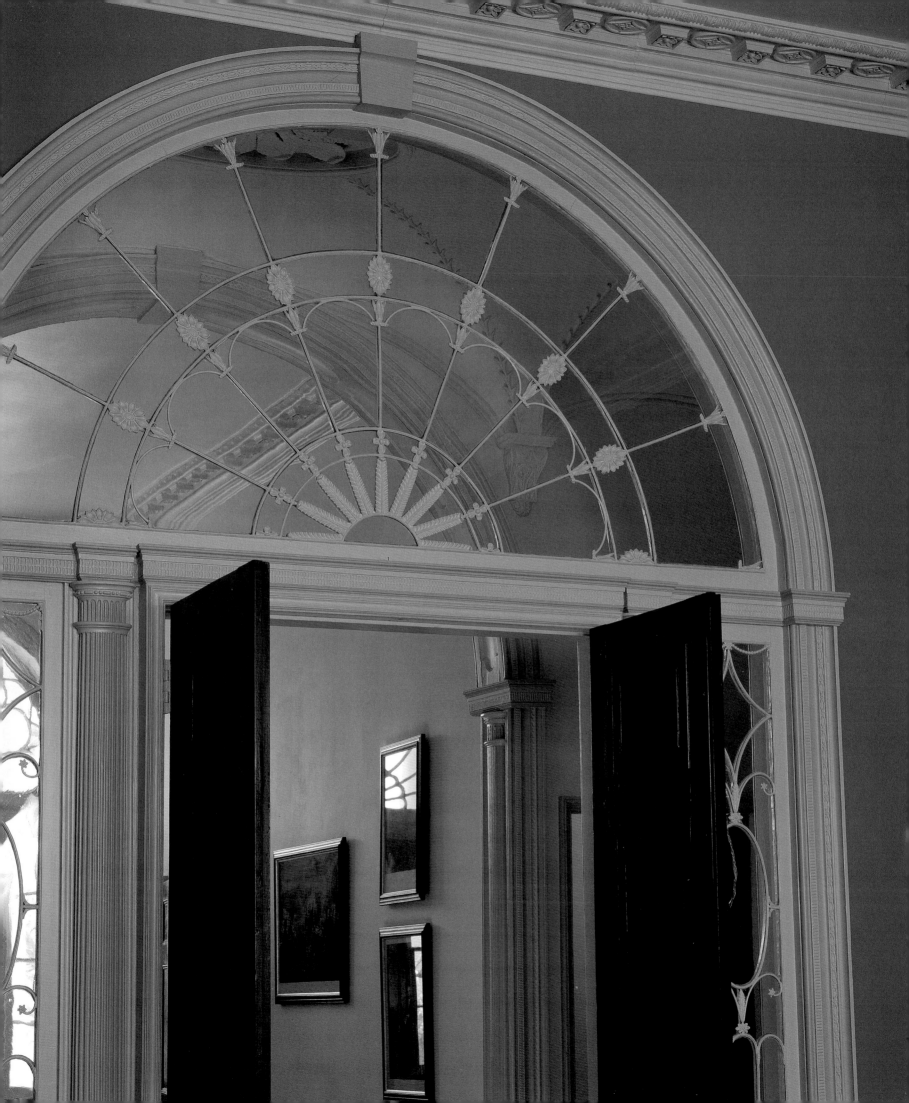

Upon entering the reception hall, the visitor would have been impressed by the vivid green walls, the elaborate detail of the plaster and woodwork (FIGS. 30 and 35), and furnishings of the highest quality. Fanlights, graduated in size from the smallest over the front door facing south to the largest facing north, made the most of natural light; an interior fanlight over the door to the cross hall allowed light to spill between the two spaces (FIG. 33).

On the portico of the north porch over the door, an observant guest would have noticed the églomisé center of the fanlight; this detail at Homewood is perhaps the only known architectural use of this process (FIG. 32). Églomisé is the process of applying gold leaf to glass, used for decorative touches since antiquity. Églomisé panels decorated mirrors and furniture in Boston, New York, and Baltimore and were an unusual and sophisticated detail of tables and case pieces, "set to embellish important pieces." Samuel Kennedy, an artisan in Baltimore, used the process to decorate inset panels for dressing tables and desks and the legs of tables. He worked on Gay Street, in an area of fancy furniture manufacturers, during the period of Homewood's construction. On 2 January 1802 Kennedy advertised in the *Alexandria Advertiser* that he would take orders for services including "gold letters or ornaments on glass."[5] Homewood's builders and craftsmen used églomisé in a unique and elegant way on the fanlight over the door on the north portico. The central element, a fan of leaves in alternating white and yellow gold, is a dramatic, unexpected detail.

The reception hall worked *en suite* with the flanking spaces—the dining room and the drawing room—as the primary entertaining spaces of the house. Guests could move easily among the reception hall, dining room, and drawing room through doors at the front of these rooms (FIG. 27). Weather permitting, the front and back doors of the house could be open, with the reception hall and garden entrance hall functioning as a breezeway through which guests could move onto the porches and out into the gardens and grounds. In the summer months, guests might even dine in the reception hall (FIG. 36).

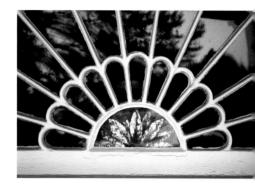

FIG. 32. The églomisé panel in the center of the north fanlight, a fan of alternating white and gold leaves, may be a unique architectural feature. Églomisé was typically used as a detail on furniture of the period; here it is an elegant and unexpected detail.

Photographs by Carl Schnepple.

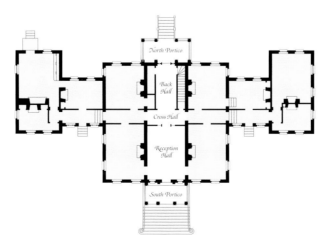

FIG. 33 (opposite). The large fanlight between the reception hall on the south side of the house and the back hall on the north allowed light to spill between the two spaces, making the most of the natural light regardless of the time of day.

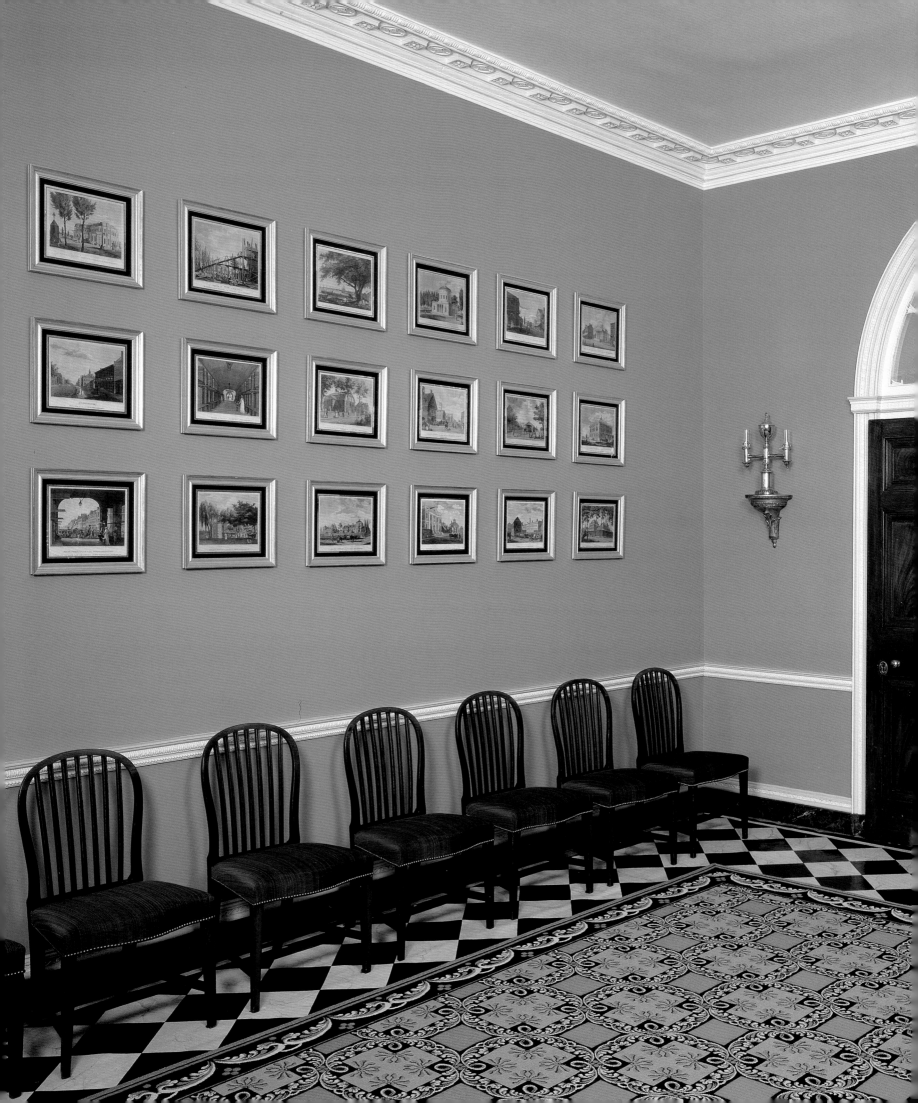

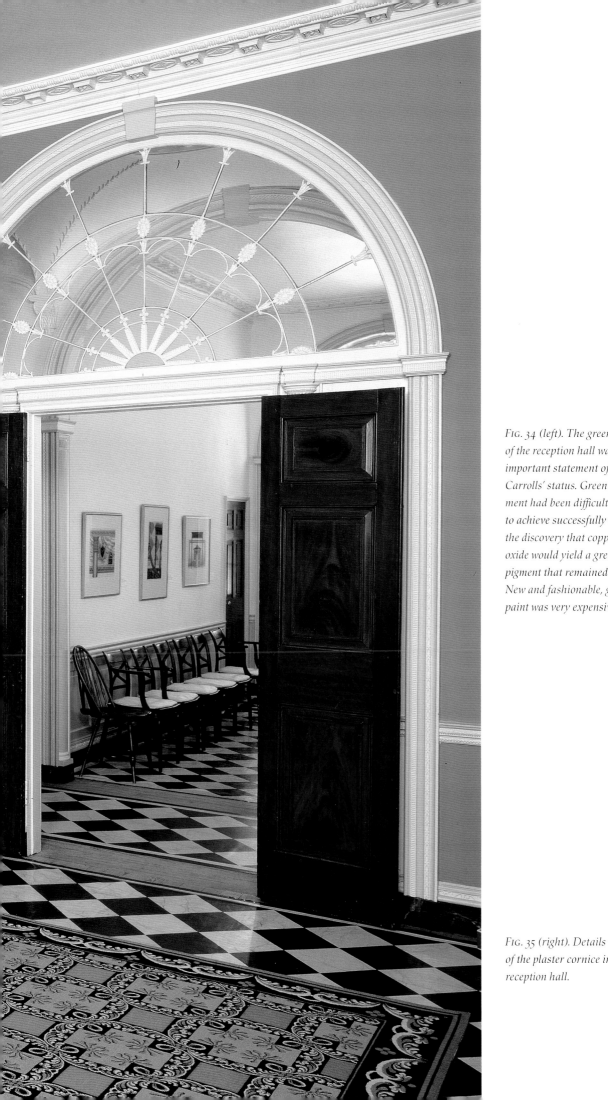

FIG. 34 (left). The green paint of the reception hall was an important statement of the Carrolls' status. Green pigment had been difficult to achieve successfully until the discovery that copper oxide would yield a green pigment that remained true. New and fashionable, green paint was very expensive.

FIG. 35 (right). Details of the plaster cornice in the reception hall.

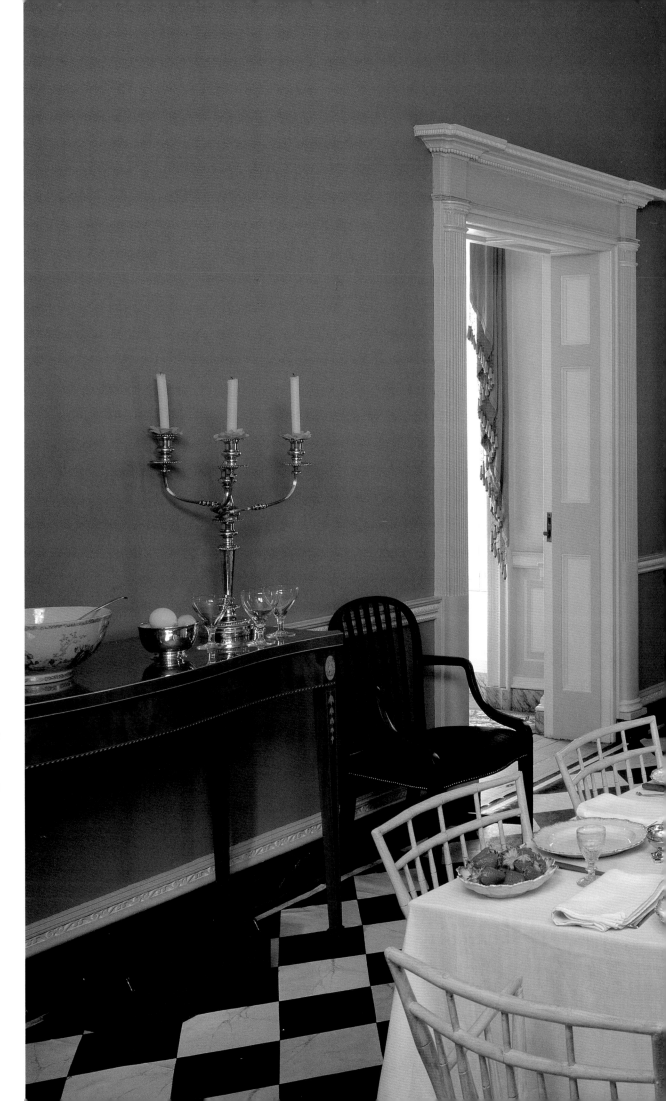

FIG. 36. *The reception hall could be used for dancing or dining and in summer months may have been one of the coolest rooms in the house. Front and back doors could be opened to take advantage of breezes that would not only be more comfortable but also dissuade flies from joining the meal. Painted Windsor chairs were found in most houses of the period. Here, because of their lightweight and highly portable nature, they have been assembled for a summer supper.*

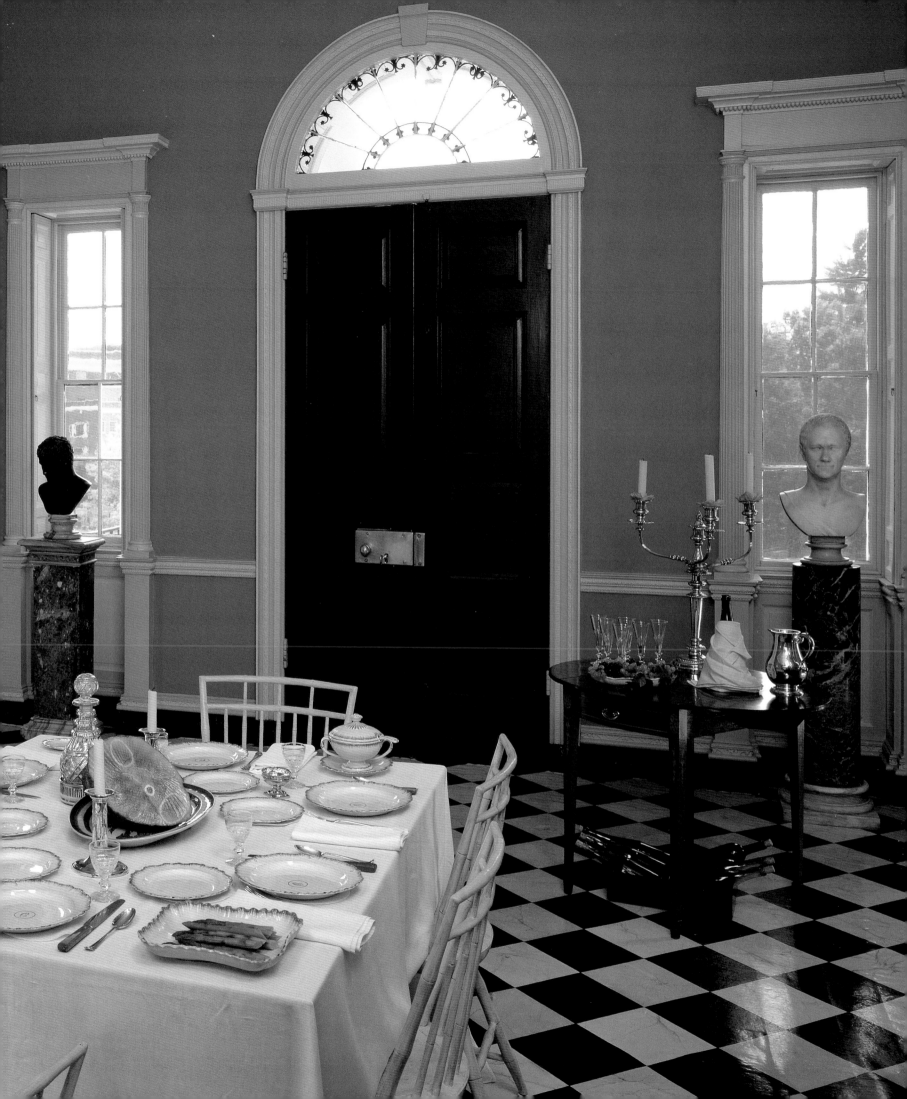

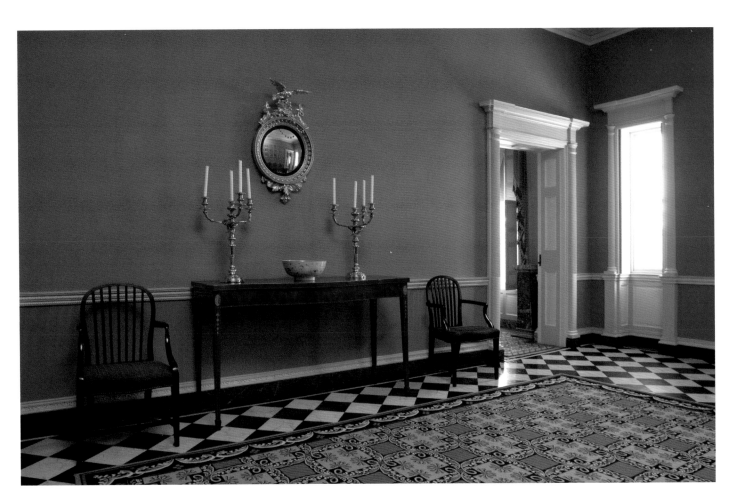

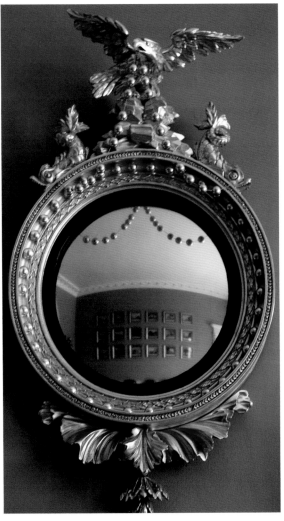

The most important piece of furniture for entertaining in the reception hall may have been a sideboard table, thought to have belonged to Charles Carroll of Carrollton (FIG. 37; *see* APP. C, CAT. 1). Such a table would have been used in either the reception hall or the dining room, and this table illustrates the height of Maryland craftsmanship during the period. The traditional sideboard, a new form in the early nineteenth century, had drawers and doors with compartments for an array of silver, bottles, and linens for entertaining. The sideboard table, which lacked such compartments, may have been used as a mixing table or server from which to offer liquid refreshments. This serpentine-front sideboard table is embellished with the full vocabulary of Maryland inlay. All four legs are ornamented with bellflowers and outlined with string inlay; a shield-breasted eagle within an oval reserve is set into the top of each leg. The top of the table follows the shape of the skirt and is bordered by crossbanded detail. Inlay was a decorative detail that represented additional expense. This sideboard table has a string of bellflowers and eagle pictorial inlay on not only the front and outer surfaces of the front legs but also the front and outside surfaces of the rear legs—an extraordinary, fine, and expensive detail (FIG. 38).

On the wall opposite the sideboard table and reflected in the convex mirror hung above it could have been an important set of eighteen engravings by William Birch and Son, entitled *Views of Philadelphia ... as it appeared in the year 1800* (FIG. 39). Birch offered subscriptions to this series; subscribers could receive them bound as a set or individually for framing. Charles Carroll of Carrollton owned two sets of this series, "one colored and one not colored."[6] Although the views had broad popular appeal because of Philadelphia's prominence and influence in government, commerce, and style, the images may have been especially meaningful to Charles Carroll Jr. and his Philadelphia-born bride; Philadelphia was where they met and where they married. The *Views* document the architecture and details of everyday life in turn-of-the-century Philadelphia. A group of English hoop-back chairs with green horsehair upholstery line the perimeter of the room and could be easily moved to suit a variety of uses—brought together for dining and for conversation or moved out of the way for dancing.

FIG. 37 *(opposite, top). A sideboard table, server, or slab table was a common item in reception halls. This example, however, is anything but common. With a Carroll family provenance, this table is an extraordinary example of Maryland craftsmanship.* Photograph by Carl Schnepple.

FIG. 38 *(opposite, left). Detail of the inlay on the sideboard table. Inlay cost extra; eagles and bellflowers were decorative devices used to ornament mahogany furniture. Here bellflowers and eagles are used to embellish two surfaces on each leg.* Photograph by Carl Schnepple.

FIG. 39 *(opposite, right). Reflected in the convex mirror hanging over the sideboard table are* Views of Philadelphia as it appeared in 1800. *The Carrolls were subscribers to this popular series of engravings published by William Birch and Son.* Photograph by Carl Schnepple.

FIG. 40. The central passage runs the length of the house from east to west, bisecting the reception hall and back hall. The placement of windows and fanlights along this axis takes advantage of the natural light. The bright yellow paint heightens the effect—even on a gray day, the passage is filled with light.

In the cross hall, where the reception hall and garden entry hall meet, a visitor could observe the beautifully detailed, cross-vaulted ceiling, a masterpiece of Adamesque design. Four slender Doric columns on plinths appear to support the ceiling but are purely decorative. Cast bellflowers along the ribs of the vaulting meet in a central oval medallion of leaves (FIG. 41). From this central point in the house, a visitor could see clearly how the hallways were designed on an axial plan. This central passage, on the east-west axis, allowed service activity from the cellar to the main floor and from the wings to the main block without disrupting activities within the three front rooms (FIG. 40). Addressing issues of privacy and practicality, doors allowed the house to be sectioned into smaller units; there is a door at each end of the cross hall and at each end of the main block. The plan of the house also provides carefully planned views. The doorways off of the central passage are not directly across from each other; instead, the doorways to the back two rooms of the main block are sited to frame the chimneypiece when viewed from the opposite front room (FIG. 42).

The dining room and drawing room were heavily ornamented with architectural design elements popular in the early nineteenth century. The builder relied on a specific design source, William Pain's *The Practical House Carpenter,* the first American edition published in 1796. From this source Charles Carroll Jr. and his builders, the Edwards brothers, selected specific moldings, cornices, chimneypieces, door surrounds, columns, and pilasters; they may have been influenced by floor plans included in the volume. The three front rooms of the main block were designed with the highest degree of finish in plasterwork and carved details (FIGS. 43 to 45). From the level of architectural virtuosity demonstrated in these rooms, it can be inferred that the furnishings, carpets, and painted surfaces would have been equally refined and elegant. Imported carpets and floorcloths, such faux finishes as grain-painted doors and marbleized baseboards, and dramatic and expensive color schemes identified the Carrolls as educated, refined, and genteel.

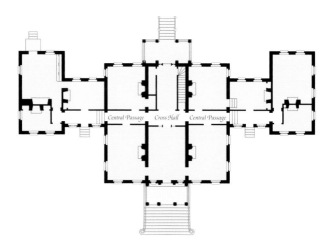

Central Passage Cross Hall Central Passage

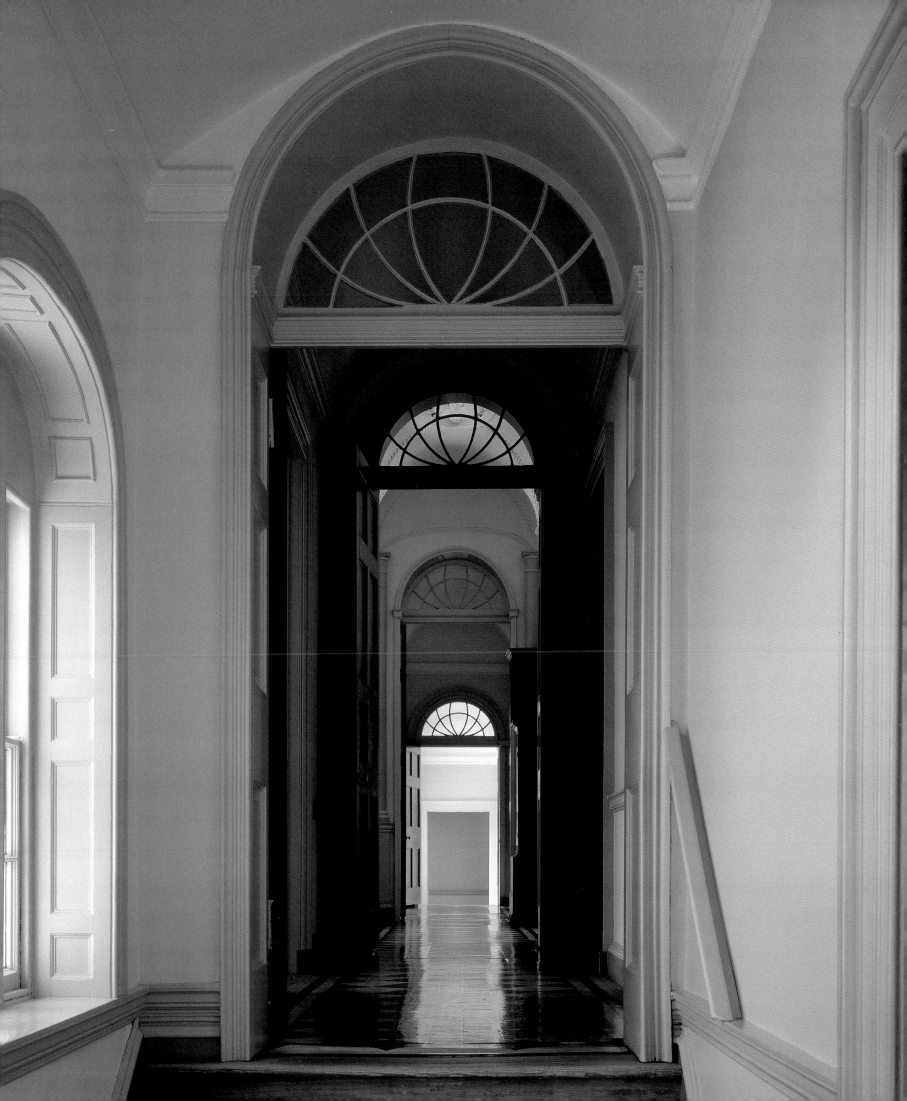

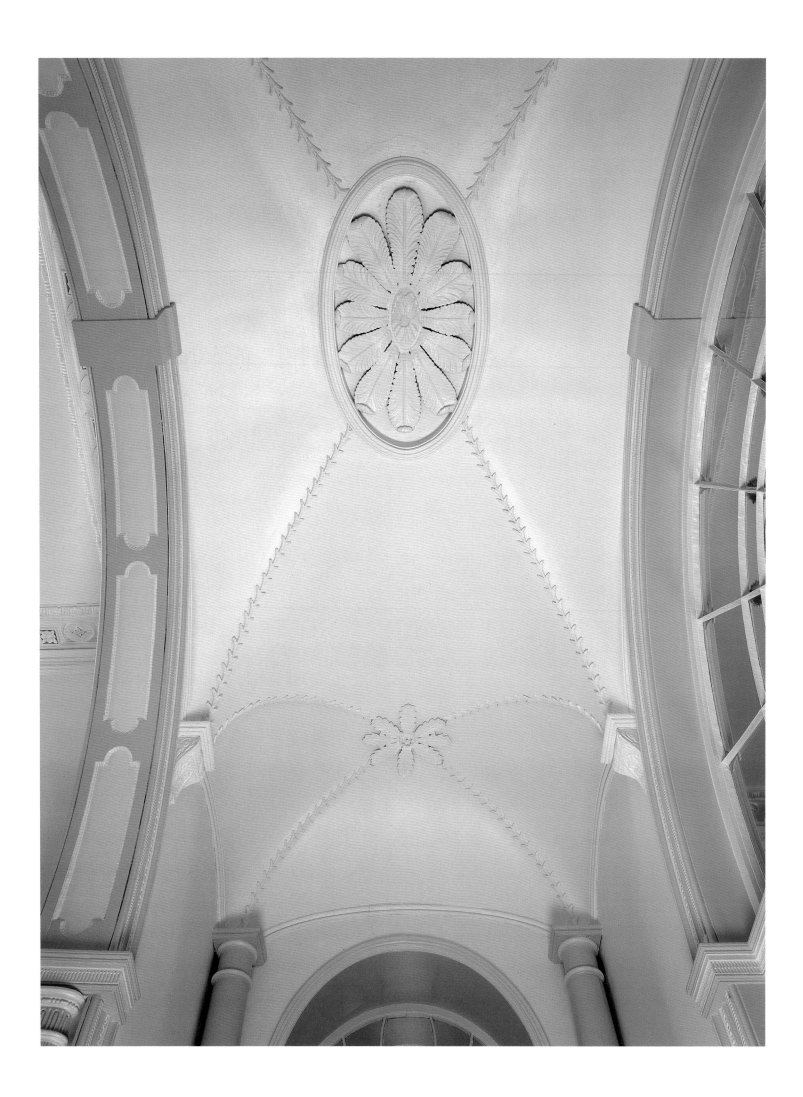

FIG. 41 (opposite). The cross
hall is embellished with the
most elegant and elaborate
plasterwork in the entire
house. An oval medallion is
centered within cross vaulting
ornamented along its ribs
with cast bellflowers.

FIG. 42. Carefully planned
vistas occur throughout the
house. Here, in the view from
the drawing room, the
chimneypiece of the Chintz
Chamber, or best guest
chamber, is framed by the
doorways of each room.

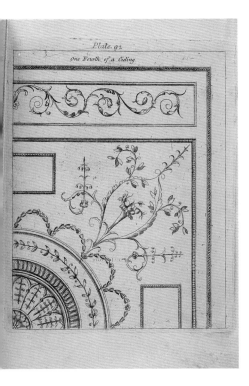

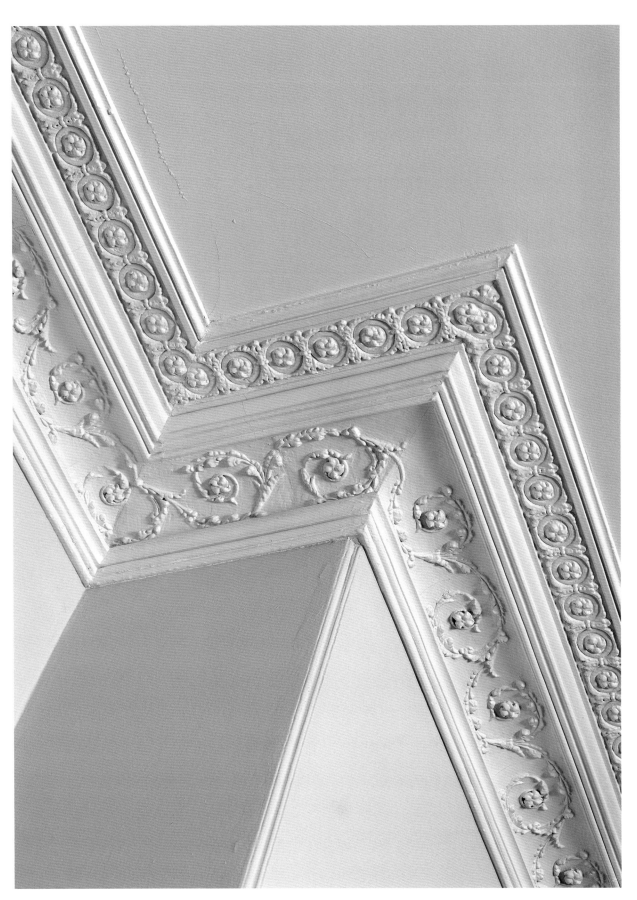

Fɪɢ. 43. *"One Fourth of
a Cieling* [sic]*" (above),
shows an elaborate design
for a plaster ceiling. At
Homewood (right), only
the ranceau pattern was
used in the plaster cornice
for the drawing room.*

William Pain, *The Practical
House Carpenter*, plate 92.

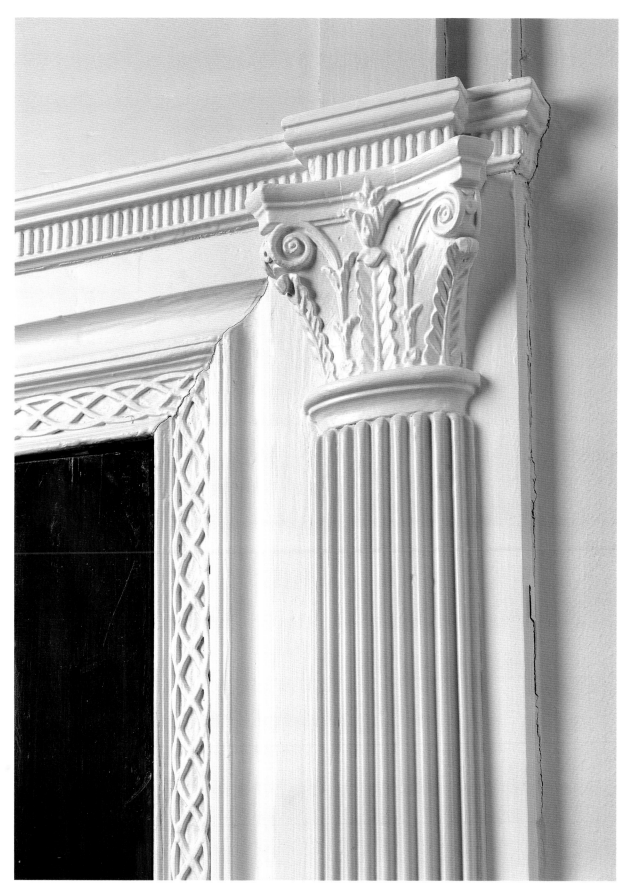

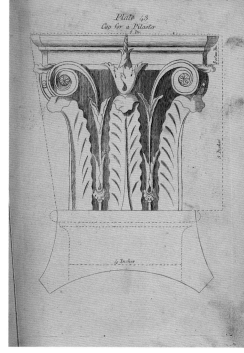

FIG. 44. *"Cap for a Pilaster"*
(above), shows the design
used for the pilasters of
the door surrounds in the
drawing room (left), the
most exact interpretation
of Pain at Homewood.

William Pain, *The Practical House
Carpenter*, plate 43.

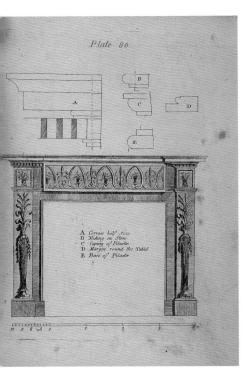

FIG. 45. *Published designs for chimneypieces were reinterpreted and simplified for use at Homewood in details of the Chintz Chamber (right) and Green Chamber (opposite). Such "designed" details were used in Homewood's best rooms.*

William Pain, *The Practical House Carpenter*, plates 86 and 87.

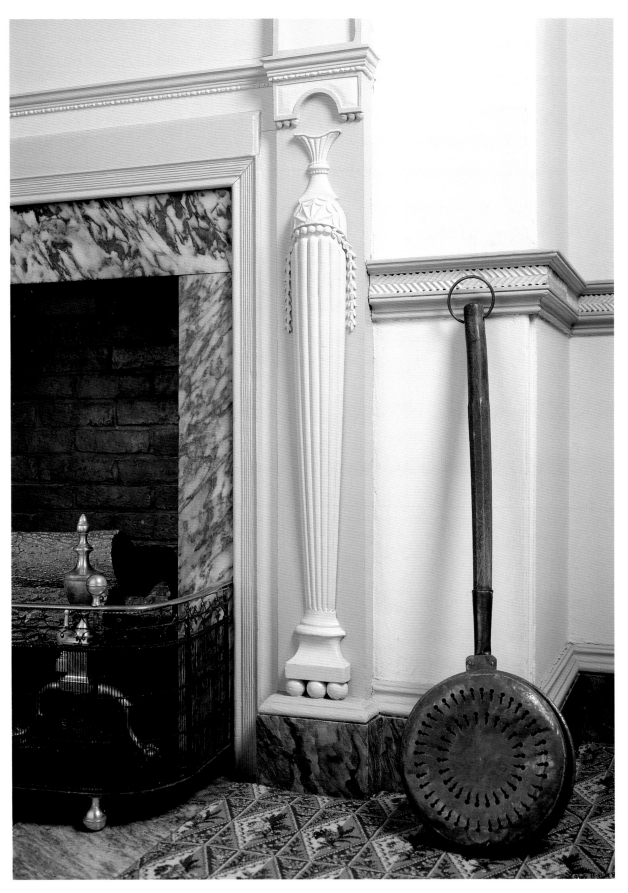

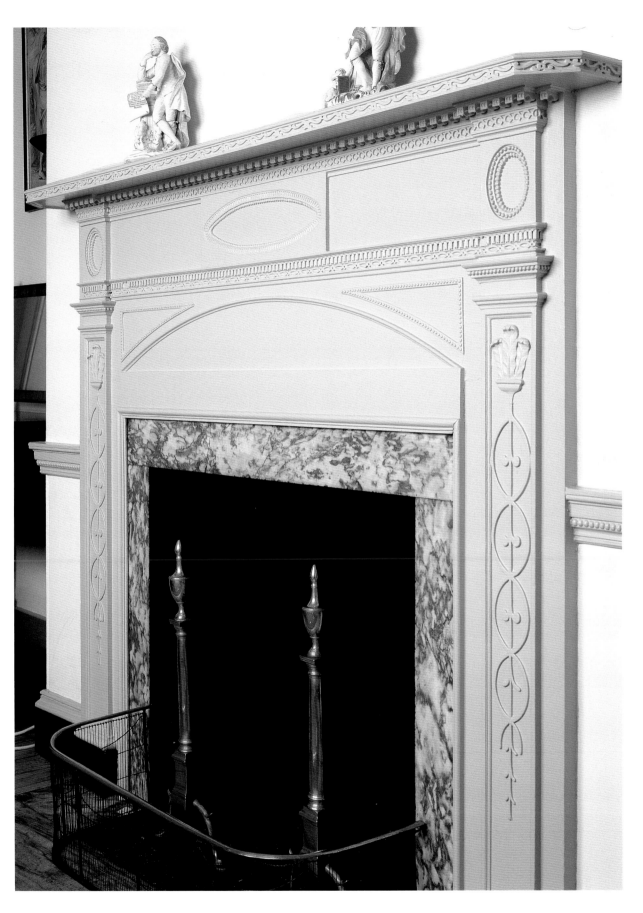

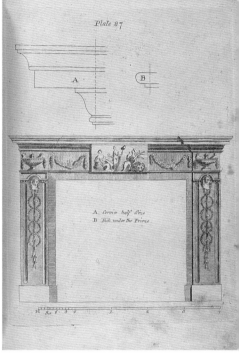

Plate 87

A Cornice half Size
B Nich under the Frieze

Faux finishes represented the height of fashion; they were perhaps more fashionable than the actual materials the finishes sought to imitate—mahogany and marble. At Homewood these finishes included grain-painted doors resembling mahogany throughout the house and marbleized baseboards in the main block of the house, which were discovered through paint analysis. Marbleizing is the painting of wood to resemble marble. Each of the three front rooms for entertaining showed a different variety and color of faux marble: green in the reception hall and through the central passage; Sienna marble, or yellow, in the dining room; and King of Prussia, or gray, marble in the drawing room (FIG. 46). Real King of Prussia marble surrounded each fireplace and formed the hearth in most of the other rooms of the house.

Other faux finishes may have included floorcloths painted to resemble marble tile. This may have been true in the case of the floorcloths Charles Carroll of Carrollton ordered from London in October 1805 "for some rooms of my son's country house near Baltimore … these floor cloths are for summer's use" (*see* FIG. 47).[7] A durable and scrubable surface, floorcloths, which were sometimes referred to as oilcloth, are cooler and much easier to clean and maintain than carpet. Floorcloths are made by applying many layers of paint to a heavy canvas ground. Popular patterns changed relatively little from the mid-eighteenth century until the mid-nineteenth-century advent of linoleum. Two influential design sources were treatises written by Batty Langley and John Carwitham in the mid-eighteenth century (FIG. 48). The running diamond and squares-on-point patterns thought to have been ordered for Homewood may have been more directly influenced by the actual marble tile on the front portico floor; with the front doors open during summer months, the appearance would have been that of a continuous, elegantly tiled surface.

The floorcloths throughout the house reproduced the designs in use at the turn of the nineteenth century. The heavy, sailcloth-grade canvas—abundant in Baltimore with its shipbuilding and textile trades—had many layers of paint; fifteen

FIG. 46. Faux finishes were the height of fashion in this period. In the dining room, the real King of Prussia marble fireplace surround contrasts with the yellow faux Sienna marble baseboard. In the drawing room and Chintz Chamber, however, the faux marble is less easily distinguishable from the real—both varieties are King of Prussia (see FIGS. 45 and 60).

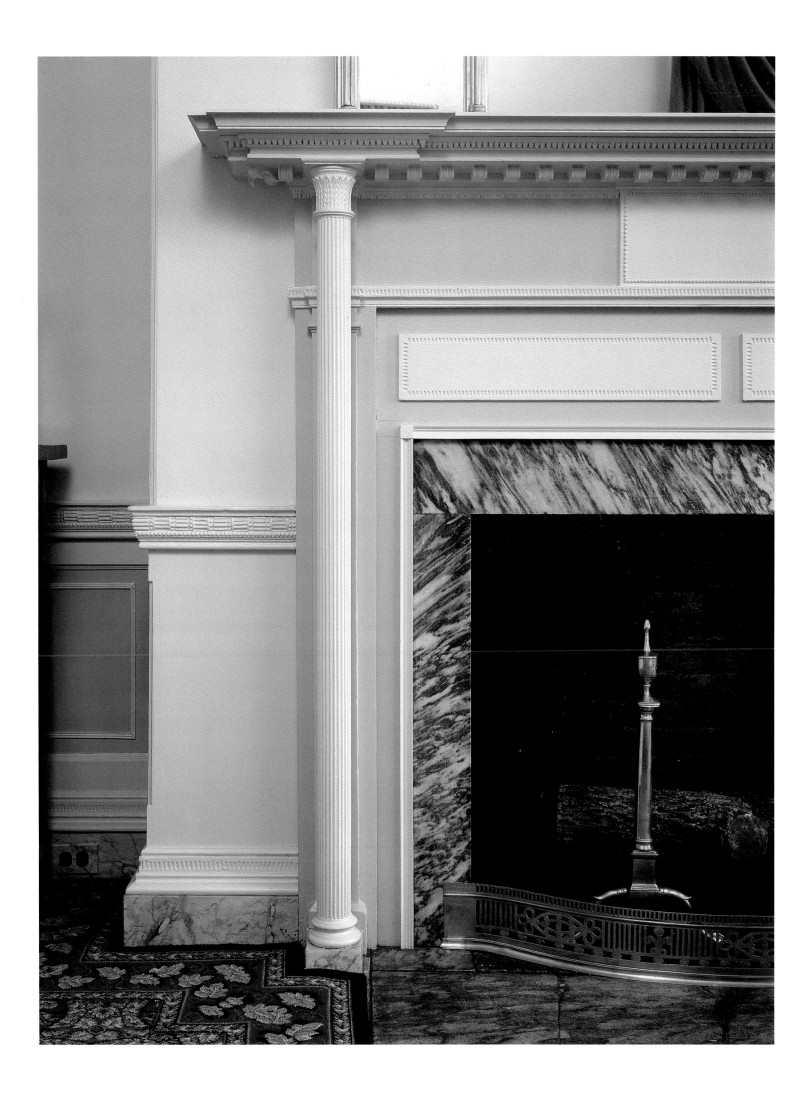

Geometrical Squares quadrupled

Geometrical Squares in a Side view

Geometrical Squares in an angular view

Geometrical Squares and Parallelograms

Regular Octagons and Geometrical Squares

Irregular Octagons and Geometrical Squares

Batty Langley Invent and Delin. 1739. Tho.ˢ Langley Sculp.

FIG. 47. *Homewood's floor-cloths are documented by orders placed with William Murdoch in London by Charles Carroll of Carrollton for "my son's country house near Baltimore." The most direct influence on their design may have been the actual tile on the front portico floor.*

Arents Collection, The New York Public Library, Astor, Lenox, and Tilden Foundations.

were used on the reproductions now at Homewood: five layers of the base coat, five layers of design, and five layers of varnish on top. Even though locally produced floorcloths were available, the Carrolls chose instead to order theirs from London, in spite of the six-month wait they could expect before their order would arrive. Originally, all three of the main entertaining rooms may have had both a floorcloth and a carpet that could be switched seasonally.

The account books also record the family's carpet purchases and preferences. Charles Carroll of Carrollton ordered "Brussels carpets" and "an elegant Wilton carpet drab ground with a small mixture of crimson in the pattern."[8] The elaborate designs on dark backgrounds were stylish—and practical. Food droppings on the drab, or camel-colored, background of the carpet would be less noticeable.

Homewood challenges early-twentieth-century ideas about the use of subdued colors in early-nineteenth-century interiors. The reason to select these bold designs and color combinations of not only the carpets but also the architectural details becomes apparent when the rooms are seen by candlelight. In dim light these bright colors are just visible; more subtle patterns and colors would be difficult, if not impossible, to distinguish.

FIG. 48 (opposite). *Better known for his work as an early landscape architect, Batty Langley also published builders' handbooks that included designs for "pavements," which were interpreted into designs for floorcloths. Langley, and later his protégé John Carwitham, popularized such designs.*

Decorations for pavements &c., plate 94, in Batty Langley (1696–1751), *The city and country builder's and workman's treasury of designs ...* (London: Printed by J. Ilive for Thomas Langley, 1740). The Winterthur Library, Printed Book and Periodical Collection, RBR NA3310L28.

Paintings and portraits form another important part of the interiors of Home-wood and create a clearer picture of the people who lived here. Charles Carroll of Carrollton referred to his own portrait at Homewood when he wrote, "I am pleased you placed my picture in such good company."[9] Among those of means, it was not unusual to have portraits of family members, especially those of preceding gener-ations, prominently displayed.

Portraits by Charles Balthazar Julien Févret de Saint-Mémin of Charles Carroll of Carrollton (*see* APP. C, CAT. 19) and his son Charles Carroll Jr. (*see* APP. C, CAT. 18) are owned, respectively, by the Maryland Historical Society and the Baltimore Museum of Art; copies of these portraits hang in Homewood's cross hall (FIG. 49). Saint-Mémin (1770–1852), a French émigré, came to America in 1796. Using a physignotrace, a device for tracing life-size profiles, he produced extremely detailed portraits enhanced with charcoal and chalk. He worked in each of the major eastern port cities from Boston to Charleston from 1798 to 1810, and his sit-ters included some of the most notable Americans of the early republic. For twenty-five dollars the patron would receive a profile portrait, an engraved copperplate of the reduced image, and twelve engravings. Saint-Mémin made portraits of Charles Carroll Jr. in 1800 in Philadelphia and of Charles Carroll of Carrollton in 1804 in Baltimore. A letter from father to son in December 1810 provides a glimpse of how the small, engraved portraits were shared among one's family. "This [letter] is to acknowledge the recpt. of yours of the 13th and to enclose an engraving of my profile of the portrait made by St. Menin [*sic*]" (FIG. 50).[10]

Harriet Chew was not drawn by Saint-Mémin, but both she and Charles Carroll Jr. were painted by Robert Field in Philadelphia in 1800, probably at the time of their marriage. The marriage ceremony itself was a point of contention between the Carrolls and the Chews. Harriet's family was Protestant, and the Carrolls were the most prominent Catholics in the country. John Carroll, first cousin of Charles Car-roll of Carrollton, was the archbishop of Baltimore, the head of the Catholic Church in America. After resolving issues such as conversion (she did not) and

FIG. 49. A copy of Saint-Mémin's portrait of Charles Carroll Jr. hangs in Homewood's cross hall. The original is owned by the Baltimore Museum of Art.

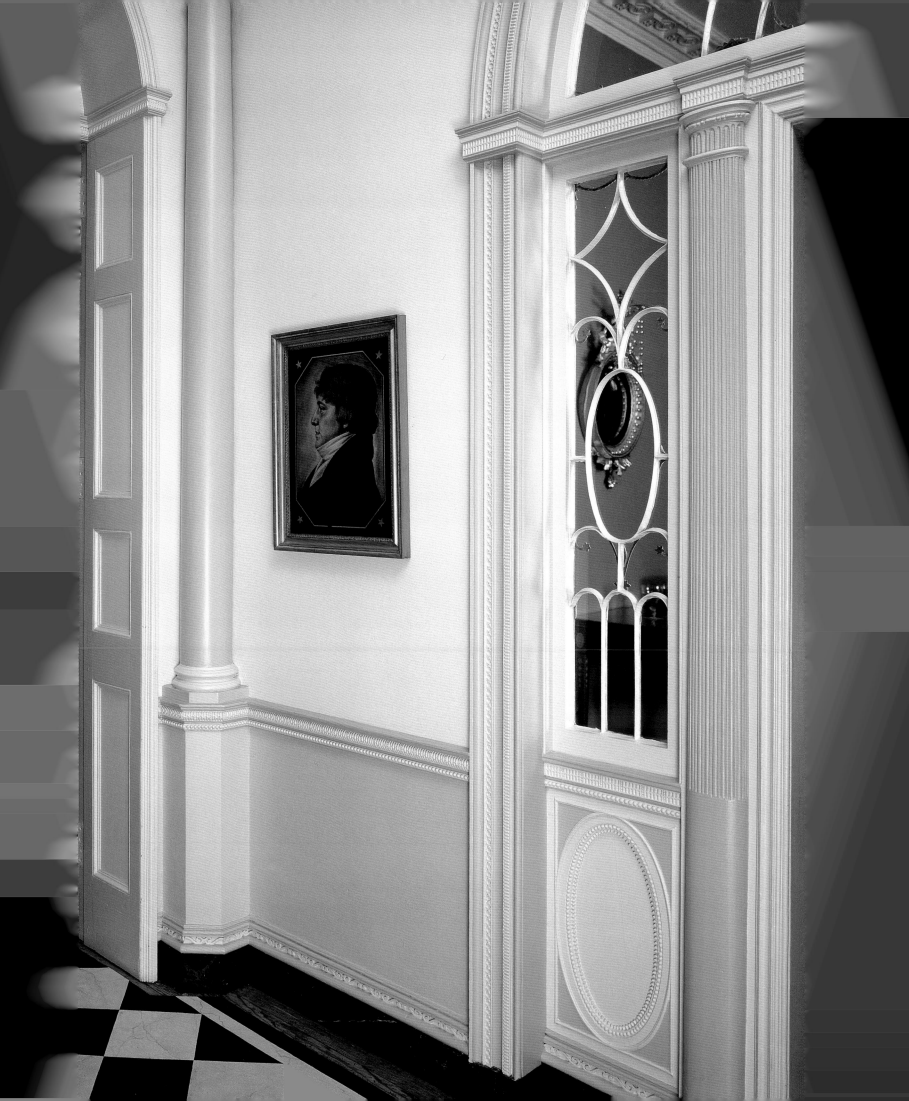

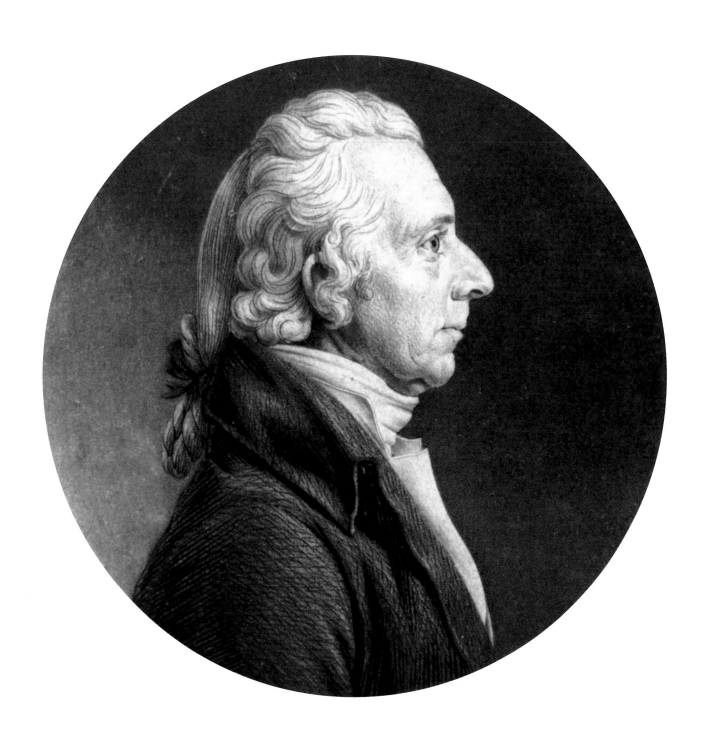

deciding the faith in which any resulting children would be raised (Catholic), Archbishop Carroll performed the marriage at Old Saint Joseph's Church in Philadelphia on 17 July 1800.

The young couple remained in Philadelphia for about six months before settling in Baltimore. Charles Carroll Jr. appears in Baltimore city directories beginning in 1800, with his dwelling listed as King George's Street, Old Town; the street was renamed Lombard Street by 1804.[11] It is from this residence in Old Town that the vision for his country house, Homewood, probably began, although it is clear that he had plans for a country house as early as 1800, when he wrote to his prospective father-in-law regarding his intention to marry Harriet. "[My father] means to fix us about a mile from the town of Baltimore. In the first instance he will bear all the expenses of a full and genteel establishment for us."[12]

In the early years of their residence at Homewood, the couple moved with ease among Baltimore's new elite. There was a wedding, parties, a reception for one hundred, and a procession of guests well entertained and fed at Homewood.

As John H. B. Latrobe, son of architect Benjamin Henry Latrobe and a guest at Homewood, noted,

Charles Carroll of Homewood was unquestionably one of the most elegant and distinguished looking men that in a large intercourse with the world, I have ever met. Of a noble presence and a most gracious manner, of an urbanity that marked his intercourse with everyone who approached him, that was remarkable even in his treatment of the domestics that waited on him; with the most scholarly attainments, ready in conversation, full of anecdote and quick at repartee—it was impossible to be in his presence without admiring him.[13]

Because of the distances and difficulties of travel, a dinner visit could last for days. Invitations were issued formally by letter or in person by a manservant. "Visiting" in the early nineteenth century is well described by a guest who arrived at Doughoregan Manor after a sixteen-mile journey in 1829:

FIG. 50. In 1810, Charles Carroll of Carrollton sent his son an engraved version of his portrait by Saint-Mémin. Engraved copies were distributed among family and friends much as photographs are shared today.

Charles Carroll Sr., engraving, Corcoran Gallery of Art.

There is perhaps a large fire in one room & none in the other … a card table in full operation in one [room] … a harp, guitar and songs sounding in another, in one people eating, in another chattering or whispering in corners. Everybody seems to catch in ten minutes all the freedom & ease of the place. Everybody is glad to see you but no body takes any trouble … on a large table in the hall, through the middle of the day, there are punch, toddy, lemonade, wine cakes, & all that sort of thing, with heaps of newspapers, new novels & You may loll on the sofa and read them, & nobody expects you to rise … you meet little parties in the garden, but you need not join them unless you like. You stay a day or a week, welcomed when you come, & you come, & going away at any hour you choose.[14]

The refinement of the dining room at Homewood demonstrates the importance placed on entertaining (FIG. 51). Architectural details such as the elaborate plasterwork and the unusual freestanding columns by the mantel provide an appropriate setting in which to be "refined." Americans were particularly eager to demonstrate their gentility through the sophistication of the dining room and the acquisition and use of an array of specialized and elegant tools for eating.

A variety of fine ceramics used by the Carroll family included blue-and-white Nanking pattern Chinese export porcelain, Wedgwood feather-edge creamware, and more common mochaware (FIGS. 52 and 53). Other groups of ceramics with a Carroll provenance survive in both museum and private collections and represent the highest-style objects available in Baltimore at the time. Carroll family silver, much of it English, could have been displayed on the sideboard. There was a silver implement for every conceivable purpose: teaspoons, gravy spoons, a siphon (for wine), a wine funnel, a cross for a bowl (trivet), oyster knives, silver marrow spoons (designed to extract marrow from the bones of meat), and other specialized eating tools.[15]

Seemingly everything in the dining room—the silver, cut glass, mirrors, brass hardware, and even highly polished mahogany furniture—was chosen to create a glittering effect by the flicker of candlelight. If the meal had begun in the midafternoon, as was customary in the period, interior shutters would be closed to block out the strong and glaring sunlight of the western exposure of Homewood's din-

FIG. 51. The dining room at Homewood set for dessert.

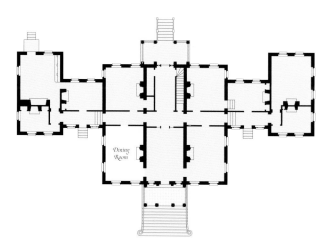

Dining Room

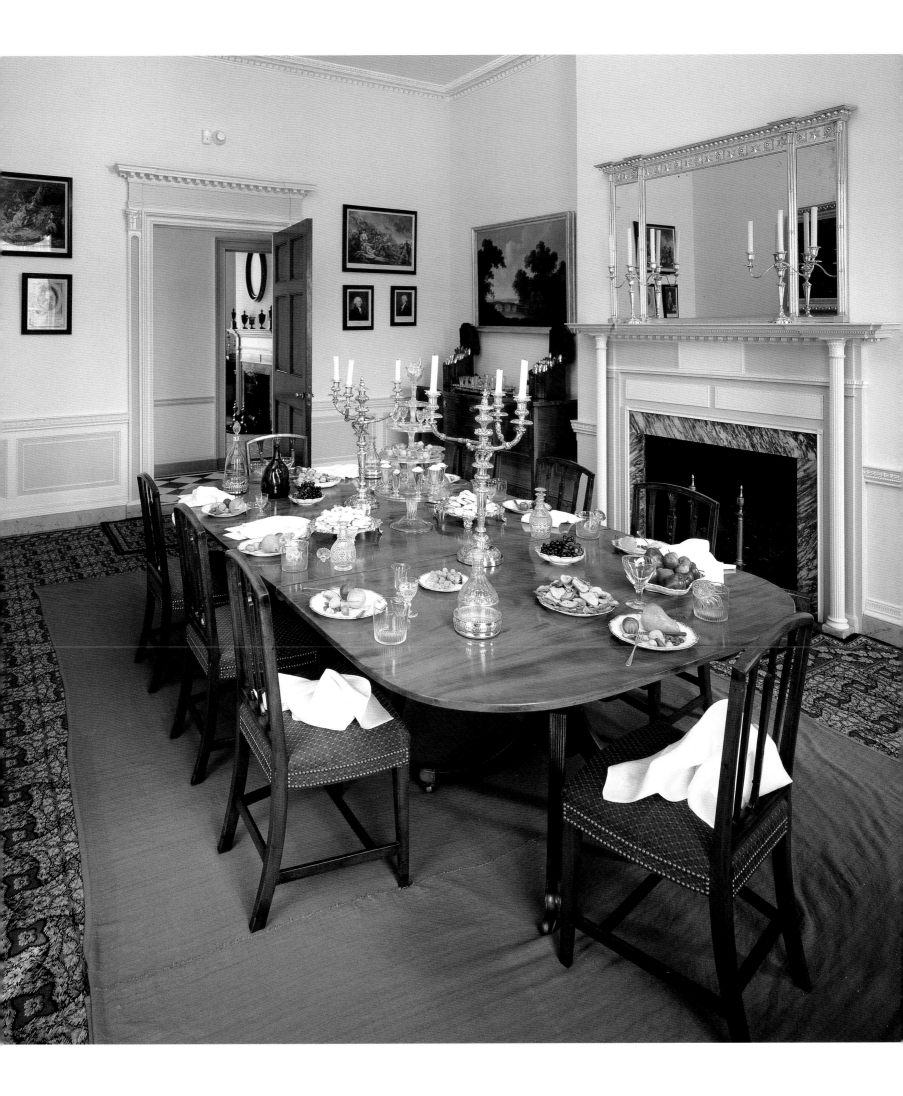

Fig. 52. Nanking pattern Chinese export porcelain was found during archaeological investigations at Homewood in 1985.

Fig. 53. A nearly complete, although broken, dendritic pattern mochaware bowl was among the archaeological finds.

ing room, which would necessitate the use of candles and sparkling accoutrements. *The Dinner Party, 10 Franklin Place, Boston,* by Henry Sargent, circa 1821, depicts a scene architecturally similar to Homewood's dining room (FIG. 54). Some details from this painting served as the basis for the window treatments, floor coverings, and even the table settings at Homewood today.[16] The painting, and likewise the dining room at Homewood, show the use of a crumb cloth beneath the table to cover and protect the carpet, catching mishaps of the meal (FIG. 55).

Table setting was an art; many recipe books and household hint manuals gave directions and diagrams not only for what to place where but for the menus themselves. When the Carrolls were entertaining at Homewood, a typical dinner would consist of as many as five or six courses accompanied by as many wines. The table would have been layered with many cloths; after each course the top cloth was removed by servants rolling it along the table while picking up and putting down items as they went. This practice ensured a clean cloth for each course and a dramatic presentation of dessert (with no cloth), when the broad expanse of highly figured and polished mahogany would add to the magical glow.

Dining was a formal event; dividing the meal into courses served one at a time was a change from the previous custom of setting the table with all of the food served at once. Rosalie Stier Calvert (1795–1821), a fashionable French-born hostess who settled in Prince George's County, Maryland, pointed out that, under the old system, "one has not time to eat sufficiently before half the dishes are cold."[17]

An elaborate dinner might consist of soup, two kinds of meat, many vegetables, and desserts. One nineteenth-century diner reported that a single meal included "soup, veal, turkey, tongue, fish, veal's head (drest turtle fashion)." A dinner at the house of Harriet's father, Benjamin Chew, offered another glimpse of contemporary entertaining. John Adams recorded a meal of "Turtle and every other thing. Flummery, jellies, sweet meats of twenty sorts. Trifles, whipped syllabubs, floating islands … and then a dessert of fruits, raisins, almonds, pears, peaches, wines most excellent and admirable. I drank Madeira at a great rate and found no inconvenience in it."[18]

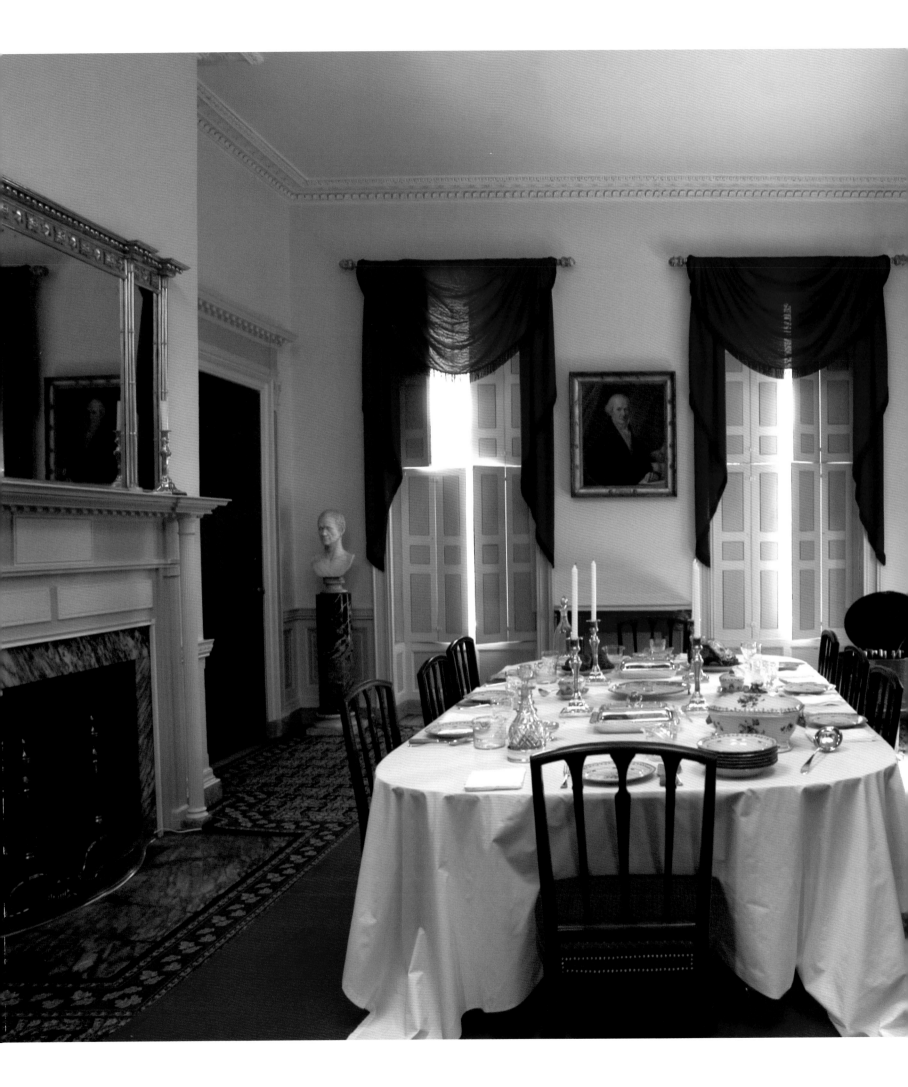

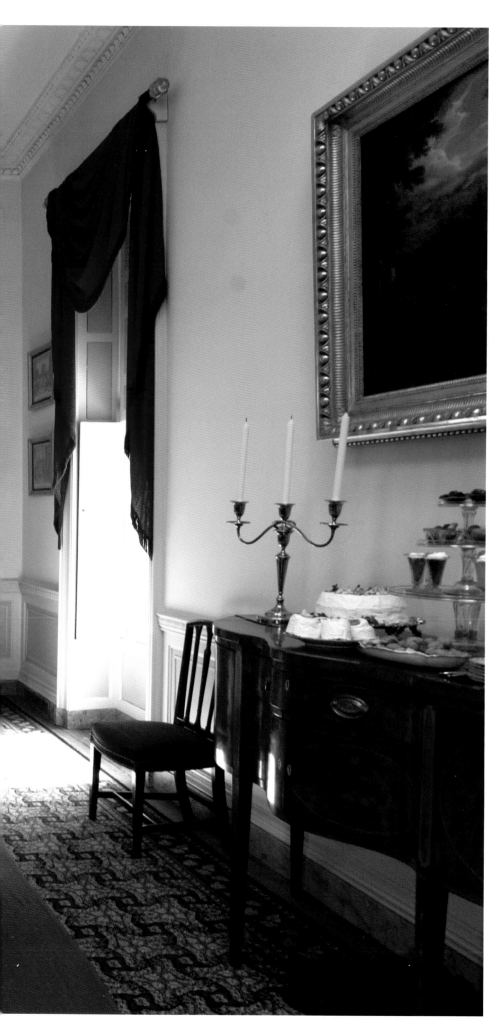

FIG. 54 (*above*). The Dinner
Party, 10 Franklin Place,
Boston, *by Henry Sargent,
c. 1821, oil on canvas.*

Museum of Fine Arts, Boston;
gift of Mrs. Horatio A. Lamb
in memory of Mr. and Mrs.
Winthrop Sargent; 19.13.
Photograph © 2003 Museum
of Fine Arts, Boston.

FIG. 55 (*left*). Homewood's
*dining room is architecturally
similar to the dining room
shown in the Sargent painting.*

FIG. 56. *An abundance
of highly reflective cut glass
added to the glittering
effect of a dinner party.*

Photograph by Carl Schnepple.

The numerous glasses on the table attest to the variety and quantity of beverages served before, during, and after the meal. From the rummer—used for mixed drinks or rum punch—to wine goblets, cordials, decanters, and wine rinsers, cut glass was a way to add sparkle to the table (FIG. 56). Wine rinsers had a lip to accommodate the stem of a wine glass so guests could rinse their glasses between wines.

Two architectural spaces at Homewood were devoted to the proper storage of wines. A wine cellar, located below the reception hall, had a series of arched vaults for storing wines in butts, casks, hogsheads, and bottles (FIG. 58).[19] A Madeira garret was located above the reception hall. This space, within the pediment of the portico and an adjoining anteroom (FIG. 57), was located just below the roof, providing an especially warm environment to help mellow the character of this popular fortified beverage. Madeira was the most highly valued item in Charles Carroll Jr.'s entire inventory, at five hundred dollars, remarkable in comparison to his best stallion colt valued at one hundred dollars or books at fifty dollars.[20]

The butler would have decanted the wine from larger containers in the wine cellar or the Madeira garret into green glass bottles or cut-glass decanters for use at the table. After the meal, the ladies usually withdrew to the drawing room for tea and desserts, while the men remained in the dining room to smoke, discuss politics, and consume fortified wines such as port or Madeira.

Americans toasted George Washington's inauguration with Madeira. The preference for Madeira in the colonies began as a result of British taxation policy. In 1665, the British banned the importation of products made or grown in Europe unless shipped on British vessels from British ports. Products from Madeira, an island located seven hundred miles south of Portugal, were exempted from this law, which allowed goods to be imported from Madeira without the added tax.

FIG. 57. *Madeira was the most highly valued item in Charles Carroll Jr.'s entire inventory, at five hundred dollars. Because it was improved by being stored in a warm environment, the Madeira garret located in the south portico pediment would have been the perfect storage solution.*

FIG. 58. *The wine cellar at Homewood, located beneath the reception hall (an unheated space), provided an excellent environment for the storage of other wines. A series of arched vaults helped maintain cool temperatures and proper humidity. The brick facing wall is probably a later addition; the original arches would have extended to the floor.*

Charles Carroll of Carrollton gave specific details of the type of Madeira he wanted and shipping instructions to his English agent, William Murdoch. "I request you to direct your partners in Madeira to ship me the ensuing fall or next spring three Butts of their best, three years old Madeira wine by some vessell bound to Baltimore," Carroll wrote. "These Butts should be made of the best Hamburgs straves, well secured with iron hoops and banded with the letters and mark in the margin of this letter and consigned to Messrs. Caton and Lawton of Baltimoretown. You will of course direct insurance to be made on this wine when shipped."[21]

The popularity of Madeira grew in successive generations. A fortified wine to which brandy is added, Madeira is improved with age and heat—a fact that explains its storage in warm places and its improvement over long voyages across the Atlantic. According to a legend, the value of a trip to the tropics was learned when a cask, forgotten in a ship's hold, returned from a trip across the equator. The wine, now smooth and velvety, tasted better than it had when the ship left. Throughout the eighteenth and nineteenth centuries, producers sent casks of their wines on long voyages to improve the wine's character, leading to the term *vina da roda* (wines of the round voyage).[22]

Sometimes a tea party followed dinner or was planned as a separate event beginning as late as 10:00 P.M.; these evening tea parties were a favorite occasion for men and women in the nineteenth century and could take the form of a small intimate gathering or a bigger, more boisterous party.[23] Another painting by Henry Sargent, *The Tea Party,* shows groupings of elegantly dressed guests in the drawing room and parlor of a Boston town house of the period (FIG. 59). Most evident in the painting is the contrast between the darkness of the night and the glow of the interior. Decorative gilt-framed mirrors and paintings each reflect and amplify the candlelight. An elaborate tea party might feature a spread of desserts, sweetmeats, and fruit along with tea and other drinks. "Cake dressed with frosting. Preserves and other good things for a tea table," wrote Emily Swift of Armenia, New York, about a tea that she gave after a wedding.

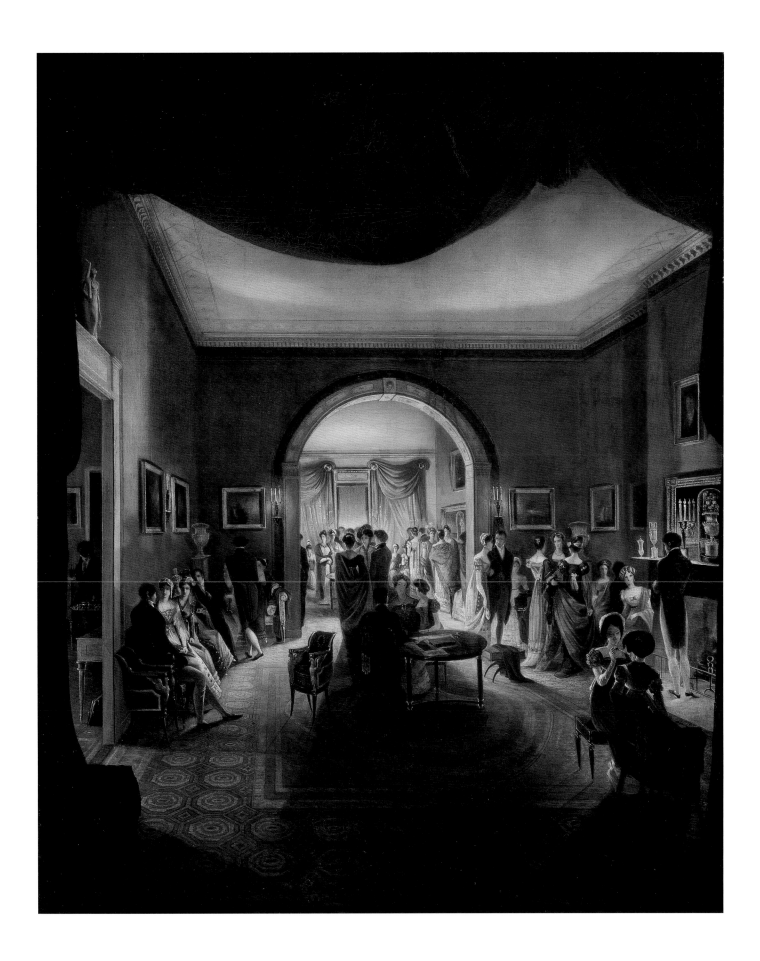

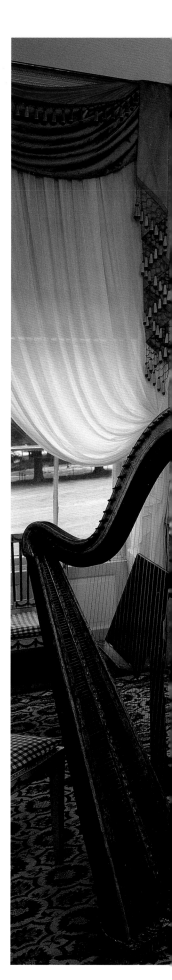

Cake in the middle of the table in form of a pyramid; three other kinds about the table arranged with all the taste I possess. Tea and coffee. After tea the Malaga, tenerife and brandy went freely around, after which almonds, filberts, beechnut, walnuts and apples were served. Our west room after tea was filled with chairs along the sides, the ladies seated. Dancing commenced with music of a violin and two flutes. This lasted until twelve in the evening.[24]

In planning and decorating his country house, Charles Carroll Jr. would have wanted his drawing room to be especially elegant and refined (FIG. 60). It was a space used exclusively for entertaining. He commissioned upholsterer William Stables (1767–1808) to assist in furnishing and decorating his drawing room. Upholsterers, a new occupation at the time, were the interior decorators of the day. Stables advertised that he made bed and window curtains "in the newest and neatest fashion, hanging tapestry, papering rooms … carpets made to any size, with or without borders, feather beds and mattrasses, made in the best manner, confidants, cabriole chairs, Duches and Sophas, done in the neatest and most elegant manner."[25]

Based on English prototypes popular in the 1780s and 1790s, painted furniture emerged as a Baltimore drawing room phenomenon by 1800. Most middle- and upper-class Baltimore houses included at least a few fancy chairs, with larger households sometimes having multiple sets along with other painted furniture. City directories and newspaper ads from the turn of the nineteenth century identify more than twenty fancy and Windsor chairmakers and ornamental painters. Brothers John (1777–1851) and Hugh (1781–1830) Finlay, Baltimore's most famous "fancy chair makers," opened their shop in Baltimore in 1803.[26] Frequent advertisements in Baltimore newspapers elucidate the scope of their business and the objects their shop produced. An important set attributed to their shop consists of ten armchairs, two settees, and one marble-topped pier table, now in the collection of the Baltimore Museum of Art. This set displays views of houses and public buildings of Baltimore. These paintings on each crest rail (and on the skirt of the pier table) are attributed to landscape painter Francis Guy (1760–1820).[27] The earliest known view of Homewood appears on the crest rail of one of the settees.

FIG. 60. The drawing room at Homewood is perhaps the most elegant and refined of the rooms for entertaining. A piano forte and harp may have been among the furnishings; the education of the Carroll girls would have included musical instruction. The painted furniture now in the room was originally for Druid Hill, the country house of Nicholas Rogers, and is on loan to Homewood from the Maryland Historical Society.

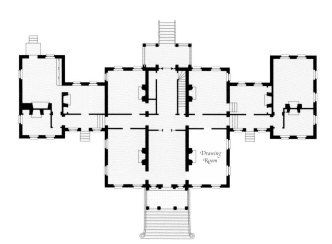

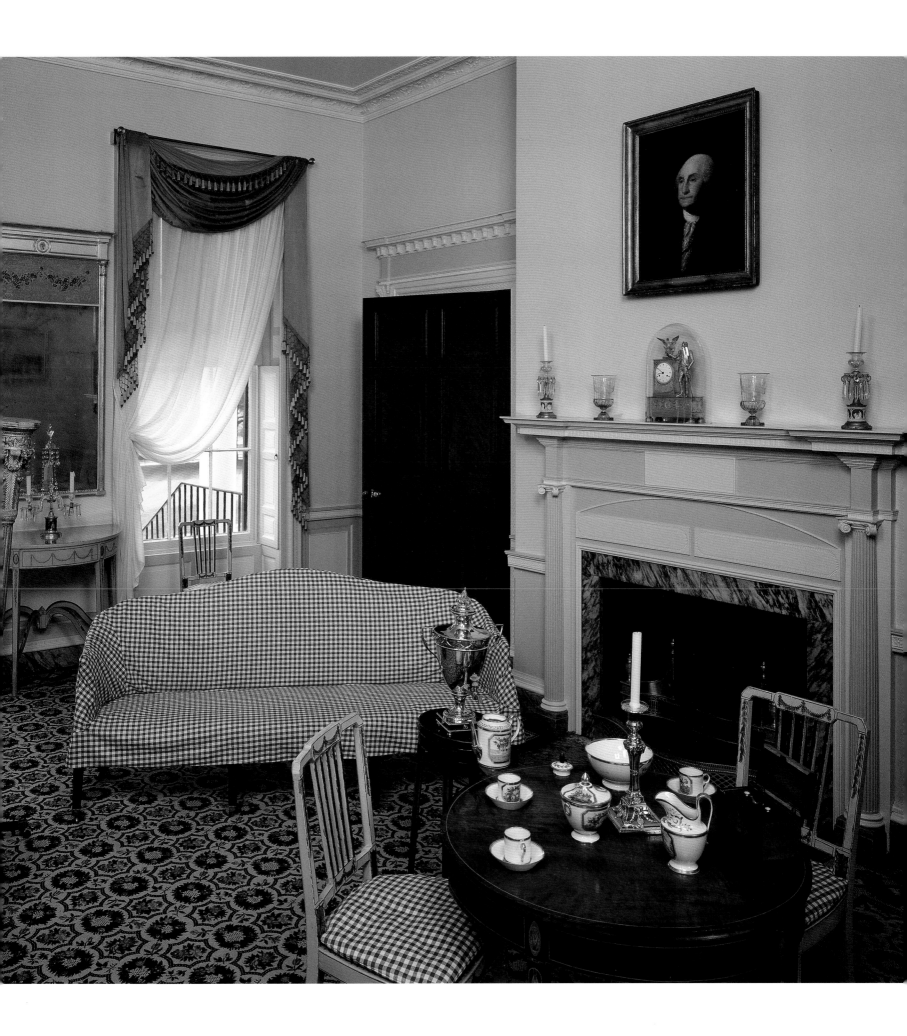

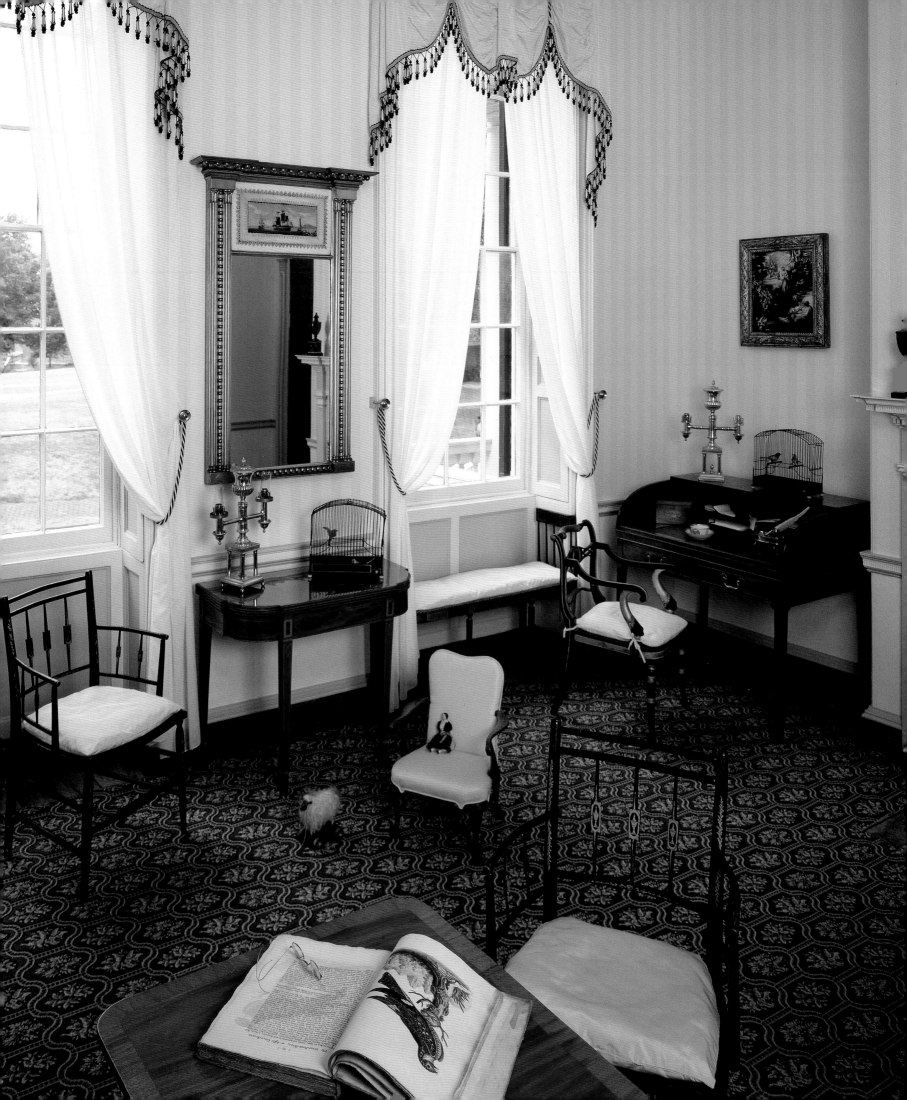

Another elegant feature of the drawing room would have been imported musical instruments. An entry in the account book Charles Carroll of Carrollton kept to record his son's expenses includes "To this sum pd for Forte Piano … $300" on 18 August 1812. A forte piano represented a significant expense and was probably for the education of the Carroll daughters. Music was an important part of the education of young women in the early nineteenth century, and musical instruments and virtuosity were an expression of refinement and gentility. Charles Carroll of Carrollton ordered a harp from England for another granddaughter, writing, "as it is intended for a present to Miss Emily Caton; I wish it to be of the best quality."[28]

A portrait of George Washington may also have been among the drawing room furnishings and was the "good company" referred to by Charles Carroll of Carrollton in his letter regarding his own portrait. He went on to say, "I greatly esteemed the living Washington and I shall revere his memory as long as I live."[29] After Washington's death on 14 December 1799, the nation went into mourning for their first president. The tremendous quantity of prints, ceramics, needlework, and other decorative arts objects produced reflected the pervasive respect and admiration for this most significant leader. Portraits of Washington were not uncommon before his death, but afterward artists such as Gilbert Stuart were so overwhelmed by demand for portraits of Washington that they employed many assistants in their studios to fill orders. The most prominent and likely placement of this portrait would have been the drawing room; period inventories show Washington portraits in the drawing rooms of prominent citizens across America.

The back parlor, or family sitting room, is less formal than the drawing room and has more understated architectural detail (FIG. 61). The family may have gathered and dined here. The location of the room in the northwest corner of the main block of the house would have captured the last light of day, perhaps making it a favorite room for late afternoon use. A fish bowl and bird cages would have made stylish additions to the room. Although no pets have been identified in family correspondence, goldfish, birds, and squirrels, as well as cats and dogs, were popular companions for children

FIG. 61. The location of the back parlor in the northwest corner of the main block of the house would have captured the last light of day, perhaps making it a favorite room for the family gatherings in the late afternoon. The Carrolls may have used this room for informal dining, reading, games, and other family pursuits.

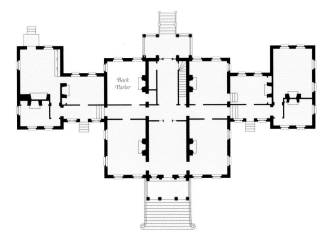

in the early nineteenth century. Games including cards, backgammon, dominoes, and charades were typical family entertainment. The room may also have served as an elegant schoolroom for the children, instructed either by their mother or by tutors. Subjects might have included history, geography, arithmetic, and languages such as French or Latin. Education also included music, dancing, and art. The girls would have received instruction in needlework that served both practical and artistic purposes. Charles Carroll of Carrollton's account book includes an 1816 entry for a tuition payment of $86.66 to a tutor, Bacconnais, for lessons for his son's daughters.[30]

Reading was another pastime suited to the back parlor. Charles Carroll Jr.'s 1825 inventory notes a "Book Case" valued at twenty dollars, representing a significant piece of mahogany furniture; another item is "Books" valued at fifty dollars, more than double the value of the bookcase itself.[31] Prints, sometimes bound as books, were decorative and educational and served as a point of conversation. "Six Prints of Shakespeare," at two dollars, undoubtedly refers to a series done by Boydell, who operated the Shakespeare Gallery in London. His series of prints illustrate the plays of Shakespeare, which were wildly popular in the period. Other Marylanders, such as the Lloyds of Wye and Annapolis, owned many of these prints, having ordered them in gilt frames with black glass mats.[32] The Ridgelys, the Howards, and others all owned similar prints from this series. Hugh Thompson, who lived on the property adjoining Homewood, Liliendale (the estate from which the Homewood property was divided), purchased six Shakespeare prints in March 1797. Charles Carroll Jr. seems to have been particularly fond of Shakespeare's works and owned a six-volume set. A letter from John Eager Howard recounts the unfortunate story of an intoxicated Charles Carroll Jr. quoting from a character and a play with which he obviously identified.[33]

The other furnishings of the back parlor include a sofa, a sofa table, and chairs. An English neoclassical armchair is the only piece of furniture that has descended with a tradition of original ownership at Homewood (*see* APP. C, CAT. 5). It represents the high-style imported English furnishings available in Baltimore and perhaps pre-

ferred by the Carrolls.[34] A roll top, or tambour, desk with an adjustable writing sur-
face would have provided workspace for correspondence. The back parlor may
have also included a family portrait, such as the oval portrait of Charles Carroll of
Annapolis (1702–82) (*see* APP. C, CAT. 16) attributed to or possibly after John Wol-
laston (flourished 1736–67).[35]

Overnight visitors to Homewood may have stayed in the best guest chamber, or
Chintz Chamber, the northeast room of the main block (FIG. 62). Floral papers were
a popular choice for bedchambers of the period and, in conjunction with a floral
carpet and floral window treatments and bedhangings would have created a styl-
ish albeit dizzying effect. Presumably, if it was all floral and all of the best quality,
it all went together. It is likely that the Carrolls would have chosen similarly.

The high-post tester bed, with its trundle bed and bed steps, in the best guest
chamber descends with the tradition of original ownership by Charles Carroll of
Carrollton (*see* APP. C, CAT. 6–8). The mattress, supported by rope, would have been
made of curled horsehair (steam was used to curl mane and tail hairs).

An adjoining room, the side chamber, may have been used as a dressing room
(FIG. 64). The location of the room in the east hyphen, along with architectural clues
like the built-in bookshelves flanking the fireplace, point to the possibility of the
room's common use as an office for Charles Carroll Jr. The hyphen doors are
located across from the side chamber and would admit light and air to the east end
of the house. The bookshelves on either side of the fireplace have doors that could
be closed and locked to protect valuable books from dust and theft. Their prox-
imity to the fireplace would allow radiant heat to help keep the books dry, pre-
venting rot, mildew, and infestation.

Charles Carroll Jr. purchased many books and subscribed to the *American Regis-
ter,* a literary and political journal. One volume cost three dollars, payable upon
delivery. The magazine provided "a sketch of the political history, foreign and
domestic, of the six months preceding" and set out "to illustrate the peculiar genius
and manners of the American people" (FIG. 63). The volume included reports on the

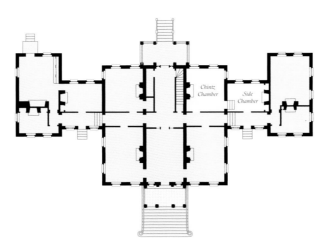

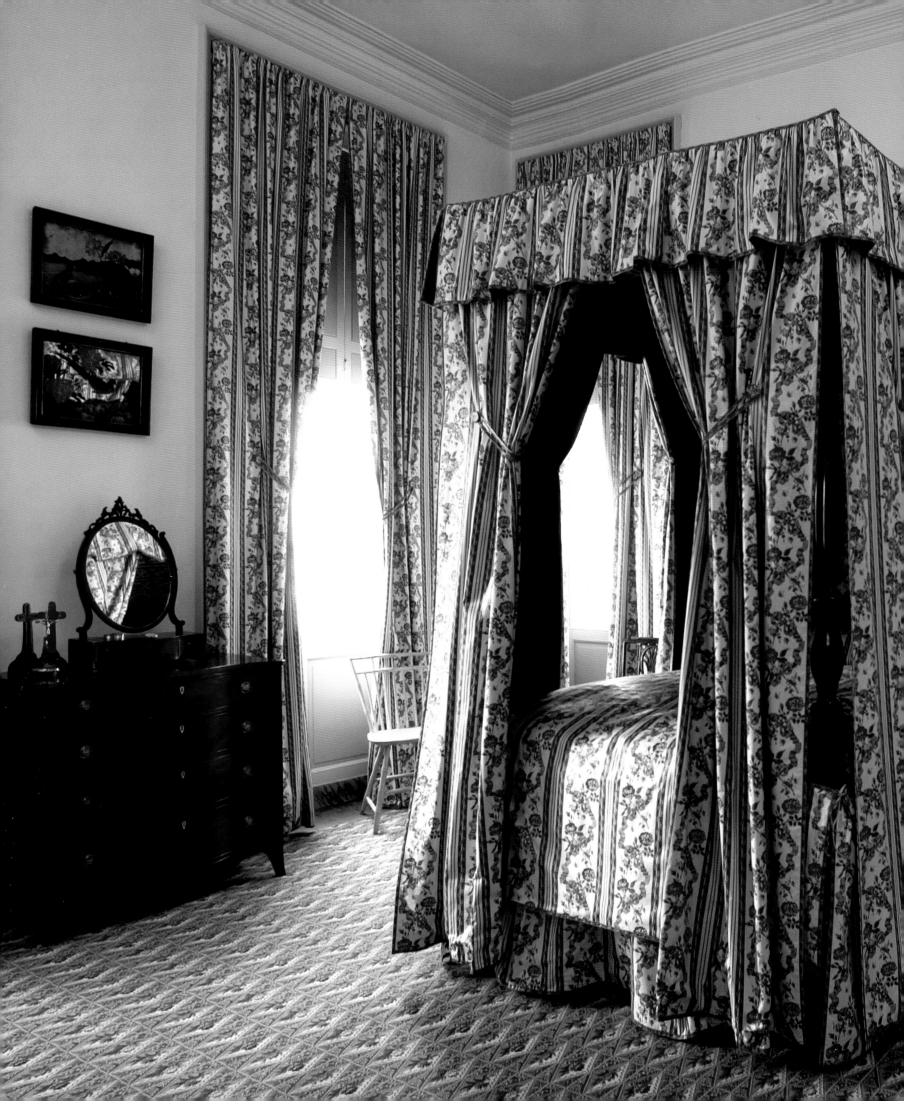

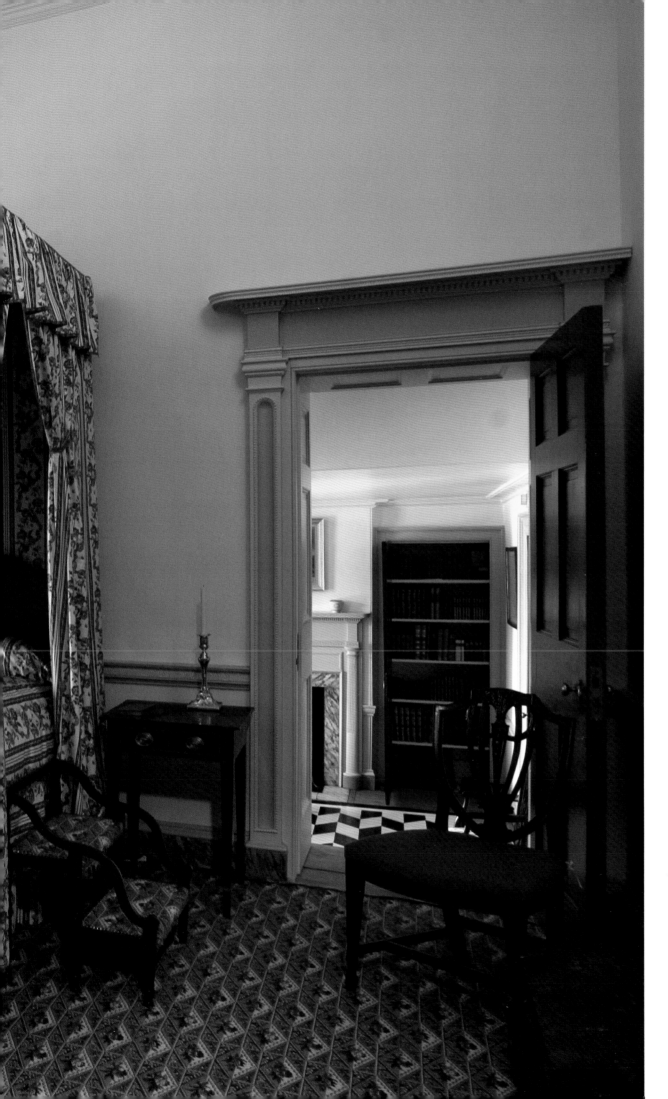

FIG. 62. *The best guest chamber, the northeast room of the main block, may have been offered to important visitors, along with the adjoining room for use as a dressing room.*

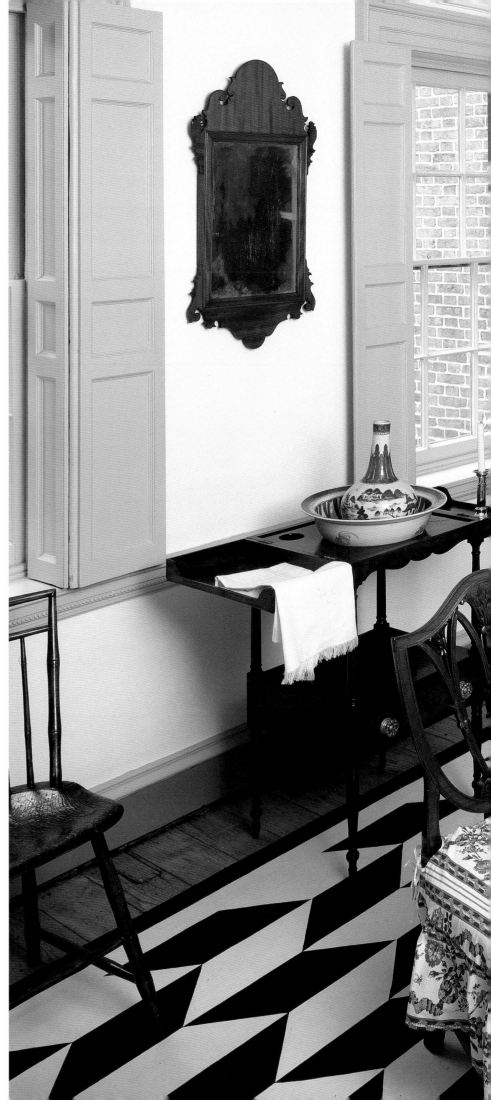

FIG. 63. *The frontispiece of the* American Register, *a literary and political journal, published in 1817 bears the signature "Charles Carroll, Jr.," making the book the only object currently identified as having been owned by him.*

FIG. 64 *(right). Besides its occasional use as a dressing room, the side chamber most likely functioned as an office for Charles Carroll Jr. Built-in bookshelves flanking the fireplace support the theory of this use.*

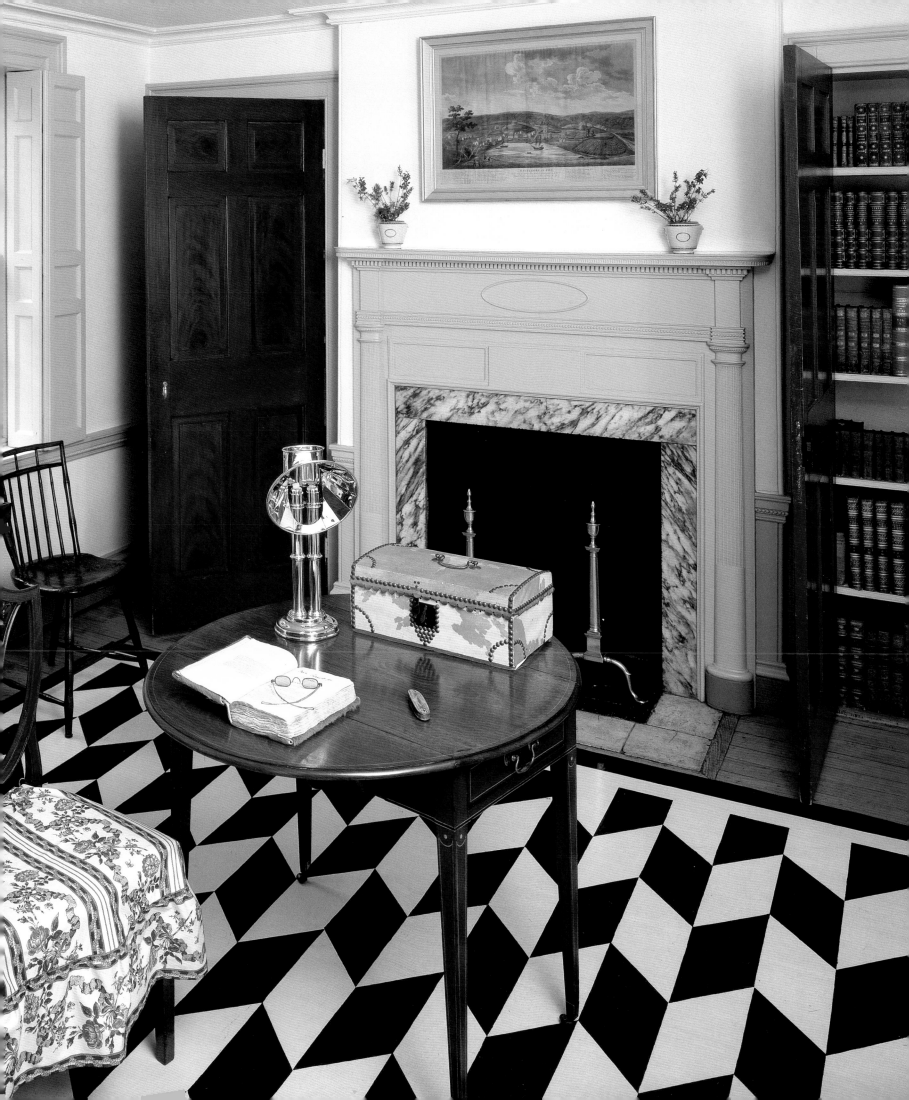

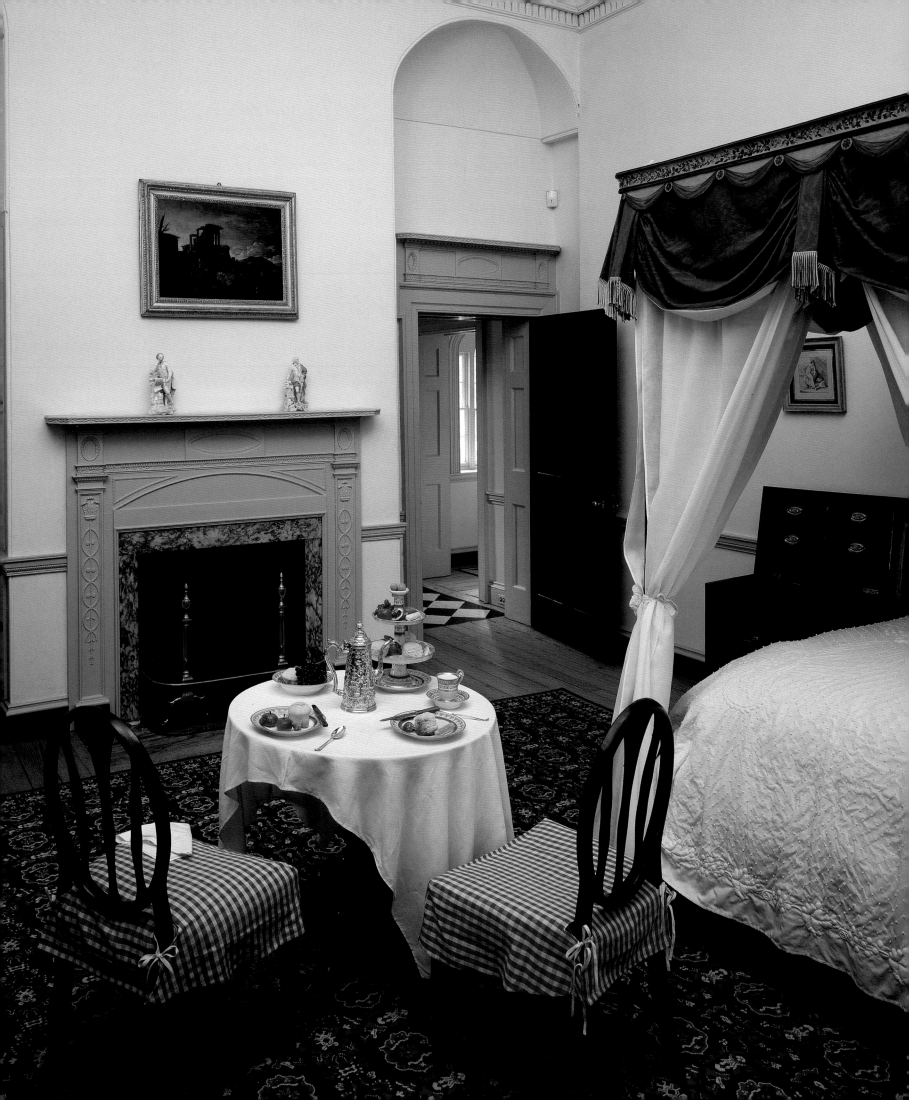

proceedings of the House of Representatives and the Senate, as well as medical miscellany and obituaries of noteworthy citizens, including his cousin John Carroll, archbishop of Baltimore. The frontispiece bears the signature "Charles Carroll, Jr.," making this book the only object currently identified as having been owned by him (*see* APP. C, CAT. 23).[36]

A letter from Charles Carroll of Carrollton addresses his son's exorbitant book purchases. "If I am to form a judgment of your character and disposition from the past, these books [which] you have imported without my knowledge or at least approbation, were intended more to decorate your book-case than for you." An 1832 inventory of "the library at Homewood," taken by Charles Carroll III (1802–62) of what was primarily his father's collection of books, illuminates Charles Carroll Jr.'s range of interests. The list includes a set of Shakespeare's works and several books by the poet Jacques DeLille, known as the "French Virgil," reflecting Carroll's classical education and taste. The presence of French authors and French-language titles, including Racine, Molière, Y. B. Rousseau, Montesquieu, and Pascal, was evidence of his knowledge of the language. There were also Latin and French dictionaries, books on mineralogy, *Polite Learning*, and *Endless Amusements*.[37]

The master bedchamber and adjacent dressing room occupy the east wing of the house (FIG. 66). This bedchamber is perhaps the most elegant room in the entire house; its high, vaulted ceiling is decorated with a large acanthus leaf medallion (FIG. 65). The elaborately carved woodwork is especially elegant for a bedchamber. Bedchambers provided an additional space in which to entertain family and close friends—a place to visit and take breakfast, tea, or hot chocolate, a popular beverage in the early nineteenth century. An elaborate repoussé chocolate pot, designed by a French émigré in London, dates as early as 1714, but the repoussé decoration may be an early-nineteenth-century addition (*see* APP. C, CAT. 10).

Other furnishings in the master bedchamber have a Carroll family provenance. The "night table," or commode, was "formed with such a deception as to appear anything but what it really is tho' not troublesome to use," as Charles Carroll of

FIG. 65. *Perhaps the most elegant room in the entire house, the master bedchamber has a vaulted ceiling fifteen feet three inches high, with a large acanthus leaf medallion in the center.*

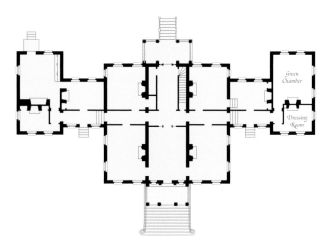

FIG. 66. *The degree of finish in Homewood's master bedchamber is remarkable and gives us insight into the importance the Carrolls placed upon entertaining family and close personal friends.*

Carrollton specified in a letter to William Murdoch. We don't know whether he was referring to this particular example or another, earlier Chippendale style. The commode now in the master bedchamber is based on plate 82 from George Hepplewhite's *The Cabinet-Maker and Upholsterer's Guide* but includes an interesting and innovative advance in technology. A lead-lined water tank and brass flush mechanism would rinse the chamber pot below, an improvement over common practice.

A traveling writing desk with inlaid brass stringing and a shield engraved with the Carroll crest was helpful in keeping up with correspondence while traveling or allowed one to work from a more comfortable spot, perhaps even while in bed. Charles Carroll Jr. hoped that John Eager Howard would "attribute the messiness of [his] writing to nothing other than that [he was] at his desk, in his bed."[38] This reference attests to this alternate use of a portable desk—tending to correspondence from the comfort of one's bed (FIG. 68) (*see* APP. C, CAT. 20).

The adjacent dressing room was used for bathing, dressing, reading, or writing (FIG. 67). A curious closet, nine feet off the floor and obviously accessible only by ladder, may have been used for seasonal storage. A small, built-in cupboard with shelves could have been used as a bookcase, medicine cabinet, or dispensary. This room may have been used by Harriet Carroll as a sitting room, where she could do needlework, write correspondence, or read and write poetry.[39]

FIG. 67 (opposite). The dressing room adjacent to the master bedchamber was used for bathing, dressing, reading, or writing. Located in the southeast corner of the house, this small room would have been flooded in morning light.

FIG. 68. A box desk was helpful in keeping up with correspondence while traveling or working from a comfortable spot. A letter from Charles Carroll Jr. to John Eager Howard mentions his writing from bed.

Photograph by Carl Schnepple.

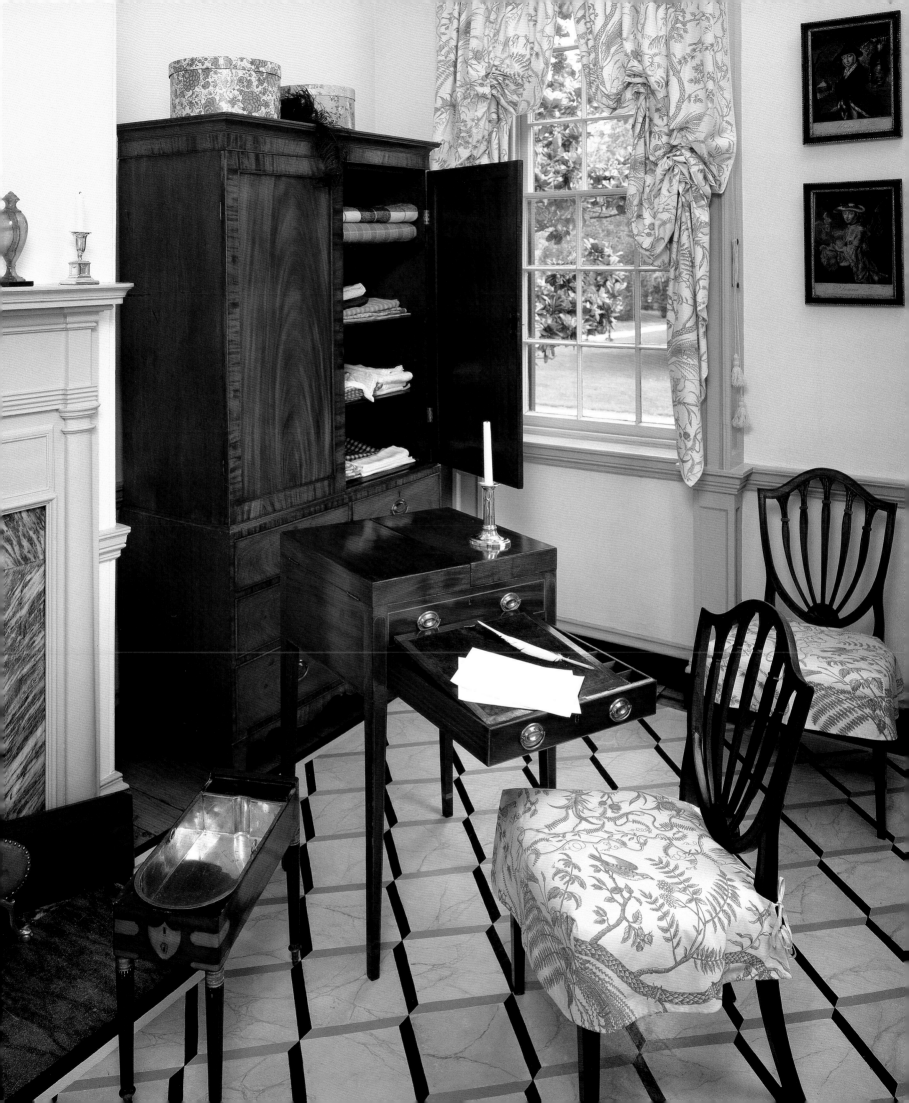

FIG. 69. The second floor is now used for staff offices, archives, and object storage. The architectural detail is less elaborate than that of the first floor; similarly, the furnishings would have been simpler, in keeping with the probable use of the space by the family's children.

The second floor is accessed by a narrow stairway off of the back hall. Upstairs, four chambers open onto a spacious central hall that would have made an ideal play space for the children (FIG. 69). A skylight and dormer windows light the rooms. Across from the stairway is the only second-floor chamber with a fireplace. On a cold evening, the housekeeper and children may have gathered into shared quarters in the northwest chamber. The second-floor walls begin to slant inward at three feet off the floor, making for tight headroom and necessitating the use of low-post beds.

Behind the scenes, servants made elaborate entertaining possible. Nancy Ware, an indentured servant who came with Harriet Chew Carroll from Philadelphia, was the housekeeper. She would have been responsible for management of the other household servants (FIGS. 70 and 71). The west hyphen room may have served as her bedchamber as well as a workspace in close proximity to the kitchen. She would have worked closely with Mrs. Carroll, and her duties as housekeeper included procuring food and household supplies, planning meals and overseeing their preparation, housecleaning, laundry, and perhaps acting as a companion and caregiver for the children.

The housekeeper and the butler, whose pantry was also located in the service wing of the house, would have shared responsibility for household management (FIG. 72). Polishing silver—with whiskey and whiting (a form of chalk)—was one of the butler's most time-consuming tasks. The butler was also responsible for maintaining the wine cellar and the Madeira garret.

The kitchen had such modern conveniences as an oven and possibly a system for the collection of rainwater. The innovative design of the original roof allowed rainwater to be easily collected and perhaps piped to the kitchen. A well was located just outside the kitchen and would have been another convenient source of water for cooking and laundry. A large shelf to the left of the chimney stack may have supported an additional cistern for unheated water. This shelf, along with clear "ghost marks" on the wall, were evidence for shelves that have been recon-

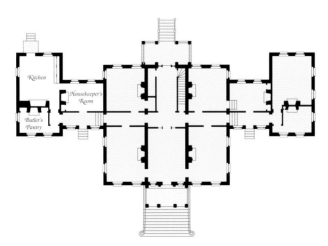

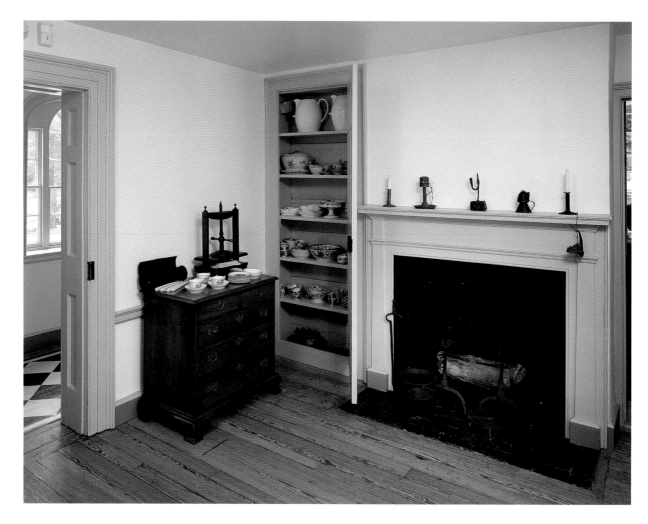

FIG. 70. The housekeeper's room is located in the west hyphen and is connected to the kitchen. Nancy Ware, a white indentured servant, would have been responsible for meal planning, oversight of other house servants, and perhaps even providing care for the Carroll children.

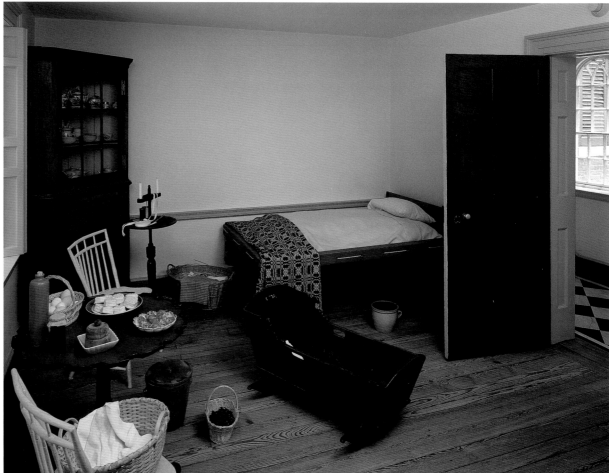

FIG. 71. The housekeeper's room may have also been used as her bedchamber. A folding bed would permit more flexible use of the room as a workspace and a bedchamber.

FIG. 72 (opposite). The butler's pantry is also located in the service wing of the house.

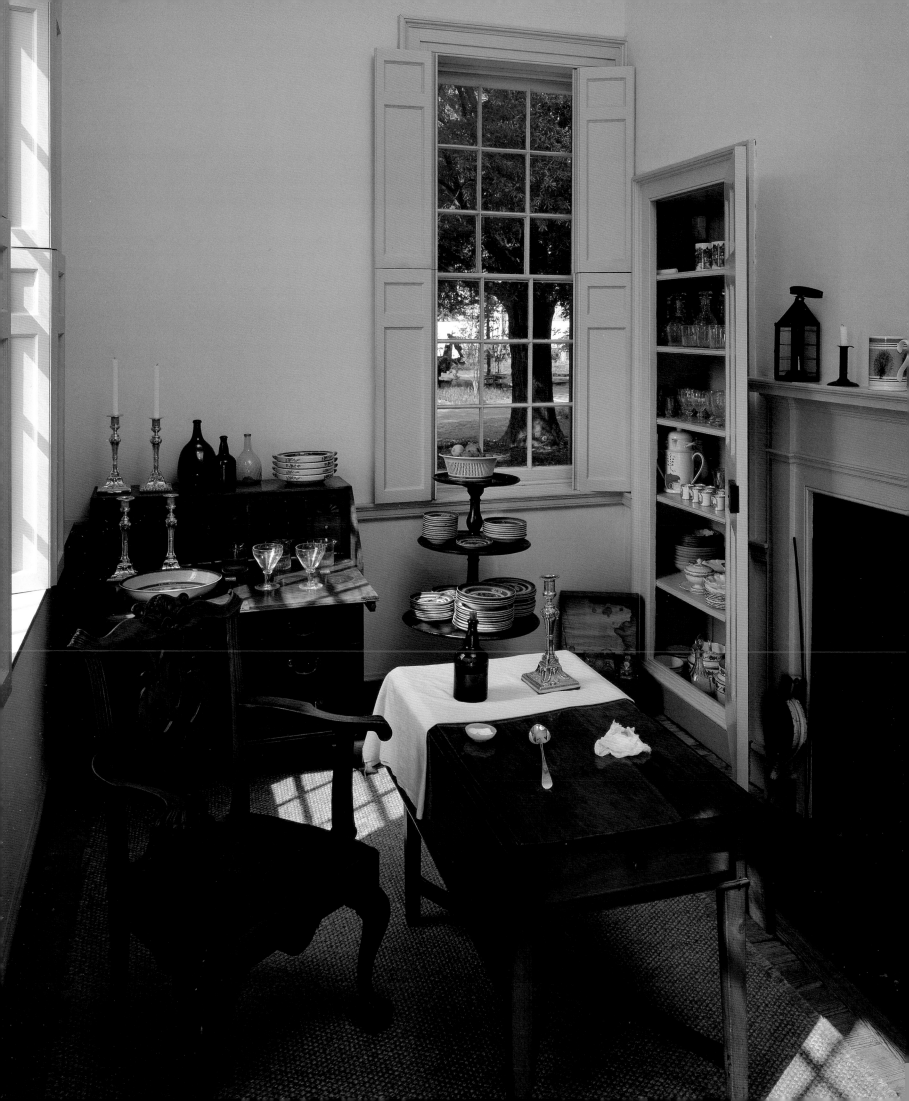

Fig. 73. *"Ghost marks" on the wall (top) provided evidence for kitchen shelves that have been reconstructed in their original location (bottom).*

structed in their original location (FIG. 73). Provisions, foodstuffs, crocks, kettles, and baskets were among the frequently used items that may have been stored on the shelves.

Sixteen slaves were included in the inventory taken at the time of Charles Carroll Jr.'s death (*see* APP. A), but there were probably more on the property during the construction of the house and the more labor-intensive planting and harvesting (FIG. 74). Several Carroll slaves learned skilled trades. Although the 1825 inventory did not mention the trades of Israel, Cis, Caesar, or Kezziah, letters from Charles Carroll of Carrollton to his son hint at both the movement of slaves between Carroll properties and the specialized skills of the slaves.

The agricultural production of the farm, which included vast acreage of wheat and corn, relied upon slave labor. An overseer would take responsibility for the daily direction and management of the slaves. The Carrolls were among the largest slaveholders in Maryland, and they took care not to separate slave families.[40] In this practice Charles Carroll of Carrollton was following his father's advice. Slaves are listed within their family groups, with notation of their ages and relationships, in the 1832–33 slave inventory. Although no architectural evidence survives, the slaves at Homewood probably lived in separate quarters on the property. It is possible that some of the household servants lived in the house, most likely in the four rooms in the cellar. The use of these rooms remains a mystery; the cellar rooms were well lighted because Homewood's plan included a raised basement. Each room has windows that would have allowed natural light and good ventilation. These would have certainly been the coolest rooms in the house and may have been used for additional bedchambers, workspace, and storage.[41]

The largest room in the basement is the wine cellar, located under the reception hall. This would have been the coolest of the basement rooms and is a typical location for wine cellars in eighteenth- and

FIG. 74. *A slave census taken by Charles Carroll of Dough-oregan on 1 January 1834 enumerates the slaves and their trades, relationships, ages, and current locations. Some slaves remained at Homewood and in Baltimore in 1834, after the deaths of both Charles Carroll Jr. and Charles Carroll of Carrollton.*

The Maryland Historical Society, Baltimore, MHS363.

FIG. 75. *At Harlem, a country*
house near Baltimore, painted
furniture is being used in the
gardens. The painting is so
incredibly detailed that it is
possible even to determine
the various species planted in
the lush and verdant garden.

Harlem, the Country House of Dr.
Edmondson, Baltimore, by Nicolino
Calyo, 1834, gouache on paper.
Winterthur Museum, 68.60.

early-nineteenth-century houses, although few actually survive. A reception hall was rarely heated and was one of the few rooms without a fireplace. The absence of chimney stacks would ensure the most agreeable condition for the proper storage of wine. The original floor of the wine cellar, brick laid in a herringbone pattern, would have helped to maintain the cool climate. Architectural evidence shows that two additional arched storage bins were removed, probably in the mid- to late nineteenth century, to accommodate a modern heating system.

The Homewood property produced timothy hay, rye, oats, and livestock including hogs, cows, and chickens.[42] A small kitchen garden was planted at the west end of the house. Vegetables, fruit, and herbs were probably grown in this garden, providing much of the produce for the family. No single Carroll family property was entirely self-sufficient but, collectively, through sharing the products of their farming activities, the Carrolls would have needed to purchase little from others. Carroll family farms exchanged seeds, produce, and even the enslaved labor force between the properties. "I will let you have as many oats as I can conveniently spare when they are thrashed out and measured," Charles Carroll of Carrollton wrote to his son in July 1802. "You should have given notice earlier that you wanted timothy seed … If you send for 16 bushels of rye, you shall have them, but give me a week's notice when you want this rye for seed."[43]

Formal gardens were located immediately to the north of the house and complemented the plan of the house and its interior spaces. During the summer months, the gardens could have extended the entertaining spaces of the house. Stylish, lightweight, easily portable painted furniture from the back hall could be carried into the gardens to provide seating for outdoor conversation and relaxation. A painting of Harlem, the Baltimore country house of Dr. Edmondson, shows high-style Baltimore painted furniture in use in the gardens (FIG. 75).[44] The formal gardens at Homewood may have been planted with roses and grass pathways; family letters document Charles Carroll Jr.'s interest in gardening and even his skill in grafting roses. At the edge of Homewood's formal garden is the privy, which

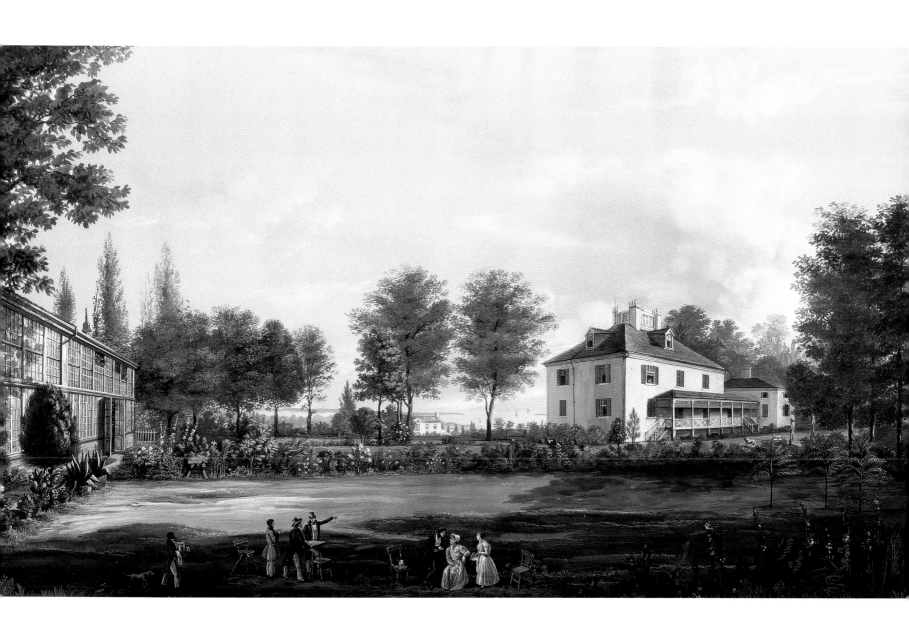

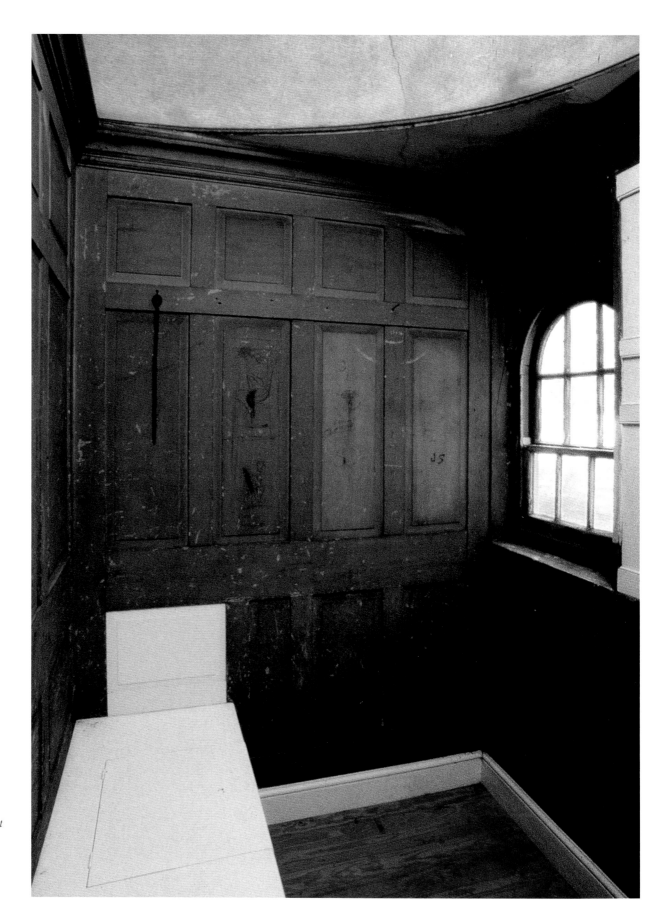

FIG. 76. *The walls of the privy are paneled in chestnut and painted* en grisaille, *in imitation of stone. The domed ceiling is an unexpected and elegant detail.*

marked the boundary of the orchards, planted with apples, seckle pears, and peaches. The location of the privy, seemingly random, actually represents a sophisticated mathematical plan. The overall 128-foot length of Homewood appears to have been used as the radius of a circle whose center is 128 feet from the north porch. The privy falls on the circumference of this circle (FIG. 77).[45]

The privy, built at the same time as the house, is a remarkable survival. Also brick, with a pyramidal roof, it was not as skillfully executed as the house itself; it may have been the work of an apprentice brickmason. It was constructed in common bond rather than the more stylish (and expensive) Flemish bond of the house (FIGS. 78 and 79). For a privy it is surprising in its permanence and its plan. Many nineteenth-century privies were frame (wood) construction, temporary structures designed to be relocated after several years' use. The brick structure and its carefully sited location indicate the permanent concept for the building, and the "pits" below each seat are lined in stone. The privy could be "sweetened" by the addition of lime. The ten- by thirteen-foot plan is commodious and is divided in half, with separate rooms for men and women, each with its own entrance. The walls are paneled in chestnut and painted *en grisaille,* in imitation of stone (FIG. 76).[46]

FIG. 77. *The location of the privy is part of a sophisticated mathematical plan. The overall 128-foot length of Homewood appears to have been used as the radius of a circle with a center point located 128 feet from the north porch. When a circle is inscribed with this center point, the privy falls precisely on the circumference of the circle.*

Based on a drawing by W. Peter Pearre, A.I.A., Trostel & Pearre, Architects.

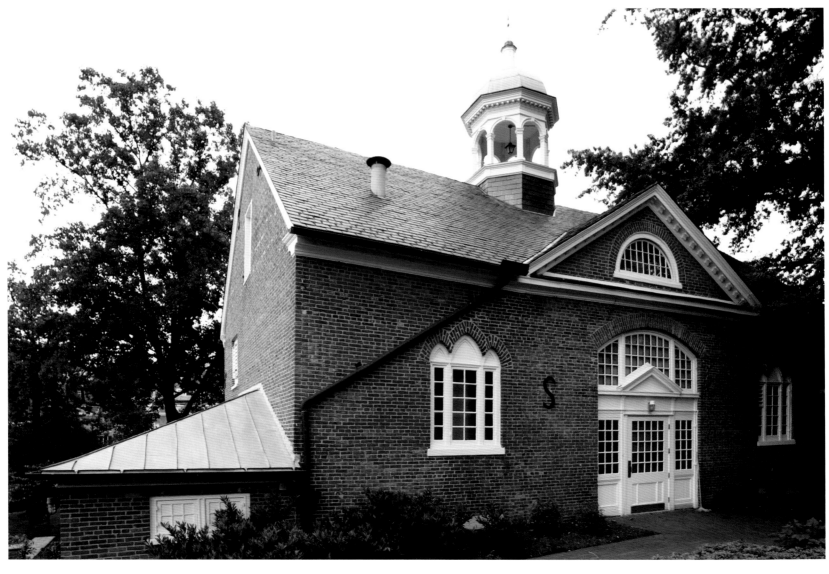

The other original outbuilding extant on the property is either the "coach house" or "stables," both mentioned in the 1817 advertisement "TO RENT" Homewood.[47] Located southwest of the house, the carriage house is built into the bank so that from the house it appears to be a story and a half. The far side of the structure is a full two and a half stories and probably provided access for horses and carriages; the upper floor may have been used to store hay. Stylistically, the brick carriage house, stable, or barn uses the Gothic as a counterpoint to the highly classical design of Homewood (FIG. 80). The elaborate and open cupola and windows with Gothic arches are decorative details suggesting that the building was intended as a folly, an architectural curiosity. The siting of the stable was playful, mathematical, and practical. Its location, 342 feet west and 399 feet south of Homewood, bears a mathematical relationship to the house. Both distances are divisible by 57, the length of the main block of the house.[48] It was practical that the stable was near the house, so horses could be harnessed and hitched and a carriage could be easily brought to the south portico. When viewed from the house, the stable would have provided a point of whimsy within the landscape. It may also indicate the location of the original approach to the house.

Nineteenth-century Americans used alcohol for pleasure and medicine for conditions both physical and mental. A traveling case of bottles stored all the fortifications one might need while enduring the arduous conditions of travel (FIG. 81). Physicians recommended alcohol as a tonic to ease pain, quiet nervous conditions, ease depression, and cure coughs and general malaise. Charles Carroll of Carrollton promoted the use of Madeira as a remedy, noting that a doctor had prescribed drinking a bottle of Madeira wine over the course of twenty-four hours for a family friend suffering from nervous disorders. From that time she took a favorable turn, and she recovered in the course of ten days.[49]

Although consumption of alcohol was part of everyday life in early America, it was not without its problems. Because water was often contaminated, causing deadly disease, children drank cider or beer with their meals. Overreliance on

FIG. 78 (opposite, left). Detail of privy brickwork, common bond. Common bond brickwork required fewer bricks to run the same square footage and was therefore less expensive than Flemish bond. Photograph by Carl Schnepple.

FIG. 79 (opposite, right). Detail of Homewood brickwork. Flemish bond (above the water table) uses bricks laid alternately as headers and stretchers. Below the water table a variant of common bond is used, with a header course every fifth or sixth row.

FIG. 80. The brick carriage house was sited southwest of the house for playful, mathematical, and practical reasons. This view is of the north side. Photograph by Carl Schnepple.

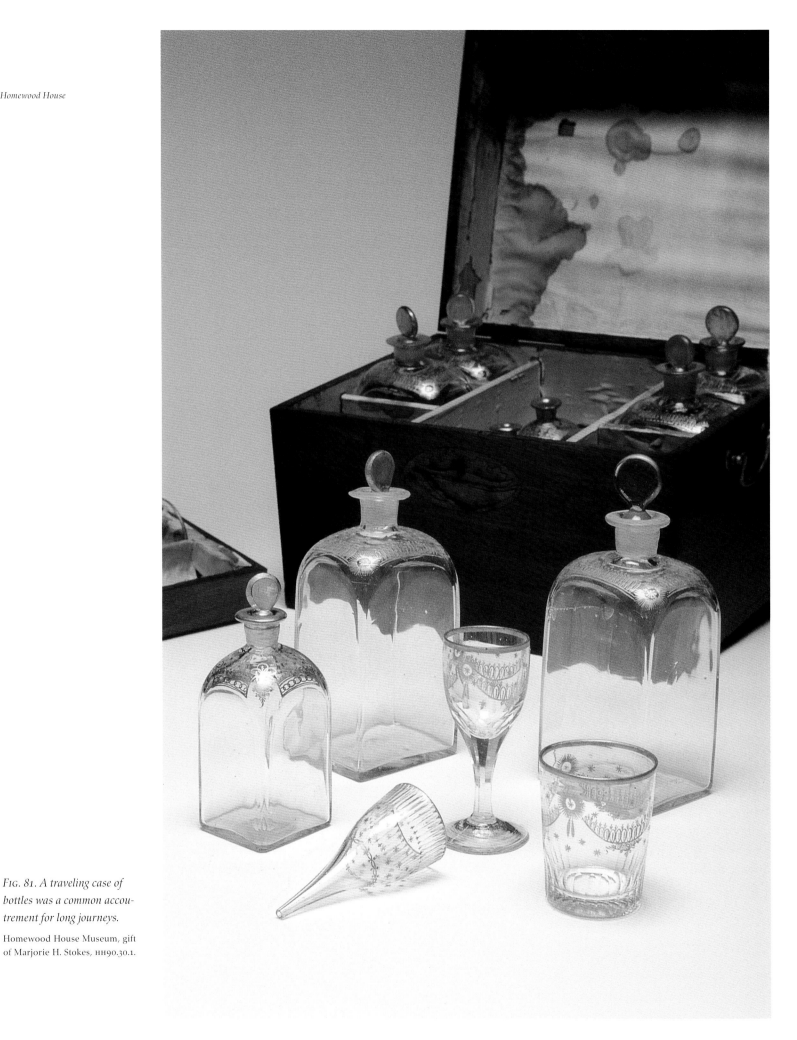

Fig. 81. *A traveling case of bottles was a common accoutrement for long journeys.*

Homewood House Museum, gift of Marjorie H. Stokes, HH90.30.1.

wines and spirits was a risk of prescribing them as a sort of cure-all. The disease of addiction and alcoholism was less understood at the time, but family tendencies were clearly observed. Overindulgence in alcohol by Charles Carroll Jr. was possibly an attempt to self-medicate for mental problems. In 1808 he explained to his father-in-law his assessment of his personal situation. "I should have done long since had I been regularly instituted a man of business, but unfortunately, from having little or nothing to do, I am like most men in my situation—unwilling to do anything or constantly putting off from hour to hour what might be as well done at first as last. This strange spirit of procrastination has gained ascendancy even over my best intentions."[50] Although there was no reference to alcohol, this letter does suggest Charles's hopeless frame of mind. It is unclear whether the lack of responsibility entrusted to Charles Carroll Jr. by his father was the cause or the effect of his despondency.

Unfortunately for Charles Carroll Jr., his dependency on alcohol took its toll on him and his relationships with everyone in the family. His father, over the course of many years, warned him to "abstain from ardent spirits" and to "drink wine only in moderation." Unable to control his drinking, he became increasingly agitated and erratic in his behavior. At a dinner party given by Robert Patterson, Charles Carroll Jr. accused his host of watering down his wine. Her husband's alcohol abuse became the cause of Harriet's extreme unhappiness. "My friends have persuaded me to try the effect of a temporary absence from him, in the hope he may be inclined to think more seriously of the serious consequences of a continued perseverance in error … He has an excellent heart and at times laments the error he has given

FIG. 82. Brandy, a fortified wine, was a popular drink of the time. This English silver bottle tag labeled and decorated the cut-glass decanter.

way to; but he has not firmness to persevere in his resolutions of amendment."[51]

By 1814 it was generally known that Charles Carroll Jr., to his great detriment, drank continuously. John Eager Howard wrote, "I have known persons who could drink large quantities of spirits, but I do not recollect anyone to equal Carroll. I have reason to believe he drinks from one to two quarts of brandy a day, besides wine, and as he is at it before day, as soon as he wakes, and at night, the effect is never off."[52]

By 1816, the couple had permanently separated and Harriet had returned with the children to Philadelphia. During an earlier separation, Charles Carroll of Carrollton had agreed to support Harriet and the children and to pay her a yearly stipend of four thousand dollars to live in Philadelphia.[53] Additionally, he offered her "a portion of the plate," the silver, from Homewood and whatever she wanted of the furniture.[54] After their separation Charles Carroll Jr. descended into deeper depression. Letters between family members indicate that being alone at Homewood exacerbated his condition. He continued to struggle with his addiction in spite of the support of family and friends. His treatment included counseling by his cousin the archbishop, the employment of a caretaker to physically prevent him from drinking, and stays at retreats affiliated with a religious order, such as one at Emmittsburg and one near Annapolis, where he eventually died at age fifty, still trying to conquer his addiction to alcohol.

His son, Charles Carroll III, inherited the property and became master of Homewood (FIG. 83). When his grandfather died in 1832, he assumed responsibility for all the major Carroll landholdings and other assets. In 1833, he left Homewood, moving his family to Doughoregan as their primary residence. He retained the Homewood property until 1838, when it was offered for sale. The purchaser was Samuel Wyman, who pasted in his account book the advertisement for the auction of Homewood, sold by Grundy and Company Auctioneers on 4 June 1838.[55]

FIG. 83. Charles Carroll of Doughoregan (1801–62).

Portrait by William Edward West, 1838–40, oil on canvas, 36 inches × 27½ inches. Private collection of a descendant. Photograph courtesy of the Baltimore Museum of Art.

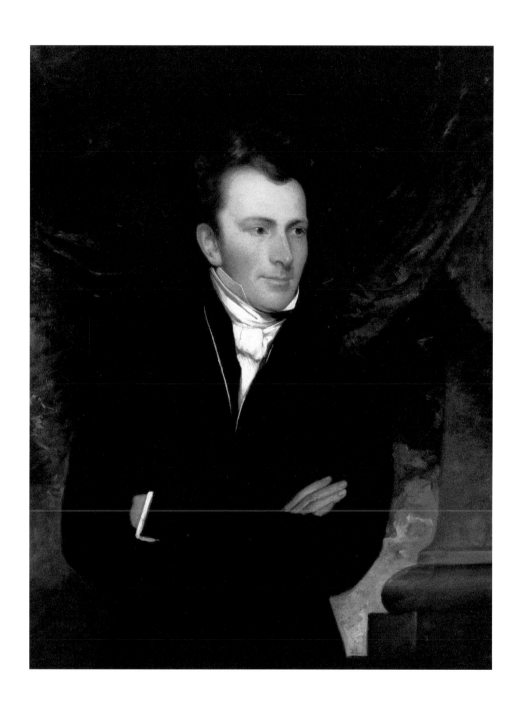

RESTORING HOMEWOOD

THE STORY of Homewood's restoration begins with Samuel Wyman, who recognized Homewood's beauty and architectural significance and left the building unmarred by major additions or renovations. Wyman purchased the house and the surrounding property from Charles Carroll III in 1838, intending to use Homewood as a summer retreat. In 1850, however, Charles Street was extended as Charles Street Avenue, bisecting the property; the noise of passing carriages and streetcars made the retreat less desirable, leading Wyman to relocate to Homewood Villa. This 1851 Italianate residence, built by his son William, stood west of Homewood House, where the university later built an administration building, Garland Hall.[1] The Wymans continued to use Homewood for entertaining and eventually rented the house to tenants for summer residence.

The Wymans' final tenant was the newly incorporated (25 June 1897) Country School for Boys. The school was based on a modern plan, combining the advantages of going to school in a country setting with rigorous course work (as in boarding school) with the ability to return home to the family each evening.[2] The Country School was founded by Anne Galbraith Carey and a board of trustees, who spent the summer preparing Homewood for the first class of thirty-two students, due to arrive on 30 September. Many photographs of Homewood taken during the Country School's occupancy survive in the Gilman School Archives. Some of these photographs include details that were helpful in the restoration efforts undertaken in the 1980s (FIGS. 84 to 86). Mrs. Carey's notes on necessary changes to the appearance of the building provide information on the condition of the house at the time the school began. In one passage she notes the necessity for a new, more subdued paint scheme because of the "shabby condition of such a hideous color." This comment reflects changing taste over the decades of the nineteenth century and may indicate that the original, federal-era paint colors had survived; they would have been not only in bad condition but also in outrageously bad taste by the 1890s. The colors Mrs. Carey proposed were a "rich colonial yellow with white woodwork and ceilings"; she carpeted the house in "dark red" to

FIG. 84. The north porch was used for class photos. One of these class pictures provided documentation for the reconstruction of the porch railing and balusters during the restoration of the house.

Gilman School, Baltimore, Maryland.

FIG. 85. *A photograph of an early student at the Country School for Boys, Tom Scott, shows the north façade of Homewood in 1907. To the left of the porch is a covered walkway, which extended from a streetcar stop on Charles Street.*

Gilman School, Baltimore, Maryland.

coordinate with the furniture, reflecting both her own personal taste and ideas of what would have been appropriate for "colonial" houses.[3] She also believed that appropriate homelike surroundings would inspire appropriate behavior and thus would serve as an additional lesson in decorum. In 1910 the Country School relocated to its Roland Park campus and officially became the Gilman Country School for Boys, renamed in honor of Daniel Coit Gilman, first president of the Johns Hopkins University.

Before the Country School left Homewood, the Johns Hopkins University had become its new landlord. Founded in 1876, the university had a downtown campus and plans to develop a suburban campus at Clifton, the country estate of Johns Hopkins (1795–1873). In his will he had made provisions to found a hospital and a university. In 1895 the Clifton property was sold to the city to generate operating funds and was no longer available to be developed. William Keyser, a university trustee, was challenged to find a new suburban site. He approached his first cousin, William Wyman, still owner of Homewood, about donating the land to the university. Keyser and a group of his friends purchased additional property surrounding the 130-acre Homewood tract. In 1902, the gift of about 179 acres was made to the trustees, and plans for the Johns Hopkins University Homewood campus began. "It requires no prophetic eye to see that in the time to come, this magnificent estate, should you see your way to accept it, will become the center of the intellectual and artistic life of the city," Keyser said in his letter to the trustees.[4]

Homewood became the inspiration for Gilman Hall, the first academic building on the new campus. This important decision to use Homewood as the architectural precedent for the campus ensured the continued survival of the house. The board of trustees appointed an architectural advisory committee, with Frederick Law Olmsted Jr., Walter Cook, and J. B. Noel Wyatt as its founding members, and this committee invited five architectural firms to submit designs for the new campus. A 1904 plan by Parker and Thomas was selected and then revised in 1912. It included the construction of a circular drive off Charles Street. In another plan, the

FIG. 86. *The 1899 baseball team posed on the steps of the east hyphen. The photograph provided details for the recreation of louvered doors for the hyphens.*

Gilman School, Baltimore, Maryland.

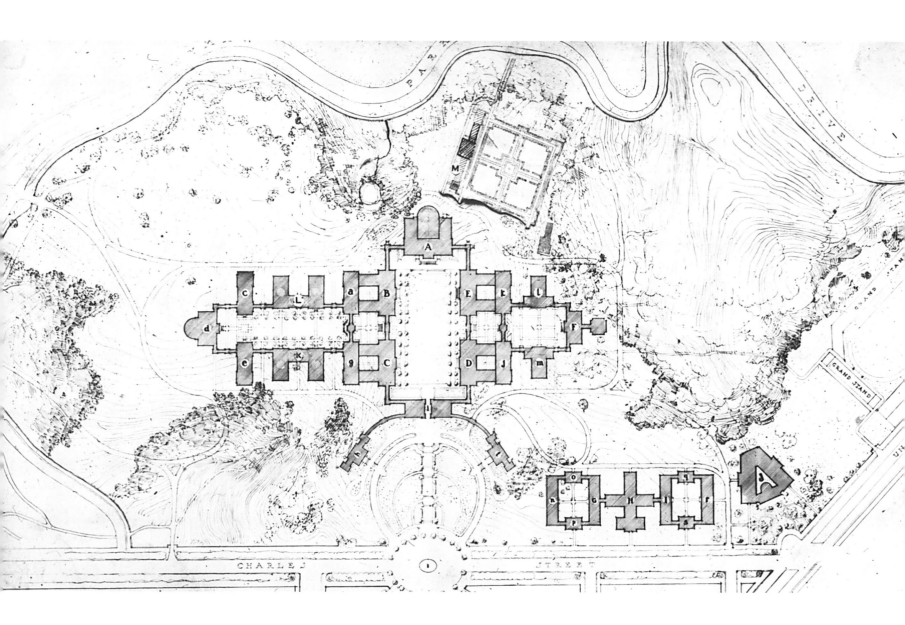

*FIG. 87. An early campus
plan by the Olmsted Brothers
proposed a replica of Home-
wood to be built across the
circle, mirroring the original.
This Homewood look-alike
was never constructed.*

Olmsted Brothers suggested building a replica of Homewood immediately across the circle to mirror the original; it was never built (FIG. 87).[5]

The university found many uses for Homewood before deciding to restore and open the house to the public as a historic house museum. Despite the most commonly held belief that this was, and is, the residence of the president of the university, it has never been used for that purpose. Homewood's earliest use by the university was as the Johns Hopkins Club, a place for faculty and alumni to gather, dine, and socialize. From 1916 to 1929, meals were served and the university president and any notable guests were commonly present. During these years, some graduate students used a few of the rooms as their dorm. One of these graduate students was Robert G. Merrick (FIG. 88).

In 1928, the Friends of Art, a local social and philanthropic organization focused on fine and decorative arts, proposed a two-week exhibition at Homewood of antiques lent by private collectors, whenever possible including those with a Carroll family provenance. President Goodnow assented and the exhibition displaced the Hopkins Club on 9–24 June 1928. A catalog of the exhibition and a series of photographs by Baltimore photographer Harry B. Leopold document the objects, the lenders, and the appearance of the rooms (FIGS. 89 to 91). Many of the objects can be identified through the combination of the catalog and the photographs; many are now in museum collections or are owned by descendants of lenders to the exhibition. The exhibition was an ambitious undertaking, especially for such a brief run, but it was important in suggesting a new use for the house—as a museum. The exhibition catalog and photographs remain useful research tools for identifying and locating original furnishings of the house.

Around 1930, Mabel Brady Garvan and Francis P. Garvan, major collectors of American decorative arts, expressed an interest in restoring and refurnishing Homewood as a museum. They were benefactors of the Yale University Art Gallery, and the bulk of their collections of American decorative arts formed the nucleus of Yale's present-day collection. For the restoration of Homewood, they enlisted the assistance

FIG. 88. *Robert G. Merrick, shown here in his senior photograph in the 1917 Hopkins yearbook* Hulla-baloo, *was the president of the student council, an officer of the cotillion club, and a member of the Beta Theta Pi fraternity.*

The Ferdinand Hamburger Jr. Archives of The Johns Hopkins University.

of R. T. H. Halsey, curator of the American Wing of the Metropolitan Museum of Art in New York, which had opened in 1924. Halsey also served as an adjunct professor at Saint John's College in Annapolis and had always been interested in Homewood.[6] Both couples, Mr. and Mrs. Garvan and R. T. H. and Elizabeth Tower Halsey, researched appropriate paint colors, room furnishings, and window treatments—all of which were made by Mrs. Halsey and Mrs. Garvan themselves (FIGS. 92 to 94). In 1935, university president Bowman proposed the use of "about half of the Homewood House for administrative offices." A 1936 "memo to the file" indicates that, "owing to the recent conversion of some of the rooms in the Homewood House into adminis-trative offices for the university, the number of rooms still open to the public has been somewhat reduced. The entire east wing of the Homewood House, however, is still operating as a museum."[7] Although the Garvans reclaimed some of their antiques as museum rooms were taken off view, many remained and were eventually given to the university upon the Garvans' deaths. These objects were the first to be acces-sioned into Homewood's museum collections.

For more than forty years, from the mid-1930s until the mid-1970s, Homewood was used as administrative offices for the university (FIG. 95). Milton S. Eisen-hower, president of the university from 1956 to 1967, had his office in the east wing bedchamber. F. Ross Jones, vice president of the university and current president of the Homewood Advisory Council, and Steven Muller, provost and later presi-dent during the restoration, had offices in the house. Secretaries and administra-tive assistants used the rooms on the second floor and in the west wing; photo-graphs show fireplaces filled with file cabinets. The quarters were elegant but not especially practical office space, and many university personnel complained of drafts and cold floors. Nevertheless, they were reluctant to relocate their offices as a new investigation of the house began. The architectural significance of Home-wood was formally recognized even before the removal of offices and the begin-ning of restoration efforts; in 1971, Homewood was listed on the National Register of Historic Places and designated a National Historic Landmark.

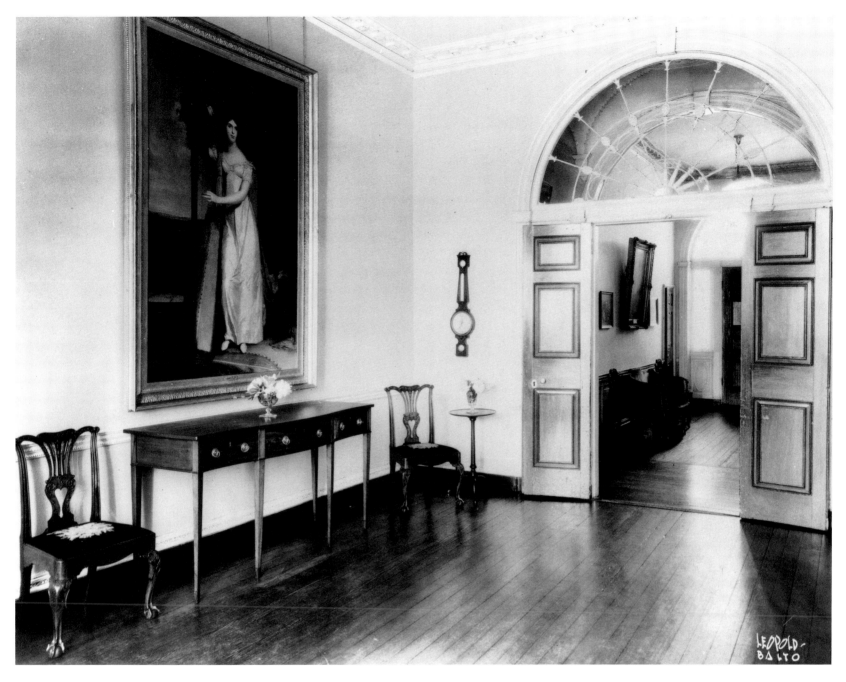
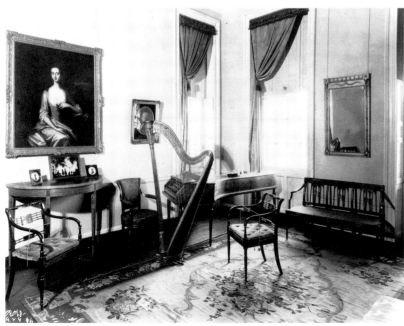
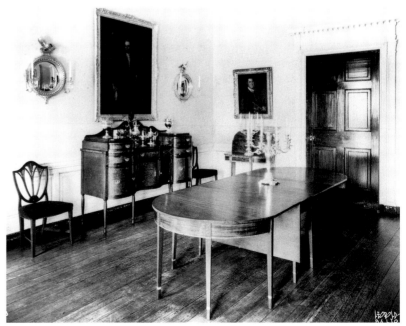

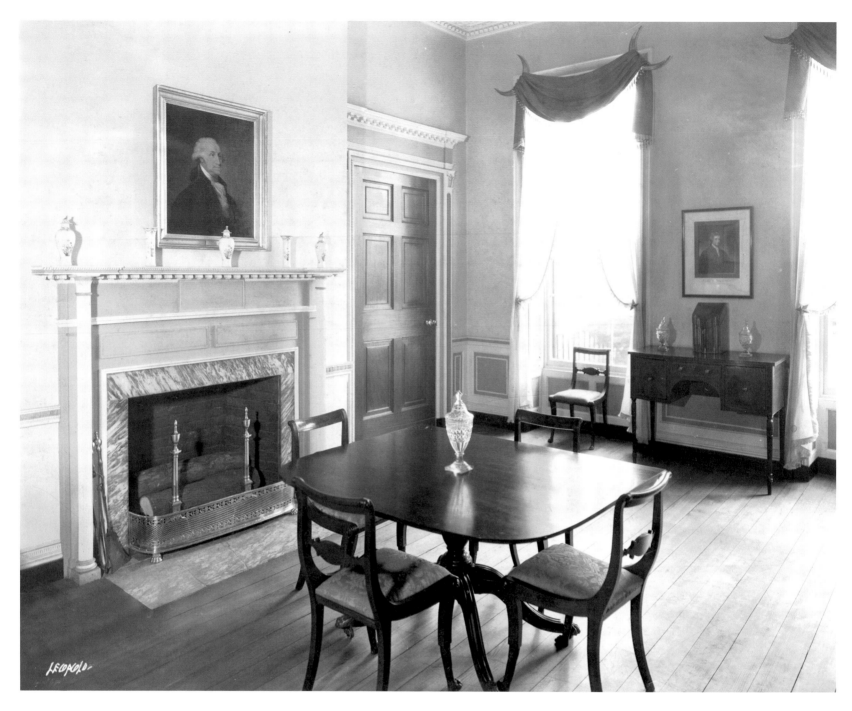

The impetus for the restoration was the vision of university trustee and alumnus Robert G. Merrick, who urged President Steven Muller to recognize more formally the significance of this historic building by making it a museum. Muller agreed but was concerned about the prohibitive costs associated with Merrick's proposed restoration of Homewood. In 1973 Merrick removed the only obstacle by providing funds for the restoration and an endowment that would support the continued operation of Homewood as a museum. Susan Gerwe Tripp, then director of university collections, was appointed to coordinate and oversee the restoration of the house. The university trustees approved the Homewood project and the formation of an advisory board.

This Homewood Restoration Advisory Committee comprised interested and informed members of the community, many of whom were also associated with other major museums and institutions.[8] Tripp, on behalf of the university, commissioned Mendel-Mesick-Cohen-Waite Architects of Albany, New York, to evaluate the building and draft the historic structures report that would guide the restoration. Mendel-Mesick-Cohen-Waite and Henry Lewis Contractors collaborated on the subsequent investigations and restoration, while Tripp led the research and documented every aspect of the project.

As physical investigation of the building progressed, it became clear that research was the key to achieving the most accurate restoration possible. Family letters, account books, and probate inventories yielded clues and evidence for the construction of the house, its furnishings, and the lives of the Carrolls who lived here.

In the summer of 1983, an archaeological investigation provided a new source of primary information for the restoration of Homewood. The dig was led by Eric

Fig. 92 (opposite, top). The dining room. The furnishings were part of the collections of Mabel Brady and Francis P. Garvan and of Elizabeth Tower and R. T. H. Halsey. Mrs. Garvan and Mrs. Halsey were responsible for making all of the window treatments. Photograph by Harry B. Leopold.

Fig. 93 (opposite, bottom left). The drawing room as part of the Garvan restoration. Many of the Garvan objects remain in the permanent collection at Homewood today. The sofa table in the center of the room is currently on display at Homewood. Photograph by Harry B. Leopold.

Fig. 94 (opposite, bottom right). The Green Chamber, Garvan restoration. Many objects included in this view represent the earliest accessions into Homewood's collection. The Signers of the Declaration of Independence *and the French George Washington mantle clock are among the most important early acquisitions.*

Fig. 95 (left). As museum attendance dwindled, the university began to use rooms for administrative offices for the president and deans. The elegant drawing room is shown here as an office.

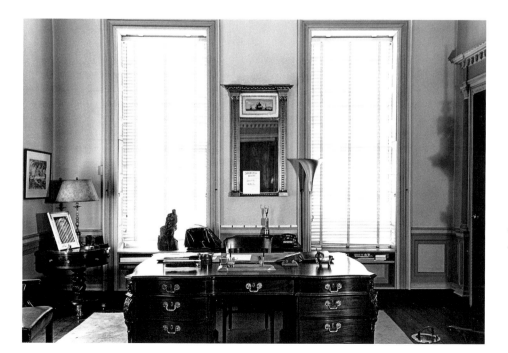

Klinglehofer and advised by Marley Brown III, director of archaeological excavation and conservation at Colonial Williamsburg. The investigation established evidence for features of the house and property—the grading and siting of the house, walkways, the carriage drive, the well, and ceramics used at Homewood. The location and composition of the original gravel drive were found, the well's location was determined (at the west end of the house in proximity to the kitchen), and artifacts documented the variety of ceramics and bottle glass used by the Carroll family (FIG. 96). These tablewares were first used as decorative and functional objects; later, when discarded, the shards helped improve drainage around the foundation of the house. A few details of construction were found as well: a brick- or stonemason's chisel, brick and marble chips, and postholes for the scaffolding used in the original construction of the south portico.[9] On the north side of the house, near the privy, numerous clay pipe bowls and stems were found, suggesting the garden as a place to linger in leisure, strolling and smoking. Subsequent architectural investigations have been undertaken as specific questions have arisen and will continue to advance knowledge of life at Homewood.

During the 1980s restoration of the house, perhaps the most urgent need was the removal of the slate roof that had been added during the earlier Garvan restoration (FIG. 97). Inappropriate for the house, the weight of the slate roof was more than the original rafters had been designed to support, and many nails had begun to loosen under the extreme weight of the slate (FIG. 98). Although structural evidence indicated an original wood shingle roof, old water stains on rafters and beams indicated that the original roof must have been abandoned in favor of a standing-seam metal roof constructed over the original design. This change would have altered the roofline and therefore the appearance of the house; it has been conjectured that the dormer windows may have been added with the construction of the second roof.[10]

Other structural repairs included improvement of the drainage around the foundation. Many changes to the grade had caused significant problems with rising

FIG. 96. The variety of objects found during archaeological investigations is remarkable, from parts of games (marbles) and implements for relaxation (clay pipes), to once-beautiful tableware, including Chinese export porcelain and English creamware, to evidence of what was actually consumed—oysters, ham, and chicken. French champagne was clearly popular from the number of bottles and wire cork cages found during the investigations. Brass buttons and even a glass cameo brooch were found.

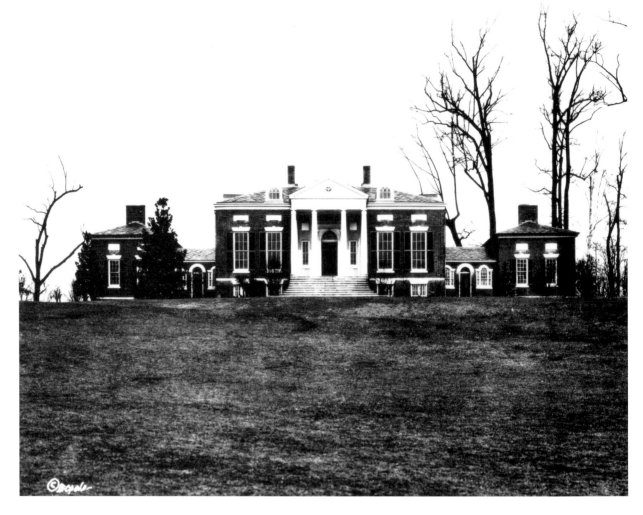

FIG. 97. *In a c. 1930 photo-*
graph by Harry B. Leopold,
Homewood is burdened
by a slate roof added during
the Garvan restoration.

FIG. 98. *Homewood's*
original cedar shingle roof
is believed to have leaked,
based on significant water
stains on the rafters. The
second roof, evident in the
earliest photographs of the
house, was a standing-seam
metal roof. During the
1980s, the decision was made,
because of fire risk and cost
constraints, to reconstruct
the metal roof the house
had for most of its history.

damp, eroded mortar, spalled brick, and damaged plaster. Inherent porosity of some of the brick and of the sandstone sills of windows in the south façade and the water table led to their deterioration. Those that were too badly damaged for repair were individually excised and replaced (FIG. 99).

Inside the house, wall-to-wall carpet covered the floors, and acoustical tile had been added to many of the ceilings to meet the demands of use as office space. At first thought, such treatments seem like a gross injustice to inflict upon a historic building, but they actually helped ensure the survival of much of the original flooring and plaster detail of the ceilings. As twentieth-century additions were removed and physical investigations begun, the remarkable condition and detail of the house became apparent.

Homewood's doors, interior and exterior, show the highly fashionable treatment of grain painting (FIG. 100). Some of the doors retain their original grain painting—only a few needed to be entirely repainted. Most were cleaned and inpainted as necessary. Made of local yellow pine, the doors were painted to resemble highly figured, imported mahogany. Perhaps more fashionable than if the doors had been made of actual mahogany, grain painting was preferred and demonstrated the painter's artifice, or skill in creating convincing artificial finishes. Doorstops had been attached to the baseboards in the main block rooms; when they were removed during the restoration, evidence of marbleizing was apparent. The baseboards of each room had been painted to look like different varieties of marble.

An extensive paint analysis was conducted to determine the original paint scheme for the exterior and the first floor rooms of the house. Paint was removed layer by layer and was analyzed both visually and microscopically to determine the original pigments and the number of subsequent paint layers.[11] The results of the study formed the basis for repainting the interior of the house to reflect its earliest appearance. These vibrant and intense colors are important in the appearance of the interiors—the chrome yellow of the central passage reflects natural light from the Palladian windows

FIG. 99. At the outset of the restoration, photographs were taken of existing conditions. Sandstone window sills, because of their extraordinary softness and porosity, were deteriorated beyond repair and were instead individually excised and replaced. The steps and doorsill were patched and repaired.

in the hyphens; even on an overcast day, the passage is filled with light (FIG. 101). When viewed by candlelight, it becomes clear that only the brightest and most saturated colors are even distinguishable. Analysis of the two back rooms of the main block of the house showed an adhesive layer, suggesting the use of wallpaper. No written evidence discusses the selection of paint colors or even payments made to painters, but a wide variety of colors were available in Baltimore by the first decade of the nineteenth century. More than forty paint colors, most of them imported from England, are mentioned in local newspaper advertisements of the period.[12]

The 1825 probate inventory for Charles Carroll Jr. (APP. A) is the primary document establishing the furnishings that may have been at Homewood. Family letters and entries in account books refer to items acquired either as gifts or purchases. An 1833 inventory lists items moved from Homewood to Doughoregan Manor by Charles Carroll III (*see* APP. B). The 1825 inventory was not particularly detailed and represented only what remained at Homewood at the time of Charles Carroll Jr.'s death. It does not account for the additional furnishings that were removed by Harriet Chew Carroll when the couple separated in 1816. Harriet would have taken things back to Philadelphia, but no final inventory of what she took survives.[13]

Contemporary inventories help create a clearer picture of what was likely to have been at Homewood. A significant number of objects have survived with a Carroll family provenance; most of these, however, are associated with Charles Carroll of Carrollton because of his prominence, both in his time and in the course of history, as the last surviving signer of the Declaration of Independence. The fact that he survived his son by seven years contributes to confusion regarding the original ownership of identified objects. Even though Charles Carroll of Carrollton was responsible for a majority of family purchases, ordering many items through his London agent, no indication was typically made for whom or for where the

FIG. 100 (below). Most of Homewood's doors, interior and exterior, were grain painted to resemble mahogany. The graining patterns were remarkably intact on some of the doors, which were only cleaned and inpainted. Others required complete repainting by skilled craftsmen whose techniques have changed very little since the late eighteenth century, when the fashion began.

FIG. 101 (opposite). Chrome yellow, chosen for the central passage, had the ability to reflect light, brightening the passage even on a gray day.

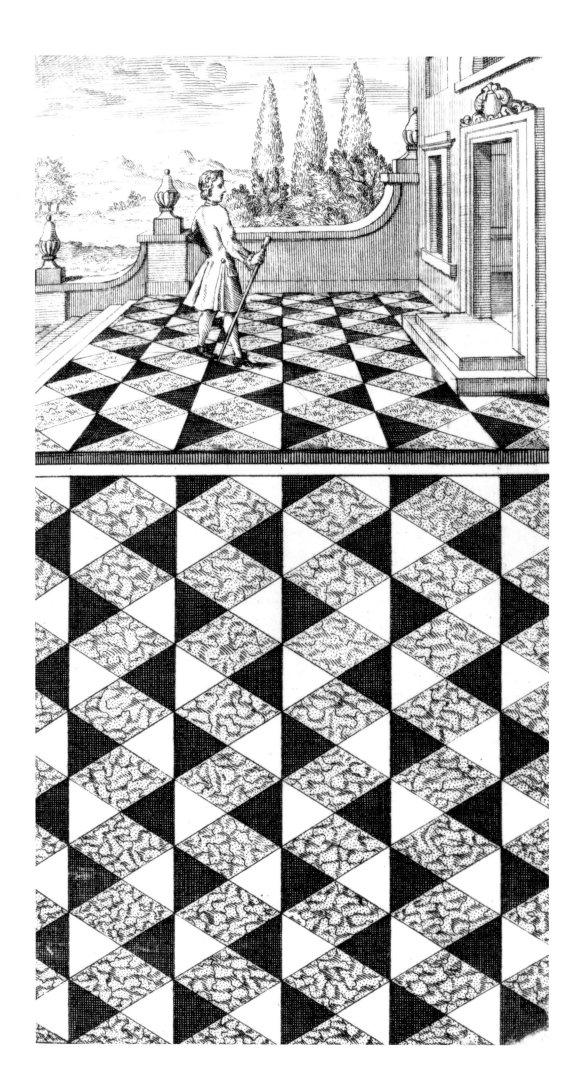

objects were intended. An object with a Carroll provenance that dates to the first decade of the nineteenth century must be considered as potentially among the original Homewood furnishings.

Window treatments and floor coverings rarely survive over time, so inventories, letterbook entries, and period design sources provide clues to what may have been some of the Carrolls' most stylish and expensive purchases. Fortunately, floorcloths and carpets are described in significant detail in Charles Carroll of Carrollton's letterbook. In the early nineteenth century, a wide variety of floor coverings were available; they would have been changed seasonally for comfort and to minimize wear. Floorcloths, also called oilcloth, were durable, scrubable surfaces that would have been much cooler and easier to care for in the summer months; they were a fashionable way to replicate marble tile. Grass or straw matting was also durable and cooler than the wool carpets that were used during the winter.

An October 1805 entry in Charles Carroll of Carrollton's letterbook records the floorcloths ordered for Homewood (*see* FIG. 47): "Inclosed [*sic*] you have drafts of floor cloths for some rooms in my son's country house near Baltimore, the directions and dimensions are written on the drafts to which I have nothing to add only that these floor cloths are for summer's use. I wish them to be shipped with my goods but in a separate package marked C.C. Jun. and charge the cost to me."[14] Unfortunately, the drawings that accompanied the original order do not survive to indicate the patterns or dimensions, which would indicate for which rooms they were intended. A black-and-white diamond pattern, or squares set on point, was one of the most popular floorcloth patterns promoted by such designers as Battie Langley and John Carwitham, who published illustrated treatises on the subject as early as the mid-eighteenth century. This pattern, also referred to as running diamond, would have replicated the marble tile on the porch of Homewood's south portico. For summer entertaining, the doors would have been open and the pattern would have appeared nearly continuous between the marble tile outside and the floorcloth in the reception hall (FIG. 102).

FIG. 102. One of Carwitham's many designs for floorcloths resembling marble floors in English country houses and their classical antecedents. The design shows both the "plan" view of the pattern and a perspective view of the floor in use in an exterior courtyard. This variant on the running diamond pattern achieves an effect similar to that of the floorcloths at Homewood.

John Carwitham, *Floor-decorations of various Kinds, both in plano & perspective* … (London: Sold by R. Caldwell, at Mercers-Hall Cheapside & at his house in King Street, 1739), plate 9. The Winterthur Library, Printed Book and Periodical Collection, RBR NA3840C33.

Charles Carroll of Carrollton's account book also included orders, placed through his London agent, for yards upon yards of "matting for passages" as virtually annual purchases each fall from 1795 to 1806. An order placed in the fall would arrive on a vessel the following spring so the grass rugs could be installed for summer's use. Although there was no specific notation for Homewood and the 1795–1801 orders were obviously not for this house, the orders demonstrate that this floor covering was in common use by the family and offer surprising insight into the disposable nature of the matting; the orders are for roughly the same quantity each year.[15]

Brussels carpets were another floor covering used at Homewood. None were readily available during restoration, and the advisory committee was determined to have accurate reproductions. Weavers at Woodward Grosvenor, one of England's oldest carpet-making establishments, were commissioned to recreate carpets based on patterns, discovered in the firm's archives, that dated back to Homewood's beginnings (*see* APP. D); designs were chosen to represent those mentioned in Carroll family letters. The carpet designs, called "point papers," were plotted in watercolor on hand-drawn graph paper, with each line representing the warp and weft on which the actual carpets were woven. These point papers, much like a needlepoint pattern, were stored in cabinets and drawers intended only for design selection and loom setup. Because they were protected from exposure to light, they survived in brilliant color (FIG. 103). Brussels and Wilton carpets were woven on looms in two-foot-wide strips (a technological limitation) and were shipped to America in rolls; they were stitched together in place to fit the room. *Brussels* referred to carpets with looped pile, and *Wilton* indicated a cut-pile carpet. The production of these two types was the same except for the final step, which involved cutting the loops.

The London carpet weaver in whose archives these point papers were held agreed to set up looms in a historically correct manner to produce extremely accurate carpets for the restoration. They also provided matting for some of the sec-

FIG. 103. *Point papers serve as directions for the weaver, allowing him to set up the loom and weave the carpet in approximately twenty-four-inch-wide strips. The strips are later sewn together in situ. It is apparent in this design for a carpet that the colors form stripes down the length of the weaving—blue, red, purple, gold. This economy meant that colors did not have to be carried over long "floats" on the backside of the carpet.*

FIG. 104. *Detail of a window treatment. George Hepplewhite's 1794* The Cabinet-Maker & Upholsterer's Guide, *3rd edition (London: I. and J. Taylor, 1794; reprint, New York: Dover, 1969) includes a "Plan of a Room—showing the proper distribution of Furniture." Such design sources served as a reference for upholsterers (the decorators of the day) and helped establish taste.*

ondary spaces of the house and workmen to complete the installation. Homewood's reproduction carpets have been influential in subsequent historic preservation projects across the country. Reproduction floorcloths were painted by Johns Hopkins University students, based on period design sources, after much experimentation with materials and technique.

Window treatments, even more than carpets, have a particularly low rate of survival because of the harmful effects of ultraviolet radiation in sunlight, which causes them to fade and deteriorate (FIG. 104) (*see* APP. D). Paintings and prints of interiors, as well as contemporary books and magazines, provide information on styles, forms, and patterns. Rare surviving upholsterers' bills, newspaper advertisements, and inventories all indicate that, by the eighteenth century, furnishing fabrics within a room were matched. In the second half of the eighteenth century, cotton materials such as furniture checks, cotton velvets, and dimity, either plain or corded, came into use. Within the nineteenth century, such designers as Sheraton, Hepplewhite, and George Smith gave recommendations for furnishing fabrics and for designs for curtains. Rudolph Ackermann described materials available in fashionable linen drapers' shops in his monthly *Ackermann's Repository*, published between 1809 and 1828. The periodical contains many hand-colored engravings of designs for window curtains and fashionable furniture that were widely copied by others.

These early-nineteenth-century designers even suggested which textiles were suitable for various types of rooms. In 1826 George Smith, another London designer, specified, "For Eating Rooms and Libraries, a material of more substance is requisite than for Rooms of a lighter cast; and for such purposes superfine cloth, or cassimere, will ever be the best; yet scarlet and crimson will ever hold the preference … calico when used should be in one color, in shades of maroon or scarlet. In elegant Drawing Rooms, plain coloured satin or figured damask assumes the first rank, as well as for use as for richness."[16] The period design sources and reproduction fabrics for Homewood are detailed in APPENDIX D.

FIG. 105. Homewood's current programming includes two exhibitions a year. Building Homewood: Vision for a Villa, 1802–2002, was a major fall exhibition celebrating the bicentennial of Homewood's construction, the centennial of Hopkins's ownership of the house, and the fifteenth anniversary of the 1987 opening of the house as a museum. A smaller focus show runs January through March each year.

Since the house opened as a museum in September 1987, refinements to Homewood's furnishings plan continue to reflect an increased understanding of how the house was used, include additional gifts to the museum, and identify additional Carroll family objects. Research is ongoing at Homewood, and through the production of two exhibitions a year (FIG. 105), the activities of the museum contribute to scholarship in the fields of architecture, decorative arts, and social history. Additional programs include an annual architectural lecture series devoted to the work of Baltimore's great architects, an Evening of Traditional Beverages that highlights the history and culture surrounding early American drink, and lectures and symposia planned in conjunction with the exhibitions. A new class of volunteer guides is trained each year to interpret the history of the house and early-nineteenth-century Baltimore for visitors. Ongoing educational opportunities are provided for existing guides, and Homewood offers courses in Johns Hopkins's Odyssey continuing education program.

During the fall semester of 2002, Homewood offered its first undergraduate-level course cross-listed in the Departments of the History of Art and History. The course was titled American Architecture 1800–1850: A View from Homewood and was taught by visiting professor W. Barksdale Maynard. Interns support many phases of research, contribute to the production of exhibitions and the accompanying catalogs, and receive academic credit for their involvement.

Homewood thus survives, a country house surrounded by the city. It stands on the campus of the Johns Hopkins University, a vibrant place for learning, and inspires students, academic departments, the community, and colleagues at other museums and historic houses to think about Homewood in new and challenging ways. This museum serves as a laboratory for the study of early-nineteenth-century architecture, decorative arts, and social and cultural history, a place for experiential learning.

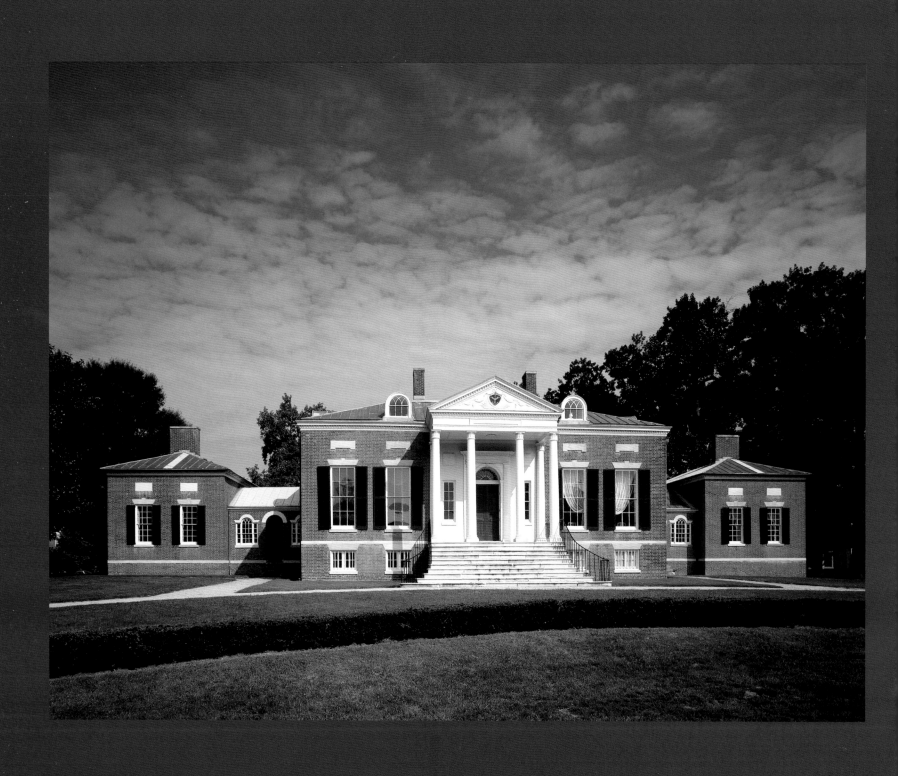

INVENTORY APPRAISAL OF CHARLES CARROLL JR. OF HOMEWOOD, 16 APRIL 1825

A true and perfect Inventory of all and singular the goods and chattels and personal estate of Charles Carroll Jr. deceased, late of Baltimore County, appraised by us the subscribers (each one of us having been first legally authorised, and duly sworn as will be seen by the annexed Warrant) this sixteenth day of April in the year of our Lord eighteen hundred and twenty five.

	$ ¢
One painted Bedstead,	10
Mahogany, "	10
" Bureau,	8
" Close Stool,	6
" Stand	4
Easy Chair,	3
Looking Glass,	5
Coverlids,	1
3 Matrasses,	10
4 Pillows,	3
2 Beds,	12
11 Blankets,	15
4 Quilts,	8
1 Bidet,	5
1 Carpet,	12
Rug,	.75
5 Trunks,	10
Portrait,	50
Watch,	10
Pistols flask Holsters,	3.50
Picture,	10
Portrait,	10
Sauce pans & Bed Pan,	5.50
Madeira Wine in Bottles,	500
Tea Set broken,	5
Dinner Set,	30
Knives and forks,	20
Set of Glass,	25
Decanters,	6
Jelly stand champagne glasses	
& salt sellars,	10.75
Castors,	1

Bottles,	24
Sword & belt,	2
Books,	50
Two Chests,	1.50
1 Fish kettle,	1.50
1 Bidet,	2
Globe Lamp,	1.75
Sleigh,	10
Mahogany Slab,	6
6 Prints of Shakespeare,	12
1 Duke of Wellington,	2
" Washington,	2
3 Looking Glasses,	69
Wine Cooler,	10
And Irons,	12
Historical Prints,	12
Mahogany Tables,	35
2 Bureaus,	12
Book Case,	20
2 brackets,	2
press,	3
1 Clock,	20
Mahogany Press,	10
Secretary,	12
Cupboard,	2
Map,	3
Mahogany Chairs,	30
Settee,	2
Knife Cases,	3
Demijohns,	20
Cot,	.75
Crib,	3
Bed Steps Pine desk And Irons	
Shovel & Tongs,	10.50
Wash stand,	2
Brass Lamps,	8
1 Table,	5
Wearing Apparel,	75
Slaves—	
Charles,	250
Israel,	250
Cis,	200
Caesar,	250

Beck,	200
Jule,	175
Kezziah,	175
John,	175
Patrick,	125
Jess,	75
Henry,	50
Sam,	250
Ben,	250
Tom,	250
Sally,	200
Anny,	200
Black Mare,	75
Bay "	45
Black "	50
Horse "	50
" Bay,	50
Stallion Colt,	100
Mare,	45
Wheat fan,	25
Threshing Machine,	100
Plate,	460
	$5310.50

We the subscribers do certify that the foregoing is a true and just Inventory and valuation of all and singular the goods and chattels of Charles Carroll Jr. late of Baltimore County, deceased as far as the same has come to our sight and knowledge and appraised by us according to the best of our skill and Judgement. Witness our hands and seals this sixteenth day of April 1825.

John H. B. Latrobe
Chas. Howard

Amount of Appraisement	$5310.50
Cash in the Bank at the time of the deceased's death	132.67
Whole amount of Inventory,	$5443.17

Charles Carroll Jr. Executor
Baltimore

NOTES RELATING TO HOMEWOOD
MADE BY CHARLES CARROLL OF DOUGHOREGAN

Transcribed by Mary Butler Davies, with the assistance of Carson Berglund, Catherine Melocik, and Jane Katz

Introduction

IT WAS A COMMON PRACTICE during the eighteenth and nineteenth centuries to keep family records, accounts, marketing lists, and other helpful information recorded in one central place. For such needs there were books that appeared to be ordinary, leather-bound volumes, with a title printed on the spine, which were full of blank pages.

Charles Carroll of Doughoregan (1801–1862) inherited Homewood upon the death his father, Charles Carroll Jr., in 1825. He lived there from 1826 until 1833, when he moved to Doughoregan Manor, and eventually sold Homewood in 1838. His journal entries cover the period from January 6, 1826, to April 21, 1836.

This particular blank book was sold by Cummings and Hilliard in Boston and Cambridge in 1822. The title reads *Common Place Book,* with the following comment, "upon the plan recommended and practised by John Locke, Esq." Homewood House holds the volume.

All of the information contained in this book that pertained to Homewood or family events of the period has here been transcribed as written by hand. No correction or change to the spelling or grammar has been made. Any modern additions or changes are within brackets.

Blanks are shown in place of letters or words that were illegible. There are also several instances of incomplete entries. The letters *dº* are often used to mean "ditto," same as above.

This important book given to the Homewood Restoration is the only known source that contains lists of furnishings and equipment once at Homewood, aside from the scanty inventory taken upon the death of Charles Carroll of Homewood in 1825.

Mary Butler Davies
January 1986

Memorandum of things sent to the Manor 1833

Nov. 2ⁿᵈ

Bag of Coffee
1 Barrel corn Sugar
5 loaves cone-Sugar
Die for screws in place
 of other
a stamp for Clem—
 Marked C. Carroll
draw knife for Ned
Mats and frames
 [crossed out]
box glass [crossed out]
1 doz plough shares 10 in.

Taylor Drake Shepphard
 [written vertically in
 left margin]

Nov. 6. box of glass.

Nov. 9ᵗʰ

Mats and 6 sash lights

Nov 13ᵗʰ

Leather
4 bush. of salt
15 lb nails
 (_____ from Taylor
Morris Patsy & baggage

Nov. 15

Strawmats
15 lbs nails spikes
raspberries fr. Sommerville

Nov 24ᵗʰ

By Harry's waggon
15 lbs Eng. Blistered steel
30 bus. Salt gr. alium
4 sacks of dº
By William.
Candle wick.
 _____ [crossed out]

Nov. 30

1 gross Buttons
10 lb nails (spikes)
a bladder of Putty
Trunk of Silver
2 boxes empty bottles
1 box candles.
Ice. By Harry
Shingles from Kirby

Dec. 18 by Harry

2 tons plaister fr. Orndorff

Dec. 26

By William, 1 Stove for Mrs
McCrodan's room

List of Medecines in the Office Nov 5th 1834

Oil Sodæ
Oxyde Bismuth
Jalap
Sulp. Antim. Præcip
Nitric Acid
Spirits Salt
Flor Bengoric
Tartar Emetic
Ipecaguana
Calomel
Rhubard
Gum Myrrha
Nitric Ether
Glass of Antimony with wax

Tar Ointment
Gambage
Borax
Gum Kino
Compound Extract Colocynth
Red Pepper

Sulphate Quinine
Mur. Tinc. Iron
Lunar Caustic
Peruvian Balsom
Pulv. Antimonialis
Fowlers Solution Arsenic
Sun Flower oil

oil of Cinnamon
Lunar Caustic
Hydr. Cinnerum
oil of Almonds
oil of anniseed
Sal Succurei

nitrate of silver
pulv. stanni
Turpeth mineral
Oxy. mur. potassœ
Laudanum
Powdered Savin
Prepared chalk
Balsom Fir
Compound soap linament
Scyllœ nadis Pulvis
Myrrha Pulvis
Phosphate of Soda
Spirits of Nitric Ether
Ferri Carbonas
Carb. Potassœ
Sugar of lead
Lima Bark
Vol Sal Ammoniæ
Tincture Rhubarb
Bark
Spirits of Ammoniæ comp.[d]

Spirits of Turpentine
Camphor
Aqua Ammoniæ
Solualde Tartar
Tinct. cantharides
Sulphur
Columbo
oil of Turpentine
Flor Zinci
Flies.
Elixir of Vitriol
Senna
sweet oil
assafœdeta
Nut galls
Manna
Sal Ammoniac
Opium
Alum
Gum Arabic
Quassia
Sago
columbo
gum Ammoniac
Ink Powder
uva urri
Gentian
Blue Stone

glauber Salts
Calcined Magnesia
Juniper Berries
Honey
Wax
Cream Tartar
Salts
Sulphuret of Antimony
Magnesia
chloride of Lime
chalk
copperas
Swanns panacea
Tinc. Cantharides
Camphor
Copal Varnish 2 bottles
Indigo
Spirits Salt
Spirit Nitric Ether
Prepared Antimony
Spirits Lavender Compound
Aromatic Spir. of Ammonia
Aromatic drops
Elixir Vitriol
Blister Plaster
Vol.

Catalogue of Books

no. of vols.

1	Latin and French Dictionary	4°
1	French and Latin Dictionary	4°
1	Gradus ad Parnassum	4°
1	Elements de la langue Latine	12°
1	Syournants Spanish dictionary	4°
1	D° French and Spanish dict.	4°
1	Conversations en Francais et Esp.	8°
1	Grammaire Espagnolle par Cormon	8°
1	Mordente's Spanish Grammar	8°
1	Grammaire de Wailey	12°
1	Dictionare de la Fable	18°
1	Oraisons funebres de Bossuet	12°
3	Rudiments de l'histoire	12
1	Gallerie du Musee Royal	12°
1	Œuvres de Boileau	18°
2	Synnonymes Francaises	12
1	Rhetorique de Girard	12
1	Fables ou la Fontaine	18°
2	Chefs d'œuvres d'Eloq. Chretienne	12°
1	Manuel du voyageur en Suisse avec charte	8°
X	Algebra de Boudou. exchanged	8
1	Geometrie de Legendre	8
X	Arithmetique de Besout. exchanged	8
1	Discours sur l'histoire Universelle	8
1	Vie de Volthaire par le Pan	12
1	Ceremonies de Romains	12
2	Works of Marquis de Tourreil	4°
2	Cuisinier Francois	8
1	Systeme de l'homme et de la femme	8°
3	Considerations sur la Rev. Fran.	8°
5	Œuvres de Corneille	8
5	Œuvres de Racine	8
6	Œuvres de Moliere	8
4	Œuvres de J. B. Rousseau	8
1	Œuvres de Gilbert	18
12	Œuvres de Florian	18

18	Œuvres de Rollin avec chartes	8°
5	Œuvres de Montesquieu	8
5	Œuvres de Pascal	8
5	Œuvres de Victor	8°
17	Œuvres de Buffon	8°
16	Œuvres de La Harpe	8
3	Caractere de la Bruyere	18
6	Essais de Montaigne	18
1	Pluralite des Mondes. Fontenelle	12
1	Memoires de 1815	8°
2	Jardins de Delille	18
1	Georgiques de Delille.	18
1	L'imagination, poeme de Delille	18
7	Voyage D'Anacharsis	12
5	Genie du Christianisme	8
3	Itineraire de Paris a Jerusalem	8
1	Vie et mort de duc De Berry	8°
6	Histoire de la Rev. Francoise	18
3	Œuvres choisis de Piron	18
10	Œuvres de Fenelon	8
2	Oraisons funebres de Flechier	18
3	Lettres de quelques _____ a Volthaire	
1	La Religion poem	18
1	Code Francais	18
2	Horace de Bincy	12°
2	Essais sur l'indifference en religion	8°
1	Ortografia Castillana	18
1	Le petit Careme de Massillon	
1	Istoria de España	8°
5	Gil Blas. Esp.	18
4	Don Quixotes. Esp.	18
1	Politesse Gourmande	8°
1	Moorish Letters, Spanish	12
1	Ainsworths Latin & Eng. dictionary	15
1	Lavoines Atlas. Folio	
1	Lexicon	8°
1	Dialogues en Espagnole.	8°
1	Locke on human understanding.	8

1	Stewart on the Mind.	8°
1	Lowths English Grammar.	12
1	Walkers Rhetorical Grammar.	
1	Blairs lectures.	8
1	Paleys evidence of christianity.	
1	Sythers history	12
1	Paleys Moral Philosophy.	8
	Boston directory.	18
1	Infantry Manual. Scot. ed.	8
X	Application of Trigonometry exchanged.	8
1	Brewsters Ferguson	8
1	Staughton's Virgil	4°
1	Dublin Correspondence	18
1	Traveller's directory thr. U.S	
2	Letters on Old Eng. by a New Eng. man.	
2	Knickerbocker's New York.	12°
X	Analitic Geometry exchanged	8
X	La croix Algebra d°	8°
1	Bible.	8°
1	Thomson's Seasons	12
1	Enfields Natural Philosophy.	4°
2	Gorhams Chemistry.	8
1	Parkes Chemical Catechism	8°
1	Pocket Atlas.	12
1	Endless Amusements.	18
1	Atlas for Rollin & Crevier.	
1	Walkers English Dictionary.	8°
2	Memoirs of the Reign of Q. Elizabeth	
2	Life of Pitt	8
1	Ten years Exile	12
1	Polite Learning.	18
1	Morses Geography.	12
2	Lives of the Signers of Decl. of In.	
12	Johnson's Works.	8°
2	Jays Political Economy	8°
1	___ of North America.	
2	Cambridge Mathematics.	12°
2	Cleavelands Mineralogy.	8°
1	Mineralogy of Boston.	Done

List of Tools and Farming Utensils left at Homewood the 9th May 1833.

1	two horse newplough	5	old hoes large & small	1	sett cart gears for	2	cradles
1	two horse draft	2	dung forks		2 horses	3	pitchforks
1	sett of plough gears	1	pick new	1	sett of plough gears	2	drags
1	small one horse plough	1	rock iron	1	roller	1	turf cutter
2	single h. swingle trees	1	shovel	1	white horse (rock)	3	scythes
1	cultivator	1	large two horse cart	1	Blend mare (Peg)	1	horse rake
1	gravel hoe			1	mare —		

List of Tools and Farming Utensils Sent from Homewood to the Manor on the 9th of May 1833.

1	seed chest with drawers	3	Buckheads	1	new pick	1	old dung drag
1	old large plough	2	spares for old patent	2	watering pots	1	bell hook
1	old small red dº		plough	2	iron rakes	1	iron to split slats
1	small patent plough	2	old spades	1	Mataxe	1	scythe
1	new cultivator	3	old small hoes	1	grubbing hoe	½	a sett of plough gears
2	three horse drafts	1	new ox cart	1	shovel	1	dung fork
1	double swingle tree	1	yoke of oxen ___ yoke	3	old hay forks	1	crowbar

List of Plate brought with me to the Manor—being Silver left to me by my father and purchased by me.

4	large Silver candlesticks	4	ladles	24	table spoons	1	sett of castors
1	Punch bowl and stand	1	fish knife	24	Desert spoons		
1	Can	1	Large silver Ladle	24	Teaspoons		silver tipped knives & forks
1	coffee Pot	1	pair of snuffers and stand	24	large forks	4	carving knives 3 dº forks
1	cream Pot	1	syphon	24	desert forks	40	dinner knives 45 dº forks
1	Teapot	2	butter knives	2	goblets	29	desert knives 42 dº forks
1	sugar dish & tongs	1	marrow spoon	1	cross for bowl	17	oyster knives plain
4	gravy spoons	4	salt spoons	1	strainer (funnel)		

List of Plate obtained in the Division of my grandfathers Estate.

1	Turreen for Soup		Fish Knife	28	desert forks,	19	old table spoons
1	Tankard		Snuffer Tray		18 with crest 6 plain	1	large gravy spoon
	Punch Bowl		Sugar bowl	9	large forks with crest	2	butter Knives
2	butter boats		dº dº or creambowl	6	large forks without crest	12	desert spoons
	Coffee Pot	3	Ladles	17	large forks, with crest		new pattern
	Tea Pot	2	candlesticks chapel		old fashion	3	plain desert spoons
4	candlesticks	2	sugar cruets	18	New pattern tea spoons	19	old desert spoons
	castors	1	small waiter stand	15	old teaspoons	33	silver handled Knives
1	pair goblets		for teapot		labels for wine	33	desert silver dº Knives
7	salt cellars & spoons		Punch Ladle	3	Tea catties in a box	3	old carvers forks
	cross for bowl		Punch strainer	12	table spoons with crest		Tops & stoppers for wine
	Goblet		Chocolate Pot	5	table spoons plain	2	marrow spoons
	scewer			4	table spoons marked C	1	pr sugar tongs

Plated ware brought with me to the Manor & obtained from my father or bought by me

2 Branch candlesticks	3 chamber candlesticks	2 do ice cream Moulds	1 plated tray for snuffers
6 wine coasters	4 long Candlesticks	4 do wine coasters	2 small plated lamps
6 Waiters	4 vegetable dishes & tops	[crossed out]	1 cheese knife
1 fish knife	plated coasters	1 Bread basket	4 Salt Stands

List of Plate made 30th Nov 1835

Homewood Plate	24 large forks	4 salt cellars	3 tea catties
4 large silver candlesticks	24 desert do	3 salt spoons	1 pr. sugar tongs
1 Punch Bowl & stand	2 Goblets	1 scewer	Tops & Stoppers
1 do ladle ebony handle	1 cross for Bowl	2 sugar cruets	Labels for wine
4 gravy spoons	1 Funnel wine	2 ladles sugar	1 silver picher
2 small ladles	2 old tea spoons	1 Punch ladle	1 coffee Pot
one with holes		1 Punch strainer	2 tea pots
1 Fish Knife	Manor Plate	1 Chocolatepot & stirrer	1 Sugar dish and tongs
2 large soup ladles	1 Turreen for Soup	1 fish knife	1 slop Bowl
1 pr snuffers and stand	1 Tankard	24 large forks	1 cream pot
1 syphon	2 Butter boats	24 small do	33 silver handled knives, large
2 Butter knives	4 Candlesticks	24 table spoons	33 do do do small
1 Marrow spoon	1 pr castors	24 desert do	3 do do carving knives
4 salt spoons	2 goblets	24 tea do	3 do do do forks

Plated Ware

1 large Waiter	3 high candlesticks (old)	1 pr plated snuffers tray	1 cheese knife
2 small Leged do	2 Branches & tops for do	8 coasters	1 asparagus knife
6 old plated waiters	2 shorter candlesticks (old)	1 Bread basket	9 Ivory handled desert-knives
2 coolers wine	11 chamber candlesticks	4 vegetable dishes & tops	9 Ivory " " -forks
chapel Plate			

[*Memoranda*]

Jan. 6th 1826 (Note)

The grounds rents and arrearages of my grandfathers ground rents in the city of Baltimore amounted to 22000. The ground rents & rents alone to 1100$.

Sulphurous acid passes in very slight acid quality. It changes vegetable blues to white instead of red. If a red rose be held in the fumes of brimstone watch the flower will become white. In the same manner stains or iron mould may be removed from linen or cloth (cotton) if the spots be previously moistened with water.

Homewood measures 129f. 2in. by 50f. deep.

Icehouse at Homewood measures 13f. from the sill of the door to the planks at the bottom and 13f. wide at bottom.

Thomas Lee Carroll

My dear child died at Homewood in the room opposite the parlour on the 7th of Nov. 1832 at 40 minutes after 8 oc in the morning aged

Nathan Leonard

Called to see me at Homewood—I told him that he would continue untill the 21st of Nov 1833. he paying me 400$. In the spring that I should call upon him to pay me 121$. 21ct. for wood unproperly taken from the Island. He said he had sowed 94 bus. of wheat that he intended to manure his cornground this winter—He is to cut rails this winter for a division fence and cultivate the part he likes in 3 fields. He is to have some oak posts for the corners of his worn fence. Told him that if Faulkner and two others would cut wood I would pay them at the rate of 37½ per cord, but they were to cuts as much oak wood as pine. Told him that all promises that I shd ever make would be in writing.

Homewood rented to Mr Tiffany

I agreed this day to rent to William Tiffany the mansion house at Homewood together with the ground usually kept in Turf and the two shrubberries with the Privies also the Carrige house—and Stables generally used for carriage horses—from the 15th of May to the 15th Nov 1833 the said Tiffany paying me 300$ in 2 quarterly payments.

It is also agreed than any supplies which he may want shall be obtained from the Farm at the usual Market prices—He is to prevent any injury to the trees or grass Plats included in the part of the pleasure grounds rented.

Booker

Charge $5.20 cents to Joseph Booker paid for meal for him

came up to the Manor on Friday on the 19th of May & divided with Mr McTavish the furniture in the Dwelling house. Finished it on Saturday

Moved Mrs Carroll and my family up on Monday the 13 May.

Mr Gibbons commenced delivering over the personal property on Friday the 17th May on Wednesday divided with Mr McTavish the plate in Mr Perines office.

Railroad expense for flour

Woodville told me in June 1833 that 25 barrels of flour could be sent for Balt. to Beally's warehouse for $2.15

$$\begin{array}{r} 2\frac{1}{2} \text{ tons of plaster up for} \quad \underline{1.05} \\ 3.20 \end{array}$$

Weights of Children 1833 Aug 9

Mary weighed 41½ Charles 33½ John 35 Baby 21 Myself 137.

Measure of roof of stable Aug 23

Edmund says the side of the roof of Brick Stable at the old quarter measures 66 feet by 30 feet.

Sept 27

Mrs Carroll & family came to town for the winter

Sept 30th Stable rented.

Rented the Stable from Robinson moved _____

1833 Lev. Shipped to N. Or. Nov. 13

Shipped Lev. to New Orleans for Mr. J. Lee he promising to do with him as I shall direct. I have agreed to allow Mr. Ridgaway 50$ for repairs on Poplar Island.

Dec 9th Yield of 100 bus. of wheat

By a memorandum from Davies, the following is the yield of 100 bus. of good wheat.

 21 bar. of Superfine flour
 a 1½ bar of midlings
 15 bushels of Ship Stuff
 20 do of Brown Stuff
 25 do of Shorts

Wheat & rye sown by Dorsey & Brown, Fall of 1833

There has been 995 bus. of wheat, blue stem, white tallavera, white chili, and red chaff and Lauder what sown this autumn and 228 bus. of Rye.

Stray Hog at Homewood Dec 21

a stray Hog came to Homewood was kept a month no owner found was killed Dec 21ˢᵗ and weighed 185 lbs. Took off the Hams which weighted 42 lb and left 143 lbs. to last them 10 weeks from the day of their next allowance.

Weight of Hogs killed Dec 26th

Two hundred and sixty three hogs killed at all the quarters up to the 24ᵗʰ of Dec. weight 36.610 lbs.

Jenny Beaver Dec 26th

Hired out Jenny Beaver this day to Elisha Lee for 5$ a month for a cook & washerwoman I am to find her in clothes and medicines and medical allowance when sick. Left 18ᵗʰ Jan′y.

1834 Horses to Livery at Owings

Sunday 5 Jan′y sent my bay horse to Owings.

Wednesday Jan′y 8ᵗʰ my two bay $$ horses at Owings

Thursday Jan′y 16ᵗʰ put my two bay (Wherf) horses at Owings

On the 28ᵗʰ & 29 of Sept had two horses at Livery at Owings′

1834 May 9th

Mrs C. and the children came up to the Manor

Tolls for 1833–1834

1ˢᵗ Toll gate from 13ᵗʰ May 1833 to 1ˢᵗ June 1834	75 31
2ⁿᵈ Toll gate from 1ˢᵗ May 1833 to 26 June 1834	80 89¾
	$156.20

Bull died 1ˢᵗ June

The early part of June my miss D.S.H bull died. he had been sick three mouths. On examination I found his kidneys rotten and his body filled with reddish water.

28 June Cow Calf by Mohawk out of Zenobia

a heifer calf dropped got by Mohawk out of Zenobia

Wheat Made on the Manor 1833

Put into Mill by Dorsey	1154.31
″ ″ ″ ″ H Brown	484
sown of my own	763
bus.	2601.31

Harvest begun 2ⁿᵈ of July finished 17 July i.e. wheat & rye harvest 14 days. weather favorable only two days of very hot weather the rest moderately warm. The greatest numbers of hands put out young & old was 90.

Wardrop

Mr Wardrop came to me Tuesday Aug 12 at 20$ p month and found.

Chernoweth

Chenoweth received from me 8 2 1 at 25$ p.ton	10 62½
″ 3 2 4 at 20 p ton	3 50
	$ 14.12½

a great drought has prevailed since the latter part of June and has injured the corn a great storm took place on the 2ⁿᵈ of July at 1 oc PM blew down a great number of trees.

Homewood assessment

132 acres at 100 p.acre. improvements 1000.14200 personal property 90$ 38.59

wheat from J. Lee Sept.

wheat weighed when rec′d 60¾ lbs per bus.	
dᵒ dᵒ when cleaned for seed	61½
Number of bushels cleaned for seed	349
dᵒ of dᵒ screenings sent to mill	139½

Servants Sold

July & 2 children in Nov 1833 for 303.85 } Money all
 and on 23 Sept 15 others for 2230 } pd to the
 } Harpers

Wool of 1833

of my own 462 ˡᵇˢ. Bought of V. Harding 30½
John Barnard 32. found in store 45. Total 569½

Rye sown Sept 1834

Dairy field at old quarter	60	bus.
Limekiln field at Coopers	50	
Walnut field at Mikes	15	
	125	bus.

Wheat sown 1834

Sycamore Field at Coopers mostly white wheat	Oct 1ˢᵗ	74	
Horse chesnut field at old quarter	Oct 8	182	
Hog pen field at dᵒ	Oct 13	216	
Woodland pasturs at dᵒ	Oct 15	134	
Dairy field at dᵒ	Oct 24	185½	
Limekiln field at Coopers	Oct 24	21	
Middle field at Mikes	Oct 4	65	
Barn field at dᵒ	Oct 6	103	
	bus.	980	

Nov. 1ˢᵗ Bayard cert. B of Md sold

Sold this day for Mary Bayard & remitted to R H Bayard same day 2630.13 cert of B of Md cert for 27 cts per 100 $710.10 Resulted in a check on the Mechanics B of Phil'a

Mules fr. Mr Clay

Mr Clay sent in his mules & mine by his son & Mayor Smith

1834 Dec 4ᵗʰ Hogs killed

236 Hogs killed Dec 4 & 5 — Weight 27982 } 29482
 13 dᵒ killed in Nov. 1500

1835 Feb 4

Gave Major Jones a rec't by Corders measurement of a load of wood due me by Wilson and Roukes 31 cords at 3.87½ cts.

Feb 7

I became endorser on a note with Mr O Horsey drawn by Mr Lee in favor of the latter at 5 months for _____$ with the understanding that I was to be put into the place of Mr Noland in the deed of assignment to Mr Bell as Trustee.

Mar 13

Blacksmith Bill was sold to me Pr. 600$ but was not sent over untill Mar 31ˢᵗ being 15 working days.

May 27

Sent to Beally 346 hams weight 3196_ $ 23 kegs lard weight 1057 nett

June 2

Sent to the folly by furniture waggon 24 Demi johns of the cercial wine & empty pipe of March 7.

June 5

Bottled my pipe London Particular. 43 doz & 8 bot.s.

June 27

Bottled a cask of Georgetown ale 154 bottles.

June 30

The large brick barn at old quarter measures on the roof 68.6. by 24.6. It contains 122.40 shingles at 1 ct a piece.

Oct 3

John Dean Lexington Mississippi.

Nov 19

Kramer came from Needwood 21ˢᵗ moved into his house I am to give him $2.50 per 1000 for 200.000 brick find him house, firewood, and shed for his brick kilns.

Duvals Measure Leveled Sept 1835

Level of the River
Whole amount of ascent from a peg standing in Mrs Crawfords Meadow on the side of the river to a bench mark on a willow tree which stands on the breast of the present Mill dam in all 26 feet 10³⁄₈ in and from a bench mark on a stump at the breast of the old saw Mill down to the mark on the willow on the breast of the present dam the ascent is 20 feet 10⅛ in The top of the Peg standing in the meadow near the turnpike where there is a good scite for a New Mill is below the mark on the willow the breast of the dam of the present Mill.

1835 Wheat sown		bus
Old quarter—	Granite field	184
	Savannah	35
	Woodland Pasture	146½
	Lawn	24½
	Jack Lot	4½
	Pinetree field	143½
Mike quarter	Barn field	84
	Meadow dᵒ	56
Bens quarter	Clovermill field	76
	Dairy field	68
Coopers quarter	House field	69
	Lime house dᵒ	112
		1003 bushels
Rye sown		167 bushels

Nov 30

Packed in the cellar 40 doz London Particular—Ma. house of Newton Gordon Murdoch Duff & Co—Imported 1832 Bottled June 1835

Nov 30

Put in cellar 9 doz & 6 clear Lisbon wine & 1 draught & 6 bottles regs. Left with housekeeper 1 doz of dᵒ

[April 1836]

Mr. Oram came to work on Thursday with his two men on Thursday Mor. Ap. 21ˢᵗ at 1.25 per d.

each Found. Dairy range work at 56¼ cents per perch range work & 40ᶜᵉⁿᵗˢ rough stone work Found.

CATALOG OF CARROLL FAMILY OBJECTS
AT HOMEWOOD HOUSE

Furniture

1. Sideboard Table
Maryland, 1790–1810
Mahogany; yellow pine, poplar
37⅞"H × 68⅜"W × 25⅝"D

The Baltimore Museum of Art, Gift of Mrs. Francis White, from the collection of Mrs. Miles White Jr., BMA1973.76.220

According to family tradition and to notes made by the late Mrs. Miles White Jr., this table was said to have belonged to Charles Carroll of Carrollton (1737–1832) and thought to have been used at Doughoregan Manor rather than in his Annapolis house. It is also possible that the sideboard table was first owned by Charles Carroll of Homewood (1775–1825) and could have been taken to Doughoregan by his son, Charles Carroll of Doughoregan (1801–1862).

The 1825 probate inventory for Charles Carroll Jr. includes a "Mahogany Slab, $6"; could this be the table? A marble-topped model of the same table form was sometimes referred to as a "mixing table" or "slab table," alluding to the practicality of a marble top for mixing drinks or the slab of marble that formed the top. This cryptic reference to a "mahogany slab" could perhaps indicate the form but with a mahogany slab for a top; that it was a table may have been commonly understood.

The eagle and bellflower inlays on this table are typical of examples found on both Baltimore and Annapolis furniture but are extraordinary in their application on this table. Bellflower inlays suspended from an inlaid loop, with elongated center petals, diminishing in size, and separated by inlaid dots, are characteristic of Baltimore examples of this time period. The bellflower inlay on this table has been applied to both the front and the outside surfaces of the front legs *and* the rear legs as well.

Construction: The front corners of the top are canted, a feature that appears on some Baltimore side tables and sideboards. The frame of the table is reinforced with a medial brace, a construction element seen on many Baltimore tables, especially card tables with two swing legs, and interestingly used on a side chair with a Carroll provenance (*see* CAT. 2). The spade feet are applied.

References:

Baltimore Furniture: The Work of Baltimore and Annapolis Cabinetmakers from 1760 to 1810 (Baltimore: Baltimore Museum of Art, 1947), cat. 29.

Ann C. Van Devanter, ed., *Anywhere So Long as There be Freedom: Charles Carroll of Carrollton, His Family and Maryland* (Baltimore: Baltimore Museum of Art, 1975), cat. 136.

William Voss Elder III and Jayne E. Stokes, *American Furniture, 1680–1880: From the Collection of the Baltimore Museum of Art* (Baltimore: Baltimore Museum of Art, 1987), cat. 110.

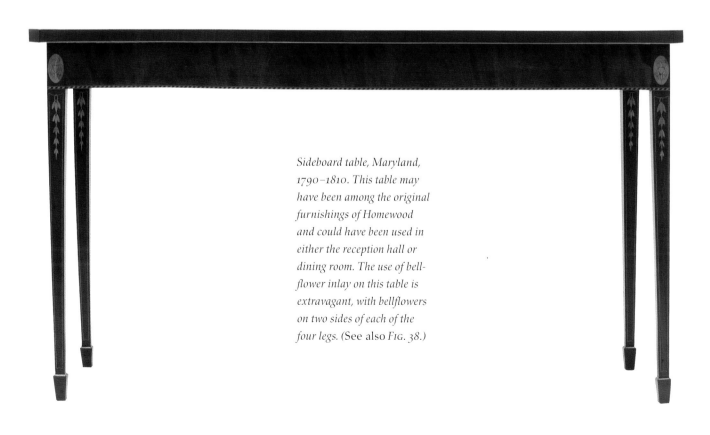

Sideboard table, Maryland, 1790–1810. This table may have been among the original furnishings of Homewood and could have been used in either the reception hall or dining room. The use of bellflower inlay on this table is extravagant, with bellflowers on two sides of each of the four legs. (See also FIG. 38.)

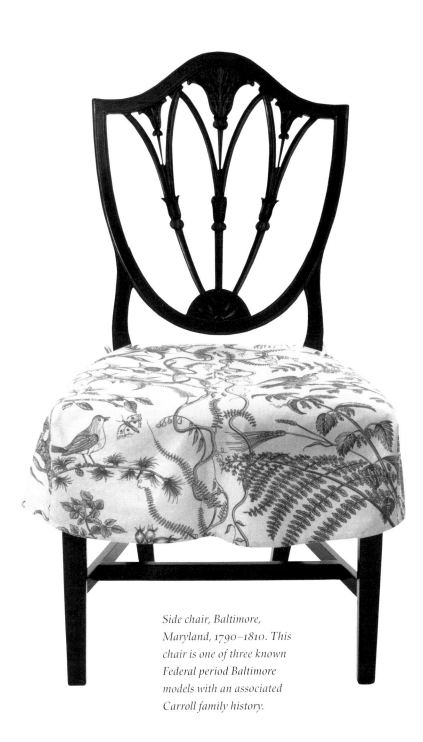

*Side chair, Baltimore,
Maryland, 1790–1810. This
chair is one of three known
Federal period Baltimore
models with an associated
Carroll family history.*

Plate 5, George Hepplewhite,
The Cabinet-Maker &
Upholsterer's Guide *(1794).*

2. Side Chair
Baltimore, 1790–1810
Mahogany; mahogany, oak
37"H × 17½"W × 19½"D

Homewood House Museum, The Johns Hopkins University, Gift of Mrs.
R. G. Harper Carroll II in memory of her husband, HH87.16.1

Chairs of a similar shield-back design, derived from the designs
of George Hepplewhite and published in *The Cabinet-Maker and Up-*
holsterer's Guide (1794), plate 5, were made in Philadelphia, New
York, and New England as well as in Baltimore. The arrangement
of the back splats, the character of the carving, the placement of
the stretchers, and construction details are typical of Baltimore ex-
amples. Many variations on this design, with molded, tapered
legs, shaped seats, and modified splats, survive in museum and pri-
vate collections. This example has plain tapered legs, although
Hepplewhite's design calls for carved bellflowers, a detail included
on a side chair (CAT. 3) and a related pair of card tables, with a pos-
sible Carroll provenance, in the collection of the Baltimore Museum
of Art (BMA 1978.60.1 & .2).

The original ownership of this chair by Charles Carroll of Car-
rollton has been supported by family tradition, but like other Car-
roll objects of this date range, this chair may have been originally
owned by Charles Carroll of Homewood and removed to
Doughoregan Manor by his son, Charles Carroll of Doughoregan.

An identical chair is in the collection of the Baltimore Museum
of Art, and matching chairs from the same set still belong to Car-
roll descendants.

Construction: The fan-shaped, carved leaf motif at the base of
the splats is applied; all other carving on the chair is integral. The
seat frame has open diagonal corner braces and a bowed medial
brace dovetailed into the front and real rails.

3. Side Chair
Baltimore, 1795–1810
Mahogany; mahogany, yellow pine
36½"H × 21⅛"W × 22"D

The Baltimore Museum of Art, Gift of Dorothea Harper Pennington Nelson, BMA1979.46

This highly carved chair represents the height of craftsmanship in early-nineteenth-century Baltimore. The design was derived from designs by Thomas Sheraton, *The Cabinet-Maker and Upholsterer's Drawing-Book* (1793), plate 36. The use of carved bellflowers on two sides of the front legs and on the central splat is unusual for Baltimore furniture, where inlaid bellflowers are typically seen. The presence of carved bellflowers on this chair, on related card tables in the collection of the Baltimore Museum of Art, and on the central splat of the oval-back chair (CAT. 4) points to a particular Carroll preference for this detail.

Like the other chairs included in this catalog of Carroll objects at Homewood, this chair is said by family tradition to have been originally owned by Charles Carroll of Carrollton, but it is possible that this example, along with the other four known examples from the set, may have belonged to Charles Carroll of Homewood.

Five chairs of this set are known. Two are at Winterthur, two at the Baltimore Museum of Art, and the fifth is in the collection of the Maryland Historical Society.

Construction: In spite of the highly successful design of this chair on a stylistic level, inherent flaws in the structural design leave all known examples in deplorable condition. All have suffered severe breaks through the front and rear legs at the points where the stretchers meet the legs. The stretchers, designed to add strength and stability to the chair, are tennoned into mortises in the legs. Because of the severe taper of the leg to accommodate the use of spade feet, too little material of the leg remained after the mortise had been cut for the chair to be structurally sound. The spade feet are cut from the solid. Although the corner blocks are replacements, there is evidence of the original use of open corner braces, a feature frequently used in conjunction with the particularly English-influenced treatment of being upholstered half-over the rail.

Reference:

Elder and Stokes, *American Furniture, 1680–1880*, cat. 23.

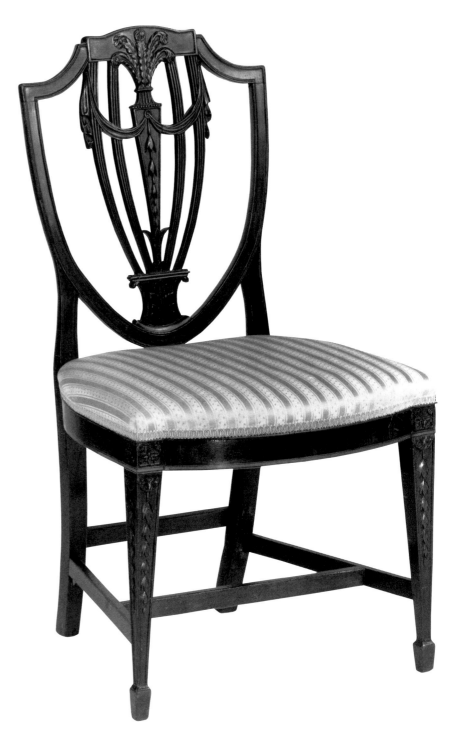

Side chair, Baltimore, Mary-land, 1795–1810. Although the bellflower was a popularly used decorative motif in late-eighteenth- and early-nineteenth-century Baltimore, it is more frequently seen as inlay rather than carved.

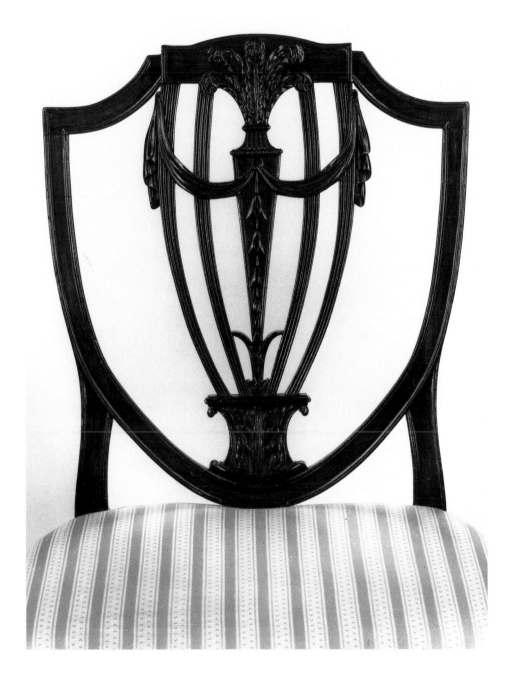

The design for the shield-shaped back is derived from Thomas Sheraton's The Cabinet-Maker and Upholsterer's Drawing-Book *(1793).*

4. Side Chair
Baltimore, 1790–1810
Mahogany; white pine (twentieth-century replacement rails)
37½"H × 20½"W × 19¼"D

On loan to Homewood House from the collection of a Carroll descendant, LHH1997.1

Oval-back chairs with three pierced vertical splats were a popular form in early-nineteenth-century Baltimore. Particularly English in design, they seem not to have been made in any quantity in other American cities. Many variations exist, although most feature inlaid bellflowers on the center splat; variations occur in seat shape and upholstery and in the treatment of the legs. Like other Carroll chairs, this example has carved bellflowers on the center splat. Of any of the known chairs with a history of Carroll family ownership, this model may be the most likely to have been made for use at Homewood. The account books of Charles Carroll of Homewood's neighbor to the northeast, Hugh Thompson, make reference to the purchase of a set of oval-back chairs from cabinetmaker Gerrard Hopkins (d. 1800). A case can be made for similar taste of these contemporaries. This chair has a shaped, bowed seat and molded legs.

The owner of this chair also owns a second example, as well as a set of Potthast Bros., Inc., reproductions c. 1940. At least three others are owned by additional descendants.

Construction: This chair and its mate (in the collection of a descendant) were extensively repaired presumably by Potthast Bros., Inc., when the owner's mother had the chairs copied to make a set. The front and side rails and corner blocks were replaced at that time. The rear seat rail and the rest of the chair is original. In spite of the rail replacements, the original seat was most likely a trapezoidal saddle seat, as shown. The oval of the back is constructed in four pieces mortised together: crest rail, shoe, and stiles that are continuous with the rear legs. The three splats are pierced and carved and are mortised into the crest and shoe. The tapered front legs are molded only on the front and outside surfaces; H-stretchers are mortised into the legs.

Side chair, Baltimore, Maryland, 1790–1810. The oval-back chair form was rarely produced in other American cities but was very popular in Baltimore. This oval-back chair also incorporates the use of carved bellflowers.

5. Armchair
England, 1800–1820
Beech; oak
33 ¼"H × 21 ⅝"W × 22 ⅛"D

Maryland Historical Society, Bequest of Edward R. McElwee, MHS1976.31.1

This chair is the only object known to have descended with the tradition of ownership by Charles Carroll of Homewood. There is ample evidence that various generations of the Carroll family frequently ordered fashionable goods from England, and this chair represents the sort of elegant and sophisticated furnishings that may have been at Homewood. Edward L. McElwee of Hagerstown acquired this chair and a sewing table from the estate of Mrs. Charles Carroll MacTavish (c. 1860–1942), whose husband was a great-grandson of Charles Carroll of Carrollton. Mr. McElwee believed the pieces were from Homewood, but there is no specific documentation to support this theory. No matching chairs are currently known.

Construction: The tops of the front legs are shaped with the front and side rails to form the seat frame. The carved arm supports are attached to the side rails by means of a sliding dovetail. The paint and gilding scheme appears to be original but has been retouched in places. The underside of the front rail has the Roman numeral XXIV scratched into the wood; if this is to indicate that this chair is one of at least twenty-four, it is extraordinary. Sets of such size are virtually unheard of, and no identical chairs have been discovered.

Reference:

Gregory R. Weidman, *Furniture in Maryland* (Baltimore: Maryland Historical Society, 1984), cat. 53.

The Homewood "heresay" chair—the only piece of furniture to survive with a tradition of original ownership at Homewood. No other chair from this set is known; similar examples have been identified.

The Maryland Historical Society, Baltimore.

6. Bedstead and Tester
7. Trundle Bed
8. Bed Steps
Baltimore, 1815–1825
Mahogany; mahogany
Bedstead 100″H × 60″W × 82″L
Tester 1″H × 60″W × 82″L
Trundle Bed 15″H × 41½″W × 60″L
Bed Steps 23½″H × 20½″W × 23½″D

Homewood House Museum, The Johns Hopkins University, Gift of Mrs. Perry Bolton (nee Aurelia Garland), HH78.13.1a–d

This bed, tester, trundle bed, and bed steps have descended with the tradition of original ownership by Charles Carroll of Carroll-ton. The bed shows many of the characteristics of full-blown late-neoclassical Baltimore furniture of the period: boldly turned and heavily reeded posts, a scrolled headboard with a central urn finial, and square-tapered and chamfered legs, with spade feet. The ori-entation of the wheels of the trundle bed indicates that it was de-signed to be pulled out from the foot of the bed rather than from the side. These items are from the collection of Dr. James Bordley Jr. (1874–1956), a Maryland furniture scholar and Carroll descendant.

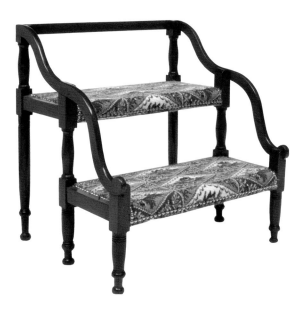

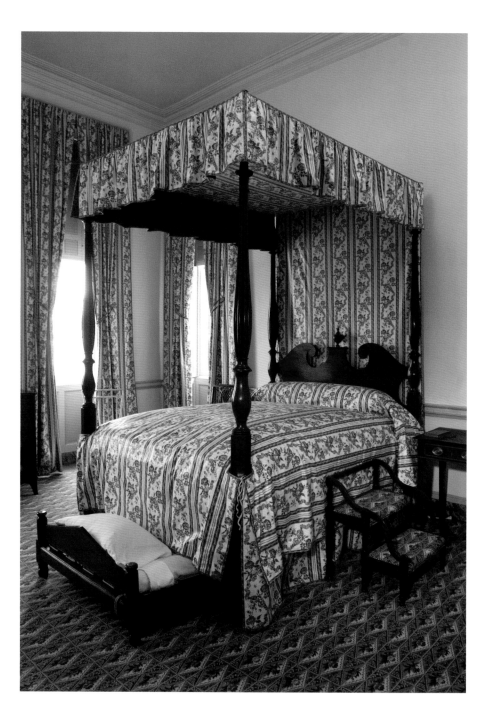

Bed steps were a necessity in the early nineteenth century, when bedsteads piled high with feather beds were the fashion.

Bedstead, tester, Baltimore, Maryland, 1815–1825. The bold reeding of the footposts is characteristic of Baltimore craftsmanship. The headposts are plain; that part of the bed would have normally been concealed by bedhangings.

9. Night Table
Baltimore, 1790–1810
Mahogany; mahogany, cedar, lead
29¾″H × 29⅞″W × 19½″D
tank 4″W × 14¾″D, seat height 18⅜″

On loan to Homewood House from a descendant, LHH87.26.1a–b

Plate 82 of Hepplewhite's *Cabinet-Maker and Upholsterer's Guide* shows two designs for night tables. This example is veneered to appear as a small chest when closed, with two drawers over two doors. Stamped brasses and keyholes assist in the deception. When opened by lifting the hinged lid, a seat and early flush mechanism are revealed. A small lead-lined tank would have held water to flush the contents of a funnel-shaped mechanism above (now missing) into a chamberpot below.

Plate 82, George Hepplewhite, The Cabinet-Maker & Upholsterer's Guide *(1794).*

Night table, Baltimore, Maryland, 1790–1810. Made to look like a chest of drawers when closed, this piece reveals its true function when open.

A lead-lined tank at the left side of the seat provided water for a flush mechanism, an improvement upon the chamberpot alone.

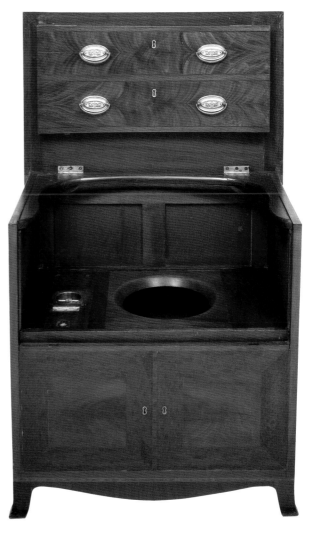

Silver

10. Chocolate Pot
London, 1713–14, and possibly Baltimore, c. 1830
Paul de Lamerie, and possibly Samuel Kirk
Silver
10½"H × 9"OW × 2⅝" diameter at top, 4½" diameter at bottom

Homewood House Museum, The Johns Hopkins University, Gift of sisters Mrs. Julia Lassotovitch, Mrs. Mary-Carroll Potter, and Mrs. Frances Snedeker in memory of their mother, Mrs. Mary Lee Carroll Muth, HH86.20.2

This chocolate pot is an anomaly. The London date marks, maker, and lighthouse form of the pot all confirm a 1713–14 date, and many repoussé-ornamented objects were made by de Lamerie, often in the Rococo style. The repoussé and chased decoration on this pot are strikingly similar in character to Chinoiserie ornament introduced and popularized by Samuel Kirk in Baltimore beginning around 1830. It is not unusual that an owner may have wanted to update the style of the silver, but it would be exceedingly odd if, in that case, the old pot was not melted down so that a new craftsman could "start over." This chocolate pot may be an unusual example of de Lamerie's work, or perhaps the Baltimore-style repoussé was a later update to an existing pot. If the work is original to de Lamerie, the presence of such objects may have influenced the Baltimore style.

Repoussé chocolate pot,
Paul de Lamerie, London,
1713–14, engraved with the
Carroll family crest.

Spoon, Thomas Wallis II, London, 1800–1801. Here the alternate, closed-winged version of the Carroll family crest, a hawk, is engraved. On the back are marks for Thomas Wallis II, 1800–1801.

11. Spoon
England, 1800–1801
Made by Thomas Wallis II

Homewood House Museum, The Johns Hopkins University, Gift of Mary-Carroll Muth Potter, HH96.5.1

This large silver spoon dates to exactly the time of the marriage of Charles Carroll Jr. and Harriet Chew, although it is not known for certain whether it was used by them or by Charles Carroll of Carrollton. The family crest, the hawk, is shown here with wings closed. A majority of known family crests show the hawk with his wings spread.

12. Seal
English or American, late eighteenth or early nineteenth century
Silver
Unmarked
1"H × ½"W

On loan to Homewood House from the Evergreen House Foundation, LHH-A85

This oval seal with intaglio Carroll crest (hawk with wings elevated) on the face of the seal and the initials CC. on the back of the seal is threaded for attachment to a handle. A handwritten note with the seal reads, "This is to certify that this silver seal was the original property of Hon. Chas. Carroll of Carrollton and presented by Mrs. McTavish to the asylum. Baltimore, July 12, 1871. Sister Maria"

Ceramics

13. Pitcher or jug
English creamware, 1810–30
*Marked "*WEDGWOOD*"*
Pattern 613, Queen's Ware Shape Book *(undated)*
*11½″*H *× 6″ diameter at top, 7″ diameter at bottom*

Homewood House Museum, Gift of Mr. and Mrs. Lewis Rumford, HH85.1.1

14. Pitcher or jug
English creamware, 1810–30
*Marked "*WEDGWOOD*"*
Pattern 613, Queen's Ware Shape Book *(undated)*
*11½″*H *× 6″ diameter at top, 7″ diameter at bottom*

Homewood House Museum, Gift of Mr. J. Jefferson Miller II, HH91.7

These ten-quart jugs in the form of barrels, engine-turned with articulated barrel hoops, are two of four known to have survived with a history of ownership by Charles Carroll of Carrollton. The other two are in private collections.

Reference:

Diana Edwards Murnaghan, *Taste and Table: A Century of Ceramics in Early Maryland,* exhibition catalog (Baltimore: Homewood House Museum, 2003).

Two English creamware jugs,
1810–1830. Marked
*"*WEDGWOOD*," pattern 613,*
Queen's Ware Shape
Book *(undated). Although*
these two jugs were given to
Homewood by different
donors, both had a history
of original ownership by
Charles Carroll of Carrollton.

15. *Part of a tea service: slop bowl, cake plate,*
and teacups and saucers
English porcelain, c. 1814
Marked "Spode," pattern "1926"
Slop bowl, 3"H × 6½"dia.; cake plate, 1⅛"H × 8⅝"dia.; teacup,
2⅜"H × 3¼"dia.; saucer, 1"H × 5¼"dia.

On loan to Homewood House from Mrs. Charles Carroll, LHH87.12.1–15

Other pieces from this service with romantic and actual land-scape views (some identified) survive in the collection of the Baltimore Museum of Art. The date of the service, identifiable because of the pattern number, makes this the most likely of known Carroll services to have been used at Homewood. The examples in Homewood's collection have significant repairs. The 1825 probate inventory includes, "Tea Set broken, $5," raising the possibility that this is what remains of the set mentioned.

Reference:

Murnaghan, *Taste and Table.*

English porcelain, c. 1812.
Marked "Spode," "1926."
Based on its date,
this service may have been
used at Homewood.

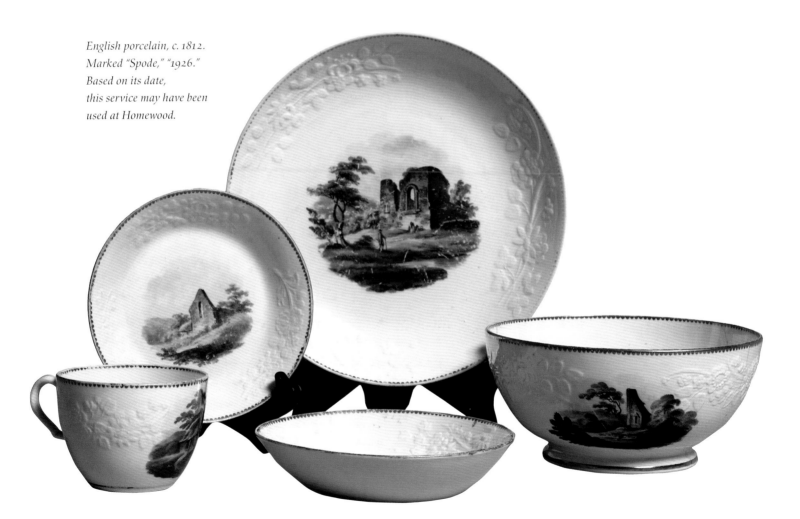

Portraits

16. Portrait of Charles Carroll of Annapolis (1702–82)
After John Wollaston (fl. 1736–67), eighteenth-century copy
Oil on canvas

Maryland Historical Society, MHSXX.5. Photograph by David Prencipe.

This oval portrait on display in Homewood's back parlor is on loan from the Maryland Historical Society. In the loan paperwork for the portrait, the subject is alternately identified as Daniel Carroll of Upper Marlboro II or Charles Carroll of Annapolis, which is scratched out, and he is reidentified as Daniel Carroll. Careful study of the facial features, especially the nose, mouth, chin, and jawline, and examination of other known portraits of these two men make clear that the sitter is Charles Carroll of Annapolis (1702–1782).

The painting is thought to be an eighteenth-century copy of one by John Wollaston that directly descended through Charles Carroll of Carrollton to his granddaughter, Emily McTavish, and through to the present owner; it is part of the McTavish Collection.

17. Portrait of Mrs. Charles Carroll of Annapolis (Elizabeth Brooke) (1709–61)
John Wollaston (fl. 1736–67), c. 1758
Oil on canvas
50⅛"H × 38⅛"W

The Baltimore Museum of Art, Bequest of Caroline Dexter Pennington, BMA1994.196

Mrs. Charles Carroll of Annapolis (Charles Carroll of Carrollton's mother) is believed to have been painted by John Wollaston, an artist born and trained in London who worked between 1736 and 1767. Wollaston came to America and painted prominent sitters in urban centers of New York, Pennsylvania, and Virginia. His work in Maryland is thought to date between 1753 and 1758, when he painted at least fifty-five Maryland subjects.

This portrait descended through Charles Carroll of Carrollton's daughter, Mrs. Robert Goodloe Harper (Catherine Carroll) (1778–1861), to Mrs. Pennington, who donated the portrait to the Baltimore Museum of Art.

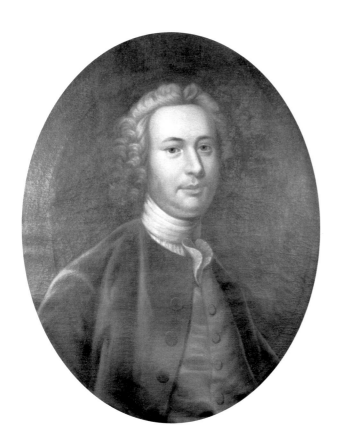

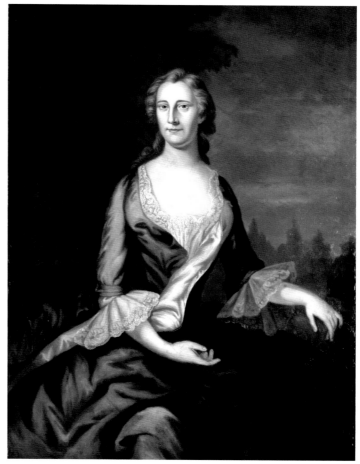

18. Profile Portrait of Charles Carroll of Homewood
Charles Balthazar Julien Févret de Saint-Mémin (1770–1825)
Philadelphia, 1800
Charcoal and chalk on paper
20⅜"H × 14¾"W

The Baltimore Museum of Art, Bequest of Ellen Howard Bayard, BMA1939.183

This portrait of the twenty-five-year-old Charles Carroll of Homewood is believed to have been done in Philadelphia around the time of his marriage to Harriet Chew on 17 July 1800. The Saint-Mémin portrait on display at Homewood is a reproduction.

References:

Ellen Miles, *Saint-Mémin and the Profile Portrait in America* (Washington, D.C.: Smithsonian Press), cat. 138.

J. Hall Pleasants, "Studies in Maryland Painting" (Baltimore: Maryland Historical Society), no. 21.

Van Devanter, *Anywhere So Long as There Be Freedom,* fig. 61, pp. 218–19.

19. Profile Portrait of Charles Carroll of Carrollton
Charles Balthazar Julien Févret de Saint-Mémin (1770–1825)
Baltimore, 1804
Charcoal and chalk on paper
21½"H × 14⅝"W

Maryland Historical Society, Gift of Dr. Clapham Pennington in memory of Emily L. Harper and Emily L. H. Harper, MHS1926.8.1

The Saint-Mémin portrait on display at Homewood is a reproduction.

References:

Miles, *Saint-Mémin and the Profile Portrait in America,* cat. 137.

Pleasants, "Studies in Maryland Painting," no. 591.

Van Devanter, *Anywhere So Long as There Be Freedom,* cat. 23, pp. 152–53.

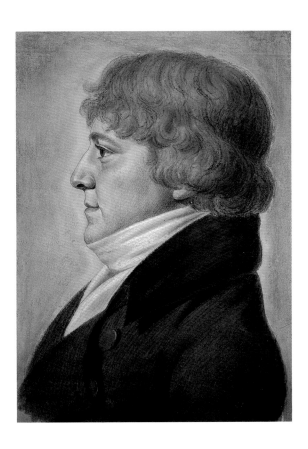

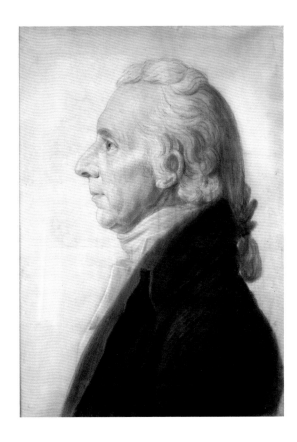

Other Household Objects

20. *Traveling Writing Desk*
England, 1780–1800
Mahogany; brass
6¾"H × 19"W × 11¾"D (closed), 23¾"D (open)

Homewood House Museum, The Johns Hopkins University, Given in memory of Samson Feldman by his sisters, Rosetta A. and Sadie B. Feldman, HH86.4.1

Traveling writing desks, or box desks, were a convenient way to tend to correspondence while traveling and a practical way to secure small valuables and important papers. A slanted writing surface can be lifted to reveal compartments for pens, ink, and perhaps a seal (e.g., CAT. 12). Writing paper, correspondence, and a journal or account book could be stored in a locking drawer on the side. Inlaid brass stringing and corner mounts are decorative and protect the desk from damage during use and travel. A brass shield with the engraved Carroll crest (hawk with wings elevated) and the name "Charles Carroll" is set into the center of the top. Brass carrying handles are flush mounted in the sides.

The desk was purchased by the donors' brother with the history of ownership by Charles Carroll of Carrollton.

A traveling writing desk or box desk made it possible to tend to correspondence while away from home. The slanted, baize-covered writing surface made it easier to read and write. Valuables and important papers could be secured in the locking drawer. The inlaid brass shield is engraved with the Carroll crest and the name of the owner, thought to be Charles Carroll of Carrollton.

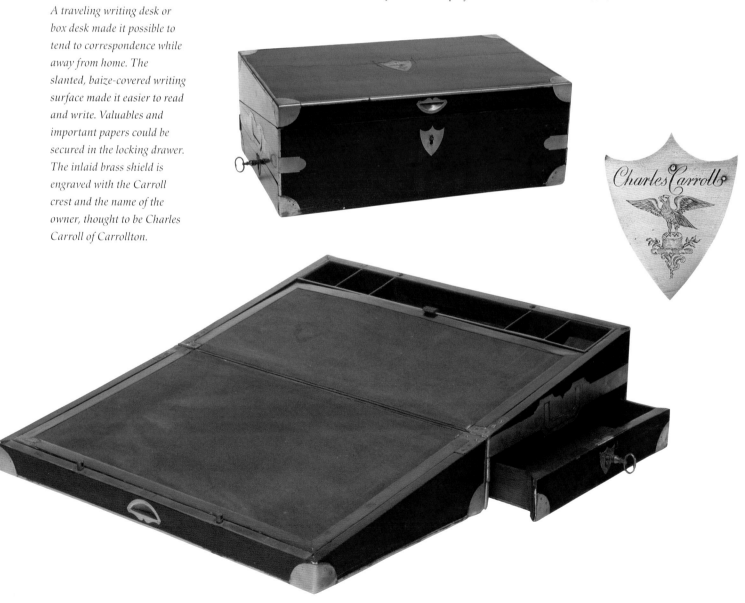

21. Oval Tortoiseshell Box
Tortoiseshell with gold and silver floral inlay and mounts
$1\frac{5}{8}"H \times 2\frac{7}{8}"W \times 1\frac{3}{8}"D$

On loan to Homewood House from the Evergreen House Foundation, LHH.2

A handwritten note accompanying the box reads, "Balto. Md. July 12, 1871. This is to certify that this box was presented by the Duke of Wellington to Hon. Chas. Carroll of Carrollton and in turn given by Mrs. McTavish to the asylum. Sister Maria."

22. Trunk
Leather-covered wood, brass, iron
English or American, c. 1800
$14\frac{1}{2}"H \times 29"W \times 15\frac{1}{4}"D$

On loan to Homewood House from a descendant, LHH1997.1

Tortoiseshell box with gold and silver inlay.

Leather-covered trunk. The 1825 inventory of Homewood lists five "traveling trunks."

Archaeological Items

23. Book
The American Register or Summary Review of History,
Politics, and Literature, *Volume II*
Published by Thomas Dobson and Son
Philadelphia, Pennsylvania, 1817

Museum Purchase, Gift of Mr. Clarence Leisinger, HH2000.3

The American Register, a semiannual publication, provided a "sketch
of the political history, foreign and domestic, of the six months im-
mediately preceding the appearance of each volume, … a synop-
sis of the debate in Congress, … and a record of occurrences which
tend to mark the progress of the arts and sciences, or to illustrate
the peculiar genius of the American people." The original sub-
scription in 1817 was three dollars per volume, payable on deliv-
ery. This particular volume bears the signature of Charles Carroll Jr.
on the table of contents page and is the only item about which we
can say with certainty that it was owned by Charles Carroll of
Homewood. The book includes a "British Account of the Attack on
Baltimore," an obituary for John Carroll, archbishop of Baltimore,
"experiments on Foreign Wines," and many other items that would
have been of great interest to an early-nineteenth-century gentle-
man. The book has been rebound in pony hide.

Chinese Export Porcelain, Nanking pattern
China

Homewood House Museum, The Johns Hopkins University—Archaeological
Fragment

Ceramic Shard
Feather-Edge Creamware
England

Homewood House Museum, The Johns Hopkins University—Archaeological
Fragment

Ceramic Shard
Mochaware, Pearlware
England

Homewood House Museum, The Johns Hopkins University—Archaeological
Fragment

Bottle Glass

Homewood House Museum, The Johns Hopkins University—Archaeological
Fragment

The American Register,
*1817. This book is one of
the few items known to
have been originally owned
by Charles Carroll Jr.*

RESTORATION AND REPRODUCTION RESOURCES

VISITORS TO HOMEWOOD are immediately struck by not only the elegance but also the intimate feel of the house. It is not difficult to imagine living here. Many visitors leave inspired to re-create some aspect of Homewood's design or decoration in their own homes; others even more ambitiously wish to create a Homewood of their own. In this appendix we list both period design sources and modern-day suppliers for paint, textiles, floor coverings, and house plans.

Paint

Painted surfaces provide one of the most character-defining elements of a period interior. The use of color can highlight and heighten the effect of architectural elements and the interplay of light and shadow. Our understanding of both the art and the chemistry of paint application is ever evolving—how many times have we seen what is presented as "original color" later updated by successive generations of preservationists? What is considered "best practice" changes as science and technology provide us with new tools for the analysis of color. The Garvan-Halsey restoration of Homewood in the 1930s included what may have been an aggressive campaign of paint removal in the quest to determine "original color," which was proudly presented in their results as accurate. What did they really find? Original surface? Intermediate primer coats? Regardless, the restoration colors of the early twentieth century were monochromatic and muted.

The current paint scheme presents the findings of paint analysis undertaken during the 1983 initial investigation and preparation of a historic structure report by Mendel-Mesick-Cohen-Waite Architects with the oversight of Susan G. Tripp. As part of the team of architects, Douglas G. Bucher was responsible for the paint analysis using two methods of investigation—"microscopic analysis of small samples of paint removed from the various painted surfaces such as the plaster walls and wood trim, as well as the actual removal of paint by scraping, layer by layer, and then visually inspecting the exposed colors using a small hand held magnifier" (Historic Structure Report, 53, Homewood Museum Archives). This analysis encompassed interior and exterior spaces, and the determination of original and successive colors is recorded on charts included in the historic structure report. These findings guided the repainting of surfaces during the restoration and as we see them today.

Rather than attempting to list all of the colors included in Homewood's complex color scheme, here we include an abbreviated list of those our visitors seem most interested in replicating in their own homes. Recognizing the difficulty of achieving an accurate replication of color in printed material (including this book), colors are recorded as they are in the historic structure report's paint seriation charts, which reference both the *Munsell Book of Color-Matte Finish Collection* (Baltimore: Munsell Color, 1976) and the Inter-Society Color Council–National Bureau of Standards (ISCC-NBS) *Centroid Color Charts* (Washington, D.C.: Office of Standard Reference Materials, 1976). Color chips that can be used for paint matching are available through Homewood's museum shop.

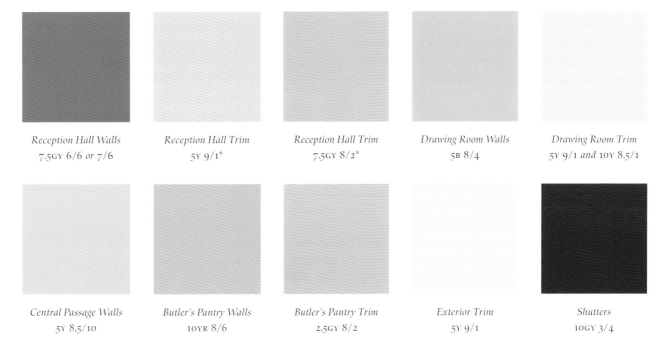

| *Reception Hall Walls* | *Reception Hall Trim* | *Reception Hall Trim* | *Drawing Room Walls* | *Drawing Room Trim* |
| 7.5GY 6/6 *or* 7/6 | 5Y 9/1* | 7.5GY 8/2* | 5B 8/4 | 5Y 9/1 *and* 10Y 8.5/1 |

| *Central Passage Walls* | *Butler's Pantry Walls* | *Butler's Pantry Trim* | *Exterior Trim* | *Shutters* |
| 5Y 8.5/10 | 10YR 8/6 | 2.5GY 8/2 | 5Y 9/1 | 10GY 3/4 |

*The most typical paint scheme used on trim throughout the house.

The cornices and ceilings throughout Homewood were originally unpainted white plaster, a typical treatment of the period. If they became soiled, cornices and ceilings were frequently whitewashed, or they might be painted if some color was desired as part of the paint scheme.

The scholarship and methodology of paint analysis have evolved since Homewood's restoration. Many historic sites have begun to reexamine their painted surfaces, and means have been discovered to account for color shift over time, fading, and other degradation of original surfaces. Mount Vernon, Colonial Williamsburg, Historic Deerfield, and the Society for the Preservation of New England Antiquities (SPNEA) have all found dramatic, even shocking results through recent analysis. For accurate restoration it is important in making decisions about color to remain uninfluenced by modern tastes. Susan Buck and Matthew Moska are among the preeminent scholars in the field and have led important new discoveries in color. *Also see* Roger Moss, *Paint in America: The Colors of Historic Buildings* (New York: John Wiley & Sons / Preservation Press, 1995).

Textiles

Historic window treatments have a particularly low rate of survival because of the damaging effects of the ultraviolet radiation in daylight, which causes textiles to fade and rot. For information on their appearance, we are dependent on graphic sources, such as paintings and prints that include details of interiors, and on books and periodicals that instructed people in the current fashions of the day.

Surviving upholsterer's bills, newspaper advertisements of textiles for sale, and inventory listings indicate that, during the eighteenth and nineteenth centuries, furnishing materials within a room generally matched. This was especially true of window and bed curtains but frequently included upholstery as well.

In the second half of the eighteenth century, cotton materials such as furniture checks, cotton velvets, and dimity, either plain or corded, came into use. For more colorful and elegant rooms, a wide variety of printed textiles, both block and copperplate printed, were favored.

During the nineteenth century, designers like Thomas Sheraton, George Hepplewhite, and George Smith recommended specific types of fabrics for furnishings and specific cuts for curtains. Rudolph Ackermann described materials available in the shops of fashionable linen drapers (retail dealers in yard goods) in his monthly Ackermann's *Repository* (1809–28). The periodical includes many hand-colored engravings of designs for window curtains and fashionable furniture, which were widely copied by others.

These early-nineteenth-century designers made recommendations of textiles suitable for various types of rooms. In his *Cabinet-*

Maker and Upholsterer's Guide (1826), George Smith suggested, "For Eating Rooms and Libraries, a material of more substance is requisite than for Rooms of a lighter cast; and for such purposes superfine cloth, or cassimere, will ever be the best; yet scarlet and crimson will ever hold the preference … Calico when used should be in one color, in shades of maroon or scarlet. In elegant Drawing Rooms, plain colored satin or figured damask assumes the first rank, as well as for use as for richness" (Smith quoted in Florence M. Montgomery, *Textiles in America, 1650–1870* [New York: Norton, 1984], 66).

Dining Room

The Dinner Party, by Henry Sargent, 1821, Museum of Fine Arts, Boston. Handwoven crimson wool camlet and handmade fringe, Kathleen B. Smith, Handweaver and Wool Dyer, Box 48, West Chesterfield, MA 01084; catalog and sample cards available: linens, woolens, tapes and trims, silk thread.

Drawing Room

Pierre de la Mésangère, *Meubles et Objets de Goût,* plate 114, left view. Blue silk satin lined with red glazed cotton, custom trim based on design source, Scalamandre, Headquarters and Customer Relations, 300 Trade Zone Drive, Ronkonkoma, NY 11779, 631-467-8800, 800-932-4361, www.scalamandre.com.

Back Parlor

Pierre de la Mésangère, *Meubles et Objets de Goût,* plate 317, left view. Yellow silk taffeta lined with yellow glazed cotton, organdy sheers, custom trim based on design source, Scalamandre.

Chintz Chamber

Window treatments and bedhangings based on the early-nineteenth-century watercolors of interiors by Mary Ellen Best (*see* Caroline Davidson, *The World of Mary Ellen Best* [New York: Vintage/Ebury (Random House), 1985]). Portland print (859340), Lee Jofa, D&D Building, 979 Third Avenue, New York, NY 10022, www.leejofa.com. Lining of blue glazed cotton (Regina, US-07160), Old World Weavers, 979 Third Avenue, New York, NY 10022.

Green Chamber

Pierre de la Mésangère, *Meubles et Objets de Goût,* plate 243. Green wool moreen lined with yellow glazed cotton, organdy sheers, custom trim based on design source, Scalamandre.

Dressing Room

Stenton, surviving document curtain, Germantown, PA, published in Montgomery, *Textiles in America.* Bird and thistle toile, Brunschwig & Fils, www.brunschwig.com.

Paris. *Meubles et Objets de Goût.* *N.º 114.*

Draperies de Croisée.

*The design at the left of plate
114, Pierre de la Mésangère,
was used as the basis for
the window treatments in
Homewood's drawing room.*

Top left.
Carpet for the reception hall.

Top right.
Carpet for the drawing room.

Bottom left.
Carpet for the back parlor.

Bottom right.
Carpet for the chintz
or best guest chamber.

Furnishings and Upholstery Textiles

Horsehair fabrics were among the most popular upholstery fabrics because of their lustrous sheen and their durability. Horsehair fabrics are woven with a cotton warp and horsehair weft across the width of the fabric and are available in a wide variety of colors and patterns, which can be woven in, embossed, or embroidered. The horsehair is from the tails of live horses, and the fabrics available range from 22 to 26 inches wide. The only manufacturer of these fabrics is John Boyd Textiles Ltd., weavers of horsehair fabrics since 1837 Castle Cary, Somerset, England and they are only available wholesale to the trade. Patterns, projects, and history of the mill can be viewed at www.johnboydtextiles.co.uk. John Rosselli is a U.S. representative who carries the full line of around 150 patterns; John Rosselli Associates, Suite 1800, 979 Third Avenue, New York, NY 10022.

Also see Jane Nylander, *Fabrics for Historic Buildings: A Guide to Selecting Reproduction Fabrics*, 4th ed. (New York: John Wiley & Sons/Preservation Press, 1990).

Floor Coverings

Floorcloths

The floorcloths at Homewood, discussed at length within the text, were produced based on the eighteenth-century designs of John Carwitham and the references within Carroll family letters. Johns Hopkins University employees Debbie Newman and Frances Lloyd experimented with floorcloth painting technique and spent the summer of 1987 painting the large pieces of canvas on the gymnasium floor. Initial experiments were conducted with a variety of oil-based paints and varnishes, but the final floorcloths were painted with interior latex paints and were finished with polyurethane. This decision considerably shortened drying times between the numerous paint layers and resulted in an extremely durable finished product. Spot cleaning with normal household cleaners and an occasional wet-mopping maintain the surface. In areas of the highest traffic, the black squares showed some scratching after ten years of use and were sanded, repainted, and refinished by curatorial assistants Rosanna Moore and Mary Plumer.

Carpets

Hearth rugs in some of these patterns are available through Homewood's museum shop; carpets are available to the trade through Woodward Grosvenor and Company, Ltd., England; U.S. agent: J. R. Burrows and Company, P.O. Box 522, Rockland, MA 02370, 800-347-1795, www.burrows.com.

Sisal

Charles Carroll of Carrollton placed orders with his London agent for "yard wide matting for passages" each fall for spring arrival. Natural fiber rugs made from grass, coconut fiber, or jute were cooler for summer use and, although Carroll replaced them regularly, were extremely durable. Such carpets can be found through many suppliers and remain extremely popular today. Stark Carpets (www.starkcarpet.com) is one of many manufacturers of high-quality sisal carpets.

Also see Helene Von Rosenstiel, *Floor Coverings for Historic Buildings: A Guide to Selecting Reproductions* (New York: John Wiley & Sons/Preservation Press, 1988).

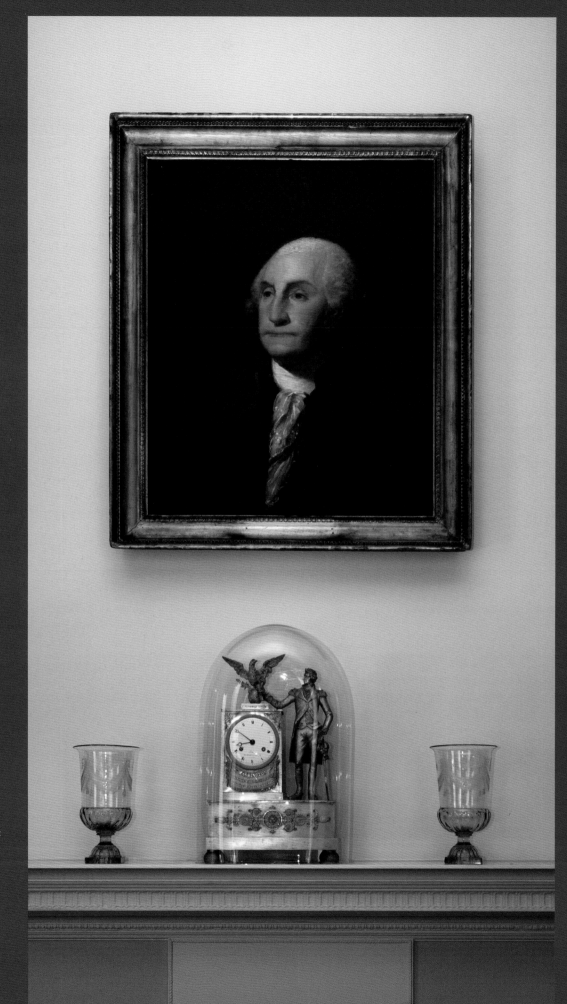

The Gilbert Stuart portrait of George Washington may have hung in the drawing room and was the "good company" referred to by Charles Carroll of Carrollton in a letter regarding his own portrait. The French George Washington mantle clock was one of the most important early accessions into Homewood's collection.

NOTES

Introduction

EPIGRAPH: Charles Carroll Jr. to Benjamin Chew Sr., 19 May 1800, Chew Family Papers, box 117, Historical Society of Pennsylvania.

1. Charles Carroll of Carrollton to Charles Carroll Jr., 12 February 1801, typescript copy, letter 12, Homewood Museum Archives; original letter whereabouts unknown.

2. Robert J. Brugger, *Maryland: A Middle Temperament, 1634–1980* (Baltimore: Johns Hopkins University Press, 1988), 773, fig. 3. Mary Ellen Hayward discusses the growth and character of the city in the late eighteenth and early nineteenth centuries in *Joshua Johnson: Freeman and Early American Portrait Painter* (Baltimore: Maryland Historical Society, 1987) and *Classical Maryland: Fine and Decorative Arts from the Golden Age* (Baltimore: Maryland Historical Society, 1993).

3. John Mullin, *The Baltimore Directory for 1799* (Baltimore: Warner & Hanna, 1799), 125.

4. Isaac Weld Jr., *Travels through the States of North America…1795, 1796, and 1797*, 2 vols. (London: John Stockdale, 1799), 1:37, as cited in Brugger, *Maryland;* J. Gilman D'Arcy Paul, *The History of Homewood* (Baltimore: Homewood House Museum, 1939), 1.

Building Homewood

1. Mills Lane, *Architecture of the Old South: Maryland* (New York: Abbeville Press, 1991), 116. For further discussion of the Baltimore Basilica and the work of Benjamin Henry Latrobe, *see* Charles E. Brownell and Jeffrey A. Cohen, *The Architectural Drawings of Benjamin Henry Latrobe* (New Haven: Maryland Historical Society, American Philosophical Society, and Yale University Press, 1994), 2 vols.

2. Ann C. Van Devanter, ed., *Anywhere So Long as There Be Freedom: Charles Carroll of Carrollton, His Family and Maryland* (Baltimore: Baltimore Museum of Art, 1975), chart I, xvii.

3. Edward Papenfuse, "English Aristocrat in an American Setting," in *Anywhere So Long,* 43–58. *See* p. 56 for an analysis of the money dispersed by Charles Carroll of Carrollton in his lifetime to the three branches of his family and the amounts to which each was entitled by his books.

4. Charles Carroll of Carrollton to Charles Carroll of Annapolis, 7 June 1758, Carroll Family Papers, 41 a,b,c,d, Maryland Historical Society; Joseph Durkin and Annabelle M. Melville, "Catholicism and the Carrolls in Early Maryland," in *Anywhere So Long,* 83–99.

5. Rufus Wilmot Griswold, *The Republican Court, or American Society in the Days of Washington* (New York: D. Appleton, 1855), 412, as cited in Durkin and Melville, "Catholicism and the Carrolls," 221.

6. John Eager Howard to Philip Nicklen, Philadelphia, 12 June 1800, Chew Family Papers, box 117, Historical Society of Pennsylvania.

7. Charles Carroll Jr. and Harriet Chew [marriage articles], 28 June 1800, Chew Family Papers, box 117.

8. Charles Carroll Jr. to Benjamin Chew Sr., 5 May 1800, Chew Family Papers, box 117.

9. Charles Carroll of Carrollton to Charles Carroll Jr., 24 July 1802, Carroll Family Papers, 114 a, Maryland Historical Society.

10. Catherine A. Rogers, "Classicism and Culture in Maryland, 1815–1845," in Mary Ellen Hayward, ed., *Classical Maryland: Fine and Decorative Arts from the Golden Age* (Baltimore: Maryland Historical Society, 1993), 15–16.

11. Asher Benjamin, *The Country Builder's Assistant* (Greenfield, Mass.: Thomas Dickman, 1797).

12. Advertisement in *Maryland Journal,* 2 July 1795, as cited in Rodris Roth, "Interior Decoration of City Houses in Baltimore: The Federal Period," *Winterthur Portfolio* 5 (1969): 74. George Andrews worked in Baltimore from 1799 to 1801 as a "composition ornament maker." *Museum of Early Southern Decorative Arts Index of Artists and Artisans* 24, no. 2 (1998): 653.

13. Advances made by Chas. Carroll Esq. of Carrollton to Chas. Carroll Junr. Esq. & Family on General or Fortune accounts, 1800 to 1832, University of San Francisco Library, C.C. 4, 49.

14. R. T. H. Halsey, *The American Wing* (New York: Metropolitan Museum of Art, 1929), 238.

15. On John Eager Howard's contracts with the Edwards brothers, *see* Howard Papers, MS 469, box 4, 1805, Maryland Historical Society. On Sarah Galloway's contracts with the Edwards brothers, *see* Howard Papers, MS 469, box 4, 1811, Maryland Historical Society. Our thanks to Judith Profitt for sharing her research on the Edwards brothers.

16. Correspondence between George Read and Matthew Pearce et al., in Richard R. Stryker Jr. and Darol Jane Flahart, Manuscript Study for the Restoration of the George Read II House, New Castle, DE, 1978.

17. Matthew Pearce to George Read, 10 February 1798; George Read to John Read, 18 May 1805, both in Stryker and Flahart, Manuscript Study.

18. William H. Pierson Jr., *American Buildings and Their Architects* (New York: Doubleday, 1970), 1:206–7.

19. Charles Carroll of Carrollton to Charles Carroll Jr., 29 August 1803, Carroll Family Papers, Maryland Historical Society; Charles Carroll of Carrollton to Charles Carroll Jr., 5 December 1805, typescript copy, letter 48, Homewood Museum Archives, original letter whereabouts unknown.

20. Until July 2002, one other contemporary building survived on the Hopkins campus. Probably the original farmhouse that Charles Carroll of Carrollton hoped his son would be content to renovate, Owen House (a twentieth-century name) stood near the Hopkins Club and was demolished to make way for the new chemistry build-

ing. An investigation of the building by a team of experts concluded that the earliest parts of the structure dated to the mid-eighteenth century. *See* Historic American Buildings Survey (HABS), National Park Service, HABS MD-1132-1–1132-14. All photographic and drawing records for HABS are part of the Library of Congress collections.

21. *Federal Gazette and Baltimore Daily Advertiser,* 13 November 1819; M. Edward Shull, "Homewood: A New World Arcadia," in *Building Homewood: Vision for a Villa* [exhibition catalog] (Baltimore: Homewood House Museum, 2002), 17–20; Property of Johns Hopkins University and Wyman Park, Baltimore, Maryland (from data from the Baltimore Topographical Survey), Olmsted Brothers Landscape Architects, Brookline, Mass., August 1905, Johns Hopkins University, Special Collections.

22. Charles Carroll of Carrollton to Charles Carroll Jr., 12 September 1802, typescript copy, letter 28; Charles Carroll of Carrollton to Charles Carroll Jr., 17 July 1801, typescript copy, letter 17; Charles Carroll of Carrollton to Charles Carroll Jr., 9 February 1801, typescript copy, letter 11, all in Homewood Museum Archives, original letters whereabouts unknown.

23. Elizabeth Oswald Chew and Benjamin Chew Sr. to Benjamin Chew Jr., 16 August 1802, Chew Family Papers, box 51.

24. Report on the Homewood Property, compiled by Jean Russo, Homewood Museum Archives, 1985.

25. On Homewood Range, *see* J. C. French (JHU librarian) to Grace Strickland, 3 October 1938, Special Collections, Eisenhower Library; Charles Carroll Jr., Last Will, 28 November 1806, Chew Family Papers, box 117.

26. *Letterbook of Charles Carroll of Carrollton,* Arents Collection, New York Public Library (hereafter *Arents Letterbook*); Charles Carroll of Annapolis to Charles Carroll of Carrollton, 1 June 1772, Carroll Family Papers, 334a, Maryland Historical Society; Charles Carroll of Carrollton, 8 January 1775, in *Arents Letterbook.*

27. Charles Carroll of Carrollton, 16 October 1801, in *Arents Letterbook.*

28. *See* Gregory R. Weidman, "Baltimore Federal Furniture: In the English Tradition," in Francis J. Puig and Michael Conforti, *The American Craftsman in the European Tradition, 1620–1820* (Minneapolis: Minneapolis Institute of Art, 1989), 256–81, for a full discussion of the Englishness of Baltimore Federal furniture.

29. Charles Carroll of Carrollton to Charles Carroll Jr. care of Archd Gracie Esqr. New York, 13 September 1797, letter 1, Homewood Museum Archives, original letter whereabouts unknown.

30. John Eager Howard to Phillip Nicklin, 12 June 1800, Chew Family Papers, box 117.

31. Charles Carroll of Carrollton to John Eager Howard, Richard Caton, and Robert Oliver Esqr., 11 June 1816, typescript copy, unnumbered letter, Homewood Museum Archives, original letter whereabouts unknown.

Living at Homewood

1. Quotation from Robert J. Brugger, *Maryland, A Middle Temperment, 1634–1980* (Baltimore: Johns Hopkins University Press, 1988), 143. Red Lane appears on the *Topographical Map of Johns Hopkins University and Wyman Park Property* (Brookline, Mass.: Olmsted Brothers, 1903), Homewood Museum Collection.

2. *Federal Gazette and Baltimore Daily Advertiser,* 13 November 1819.

3. Sumwalt's Run is a stream now covered over by ten feet of earth and brick in Wyman Park Dell in front of the Baltimore Museum of Art. Charles Carroll of Carrollton to Charles Carroll Jr., 12 September 1802, typescript copy, letter 28, Homewood Museum Archives, original letter whereabouts unknown.

4. The carriage house is now Merrick Barn theater.

5. J. Michael Flanigan, *American Furniture from the Kaufman Collection* (Washington, D.C.: National Gallery of Art, 1986), 192.

6. Maryland scholar J. Hall Pleasants made notes regarding Maryland subscribers for the first (1800) edition. This list is included in Catherine Rogers Arthur, *W. Birch & Son's Views of Philadelphia* [exhibition catalog] (Baltimore: Homewood House Museum, 2001), 7.

7. 18 October 1805, *Arents Letterbook.*

8. 22 June 1793, *Arents Letterbook.*

9. Charles Carroll of Carrollton to Charles Carroll Jun'r, 4 September 1803, letter 35, typescript copy, Homewood Museum Archives, original letter whereabouts unknown.

10. Charles Carroll of Carrollton to Charles Carroll Jun'r, Annapolis, 9 o'clock p.m., 14 December 1810, letter 116, typescript copy, Homewood Museum Archives, original letter whereabouts unknown.

11. Charles Carroll Jr. is listed in the 1800–1801 and 1803 city directories on King George's Street, Old Town. By 6 November 1806, when he wrote his will, there seems to be some confusion over the actual name of the street. Regarding his town house he says, "Also the use or rent of my house in Baltimore situated in King Georges Street (I believe that to be the name of the Street.)"

12. Charles Carroll Jr. to Benjamin Chew Sr., 19 May 1800, Chew Family Papers, box 117, Historical Society of Pennsylvania.

13. John H. B. Latrobe is quoted in J. Gilman D'Arcy Paul, *The History of Homewood* (Baltimore: Homewood House Museum, 1939), 4.

14. William Voss Elder, "The House in Annapolis and Doughoregan Manor," in Ann C. Van Devanter, ed., *Anywhere So Long as There Be Freedom: Charles Carroll of Carrollton, His Family and Maryland* (Baltimore: Baltimore Museum of Art, 1975), 79.

15. Charles Carroll of Doughoregan, "Notes Relating to Homewood," recorded in *A Common Place Book* (Boston: Cummings & Hilliard, 1822); *see* APP. B.

16. *The Dinner Party, 10 Franklin Place, Boston,* oil on canvas, by Henry Sargent, c. 1821.

17. Margaret Callcott, ed., *Mistress of Riversdale* (Baltimore: Johns Hopkins University Press, 1991), 33.

18. Ibid.; David McCullough, *John Adams* (New York: Simon & Schuster, 2001), 85.

19. Madeira and other wines were typically stored in casks of various sizes: butts (approximately 222 gallons), pipes (110 gallons), hogsheads (55 gallons), and quarter casks (27 gallons). Emanuel Berk, *A Century Past: A Celebration of the Madeira Party in America* (Sonoma, Calif.: Rare Wine Co., 1999), 7.

20. Inventory of Charles Carroll Jr., Maryland Hall of Records, Baltimore County Register of Wills (inventories), vol. 35 [MdHR 11, 688], Charles Carroll Jr., 19 April 1825, 179–80.

21. 15 April 1795, *Arents Letterbook.*

22. Berk, *A Century Past,* 21.

23. Louise Conway Belden, *The Festive Tradition: Table Decoration and Desserts in America, 1650–1900* (New York: Norton, 1983), 250.

24. Ibid., 25.

25. Advances made by Chas. Carroll Esq. of Carrollton to Chas. Carroll Junr. Esq. & Family on General or Fortune accounts, 1800 to 1832, University of San Francisco Library, C.C. 4, entry for 28 February 1806, 21.

26. Gregory R. Weidman, *Furniture in Maryland* (Baltimore: Maryland Historical Society, 1984), 72; Weidman, "The Furniture of Classical Maryland, 1815–1845," in Mary Ellen Hayward, ed., *Classical Maryland: Fine and Decorative Arts from the Golden Age* (Baltimore: Maryland Historical Society, 1993), 89–110.

27. For more on this suite of furniture, *see* Lance Humphries, "Provenance, Patronage, and Perception: The Morris Suite of Baltimore Painted Furniture," in *American Furniture 2003* (Hanover, N.H.: Chipstone Foundation and University Press of New England), 138–213, for exciting new consideration of this suite as having been originally for the Baltimore Assembly Rooms. *Also see* William Voss Elder III, *Baltimore Painted Furniture, 1800–1840* (Baltimore: Baltimore Museum of Art, 1972). For more on this suite and the work of artist Francis Guy, *see Francis Guy, 1760–1820* (Baltimore: Maryland Historical Society, Museum and Library of Maryland History, 1981).

28. 17 October 1806, *Arents Letterbook.*

29. Charles Carroll of Carrollton to Charles Carroll Jr., 4 September 1803, typescript copy, letter 35, Homewood Museum Archives, original letter whereabouts unknown.

30. *See* Catherine Rogers Arthur, *Needles and Threads: Women's Handiwork, Men's Craftsmanship* (Baltimore: Homewood House Museum, 2001), for a more complete discussion of needlework and the education of the Carroll children. Account book, 31 December 1816 entry, Advances made by Chas. Carroll Esq. of Carrollton to Chas. Carroll Junr. Esq. & Family on General or Fortune accounts, 1800 to 1832, University of San Francisco Library, C.C. 4, 49. Louis

[Lewis] Bacconais [Baconais] appears in the Baltimore city directories from 1812 to 1818 with his dwelling and a "young ladies academy" at 11 South Charles Street. Thank you to Elizabeth Shaw for finding his working dates.

31. Inventory of Charles Carroll Jr., Maryland Hall of Records, Baltimore County Register of Wills (inventories), vol. 35 [MdHR 11, 688], Charles Carroll Jr., 16 April 1825, 179–80.

32. Alexandra Alevizatos, "'Procured of the Best and Most Fashionable Materials': The Furniture and Furnishings of the Lloyd Family, 1750–1850," unpublished master's thesis, University of Delaware, 1999.

33. Receipt from Messrs. Boydell, Shakespeare Gallery to Hugh Thompson, 2 March 1797, Hugh Thompson Miscellaneous Papers, Maryland Historical Society, MS 990; Inventory of Charles Carroll Jr. of Homewood, 16 April 1825 (*see* APP. A); John Eager Howard to Benjamin Chew Esq., 15 and 16 June 1814, Chew Family Papers, box 117.

34. Maryland Historical Society, MHS76.31.1, cat. 53; Weidman, *Furniture in Maryland,* 103.

35. Maryland Historical Society, MHSXX.5.

36. Catherine Rogers Arthur, *At Homewood* (newsletter), Fall 2000, 1.

37. Charles Carroll of Carrollton to Charles Carroll Jr., 17 July 1801, typescript copy, letter 17, Homewood Museum Archives, original letter whereabouts unknown; Charles Carroll of Doughoregan, "Notes Relating to Homewood," in *A Common Place Book.*

38. 15 May 1775, *Arents Letterbook;* Howard Papers, Maryland Historical Society.

39. Harriet Chew Carroll's poetry and other writings survive in three volumes; two include her girlhood lessons from 1787 and 1789, and one records her favorite poems and some of her own poetry from 1822–25. Homewood Museum Collection, gift of Elizabeth Thomas Sweitzer.

40. Edward Papenfuse, "English Aristocrat in an American Setting," in Van Devanter, *Anywhere So Long,* 51.

41. *See* Bernard Herman, "Peopling Homewood," in *Building Homewood: Vision for a Villa* [exhibition catalog] (Baltimore: Homewood House Museum, 2002), 21–28, for a full discussion of possible uses for the cellar rooms.

42. Carroll Family Letters, 1802–25, Homewood Museum Archives.

43. Charles Carroll of Carrollton to Charles Carroll Jr., 28 August 1802, Carroll Family Papers, Maryland Historical Society.

44. *Eye for Excellence: Masterworks from Winterthur* (Winterthur, Del.: Henry Francis du Pont Museum, 1994), 125.

45. M. Edward Shull and W. Peter Pearre, unpublished study completed in 2001, Homewood Museum Archives.

46. *See* May Brawley Hill, "Making a Virtue of Necessity: Decorative American Privies," *Magazine Antiques* 154, no. 2 (August 1998): 182–89.

47. *Federal Gazette and Baltimore Daily Advertiser,* 13 November 1819.

48. M. Edward Shull, "Homewood: A New World Arcadia," in *Building Homewood,* 19.

49. Charles Carroll of Carrollton to Charles Carroll Jr., 28 July 1806, Carroll Family Papers, Maryland Historical Society.

50. Charles Carroll Jr. to Benjamin Chew, 30 May 1808, Chew Family Papers, box 117, Historical Society of Pennsylvania.

51. Charles Carroll of Carrollton to Charles Carroll Jr., 25 May 1813, typescript copy, letter 142, Homewood Museum Archives, original letter whereabouts unknown; Harriet Chew to Doctor John Carroll, 29 April 1813, Chew Family Papers, box 117.

52. John Eager Howard to Benjamin Chew Jr., 21 June 1814, Chew Family Papers, box 117.

53. John Eager Howard probably to Benjamin Chew, 4 August 1814, Chew Family Papers, Pennsylvania Historical Society.

54. "Requests and Directions to Col. Howard & Messrs. Caton and Oliver" [terms and details of property division upon the separation of Charles Carroll Jr. and Harriet Chew Carroll]; Charles Carroll of Carrollton to John Eager Howard, Richard Caton, and Robert Oliver, 11 June 1816, typescript copy, unnumbered letter, Homewood Museum Archives, original whereabouts unknown.

55. Auction notice, unknown 1838 newspaper, included in Wyman account book, Wyman Papers, Maryland Historical Society.

Restoring Homewood

1. Brian Harrington, *A Brief History of the Homewood Campus* (Baltimore: Johns Hopkins University, 1991), 13. Homewood Villa was designed by Richard Upjohn, based on popular designs published by A. J. Downing in *The Architecture of Country Houses* (New York: D. Appleton, 1850). Homewood Villa was based on design 28. The gatehouse for Homewood or Wyman Villa currently stands at the corner of North Charles Street and Art Museum Drive and is used as the office of the *News-Letter,* Johns Hopkins University's student newspaper.

2. Patrick Smithwick, *Gilman Voices, 1987–1997* (Baltimore: Gilman School, 1997), 3.

3. Bradford McE. Jacobs, *Gilman Walls Will Echo: The Story of the Gilman Country School, 1897–1949* (Baltimore: Gilman School, 1947), 13.

4. For details of the various tracts and gifts, including a map, *see* W. H. Buckler, *Assembling the Homewood File* (Baltimore: Johns Hopkins University, 1941). William Keyser to the Trustees of Johns Hopkins University, 1 February 1901, Milton S. Eisenhower Library, Special Collections.

5. Brian Harrington, *A Brief History of the Homewood Campus,* iii. The reconstruction of the circular drive was part of the Johns Hopkins University Homewood Campus 2000 open space and master plans. The original Olmsted Brothers plan is housed in the Milton S. Eisenhower Library, Special Collections.

6. A brief biography of R. T. H. Halsey appeared in the January 2000 issue of the *Magazine Antiques.* He is also discussed in Elizabeth Stillinger, *The Antiquers* (New York: Knopf, 1980).

7. Memo from President Bowman to E. M. Sauerwein, subject: Homewood House, 10-30-35; memo to the file, 4-20-36, both Homewood Museum Archives.

8. The original members of the Homewood Restoration Advisory Committee were Aurelia Bolton, Douglas Boucher, Stiles Tuttle Colwill, William Voss Elder III, Austin Fine, William Johnston, F. Ross Jones, Henry Lewis, Thomas McCracken, Anne M. Pinkard, Bettie Radcliffe, John Waite, and William Whitridge.

9. Details of each of these discoveries are documented in Eric Klinglehofer, Archaeology: A Report on the 1983 Field Excavations, 1983, Homewood Museum Archives.

10. The only contemporary view of the house is painted on the crest rail of a settee attributed to John and Hugh Finlay, 1803–5, currently in the collection of the Baltimore Museum of Art (BMA1966.26.11). In this depiction of the house, there are no dormer windows (*see* FIG. 3). It is unknown whether this detail is accurate or represents artistic license.

11. Paint seriation charts are included in appendix A of the Historic Structures Report detailing the results of the study, Homewood Museum Archives.

12. Rodris Roth, "Interior Decoration of City Houses in Baltimore: The Federal Period," *Winterthur Portfolio* 5 (1969): 66.

13. "Requests and Directions to Col. Howard & Messrs. Caton and Oliver" from Charles Carroll of Carrollton to John Eager Howard, Richard Caton, and Robert Oliver, 11 June 1816, typescript copy, unnumbered letter, Homewood Museum Archives, original whereabouts unknown. At the time of the separation, Charles Carroll of Carrollton directed Howard, Caton, and Oliver to oversee the division of property and to coordinate its shipment to Philadelphia by sea. The letter indicates four beds, mattresses, and sheets but is nonspecific in regard to description. A "proportion of the plate" is similarly nonspecific. The coach and horses from Doughoregan and named servants are itemized.

14. 18 October 1805, *Arents Letterbook.*

15. Frances T. Lloyd, "Orders and References to Floor Coverings (Other than Carpets)," *Arents Letterbook,* Charles Carroll of Carrollton, compiled June 1986.

16. Florence M. Montgomery, *Textiles in America, 1650–1870* (New York: Norton, 1984), 66.

INDEX

A Note on the Types

The text of this book is composed in Renaissance Antiqua, designed by Hermann Zapf in 1985 for Scangraphic. This type represents a carefully considered digital refinement of Zapf's earlier calligraphic typeface for metal, the ubiquitous Palatino of 1949, and incorporates the classical proportions of Italian lettering during the late fifteenth-century Incunabula. The display type is set in Senatus, designed by Werner Schneider in 2003 for Berthold and inspired by an inscription on the triumphal Arch of Titus at the upper end of the Roman Forum. The arch was dedicated by the Senate and People of Rome to Titus in commemoration of his capture of Jerusalem in 70 A.D.